BOSTON

A YEAR IN THE LIFE

Photographs by

BILL BRETT

Text by
Carol Beggy

Foreword by
David G. Mugar

COMMONWEALTH EDITIONS • BEVERLY, MASSACHUSETTS

ISBN 978-1-933212-74-6

Cover design by John Barnett / 4 Eyes Design

Printed in Korea

Commonwealth Editions is the trade imprint of Memoirs Unlimited, Inc., 266 Cabot Street, Beverly, Massachusetts 01915. Visit us on the Web at www.commonwealtheditions.com.

10 9 8 7 6 5 4 3 2 1

Foreword

The book you are holding in your hands is a gift to Boston from my friend, Bill Brett, an artist with a camera who has lived all his life in love with Boston. Having worked as a photographer for the *Boston Globe* for more than forty years and having published two books of photographs, in 2005 and 2007, he embarked on an odyssey of sorts—to produce one memorable photograph of Boston every day for twelve months. The result is this intimate book and loving look at our city and ourselves.

The adventure begins and ends in springtime, at one of the city's most celebrated events, the Boston Marathon, which is appropriate, for in committing to the daunting challenge to produce a photograph a day for a year, Bill Brett was running a marathon of his own. None of us envisioned what it would demand of him to be on the street every day, in rain and snow and heat and sleet, just like mail carriers, except that they have Sundays off and a summer vacation.

But what a race it has been, and at the finish the prize goes to Bill Brett and to all of us, for he has given us the opportunity to see ourselves in a mirror, frozen in time, so that we may dwell today, tomorrow, and through the years not only on where we live, but also on who we are—in all our hues and views and tints and tones and shades and shadows of light and dark and blacks and whites.

What Monet did for Paris with his brush, what Tennessee Williams did for New Orleans with words, and what Duke Ellington did for Harlem with music, Bill Brett has done for Boston with his photographs.

Each morning, he'd set out, armed with his Canon, his keen eye, and his intimate knowledge of the city. And did I mention the spider web of contacts he has in Boston's boardrooms, firehouses, police stations, waterfront condos, neighborhood three-deckers, fancy hotels and homeless shelters—all those folks eager to dial his cell phone and confide, sometimes in a whisper, "Say, Bill, have you heard that . . . "

No one is more qualified for this challenge than Bill Brett, for no one knows Boston better, its main streets and back alleys, its culture and its people, and what he captures in his creative eye is filtered through his various lenses, into his Canon, and then onto the pages of this book and into our perception of Boston.

As we turn the pages, it's our journey, too, for we drive the roads and walk the streets of Boston with Bill Brett as he searches for the photograph of the day, be it a woman at work, a kid at play, a public or private occasion, a weather event, an artistic expression or simply

that flash in his eye, that moment of insight when color, light and shadow merge to give Boston that certain look. It's a perception you cannot learn, for it's a gift from God, and Bill Brett has it.

Every photograph touches the senses. At Copley Plaza, you see Boston in the mass of tulips, springtime red and fortunate to be planted among such architectural master-pieces as McKim's Boston Public Library and Richardson's Trinity Church. On Hanover Street in the North End, under the neon lights of Mike's Pastry Shop, you smell Boston in the aroma of sugar-sweet cannoli. At the Public Garden lagoon, you feel Boston in the gentle breeze as a Swan Boat glides under the suspension bridge. At Harborfest on City Hall Plaza, you taste Boston in the ladles of thick clam chowder. At what used to be Bob the Chef's in the South End, you hear Boston in the brassy slide trombone that rouses a sassy crowd to a clap-along.

Just as Cézanne saw a simple fruit and ennobled it in his painting, so, too, Bill Brett sees a familiar image in Boston and exalts it in a photograph.

One day in South Boston, for example, he spotted a middle-aged man, leaning for-ward, a rope around his torso as he struggled up a hill, dragging two shopping carts laden with empty cans and bottles in plastic bags seven feet high. This is neither king nor president, but simply a can man, and yet Bill saw him angled in a light that makes the photograph unforgettable.

Given the demanding schedule for this project, Bill was fortunate to have enjoyed the patience and encouragement of his family, and also to have remained healthful, with the exception of a fall he took while photographing a bicycle race. The injury to his foot required a therapeutic boot that left him hobbling for two weeks.

To make parking easier, he abandoned his Crown Victoria for a Toyota Camry and put more than forty thousand miles on it. Thanks to a bottomless pocket of quarters for meters, not to mention the occasional ten dollars for pliant doormen, Bill never got a park-ing ticket, not one.

He walked miles through neighborhoods and lost weight. In pursuit of the right angle, he perched on fire trucks, scampered up ladders, scouted from rooftops, skimmed the city in helicopters, focused from aerial buckets, hung over balconies, and dangled from boats.

The photographs themselves defy classification, for they cover our lives, from births to children at play, to students and college commencements, to men and women at work and at leisure and, finally, to the melancholy of death, like the photograph of the old man at Mt. Hope Cemetery on Veterans Day, bowing his head as American flags flutter over too many graves of too many soldiers. One of my favorites captures a moment at Granary Burying Ground, when a well-dressed young woman, a tourist perhaps, bends to squint and read an engraving noting that Matthew Webb died in 1769 at age thirty-three.

My friendship with Bill Brett dates back nearly fifty years. I don't remember precisely when we came together. As with many friendships, there's no memory of meeting, but like plants that grow side by side, over time the roots entwine and two seem as one.

I do remember that when Bill was about fifteen, he'd grab his Brownie camera and ride his red bicycle from his home in Dorchester to a Howard Johnson's parking lot on Massachusetts Avenue, a hangout for news photographers and sparks like myself, news buffs with police radios who'd follow newsmen to fire or police calls.

On the street at night, you learn fast about life and death. I took photographs and sold them to newspapers, and Bill began to sell his, too. I was a wealthy kid from the suburbs, and Bill was a city kid, but we struck up a friendship and soon I was seeing Boston through Bill's eyes. With his magnetic personality, he developed contacts everywhere, and soon he was introducing me to cops, firefighters, and politicians. Everybody likes Billy.

Among these photographs are a few celebrities: Bill Russell, Oil Can Boyd, Meg Ryan, Tom Hanks, and our own Jack Connors. But the focus is on average folks, from the gentleman on a three-step ladder, dusting a window casement in the lobby of the Fairmont Copley Plaza, to the workers in a bucket suspended high enough for them to clean the statue of General Hooker astride his horse on the State House lawn.

The montage of Bill Brett's Boston would not be complete without acknowledgment of his only granddaughter, Morgan Hurley, three, seen posing with a gorilla at Franklin Park, and his only grandson, Greyson Gunter, shown a moment after his birth on May 17, 2007— and boy, does he look annoyed!

There's history, too, in the photograph of the eight surviving O'Neil sisters, reunited at Doyle's Café, as beautiful as they were a half-century ago when, as little girls, they marched in the Easter Parade on Commonwealth Avenue, all dressed identically in clothes sewn by their mother. Former mayor Kevin White appears, too, jacket over his shoulder, standing alongside a statue of Kevin White, jacket over his shoulder.

Given Bill Brett's puckish humor, there are photographs to amuse you, too, especially one taken during Chinese New Year, when an earnest cop writes a parking ticket seemingly unaware of the ten-foot "dragon" walking in back of him. And don't miss the photograph of two delivery trucks heading in opposite directions along a street so narrow they are separated by inches until one driver reaches out to fold back the mirror on a parked car.

When you finish perusing these pages, keep this memoir. Give it a prominent place in your home, for you'll want to savor it again, and one day you'll leave it to your children. As time goes by, it will become valuable to them as an insight into the city where you lived one year early in the twenty-first century.

For that enduring legacy, all of us who love Boston say to Bill Brett, thank you!

—David G. Mugar

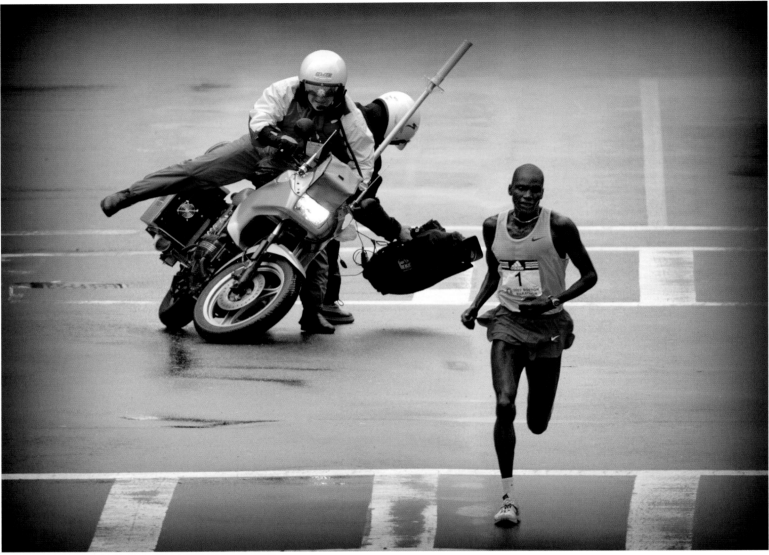

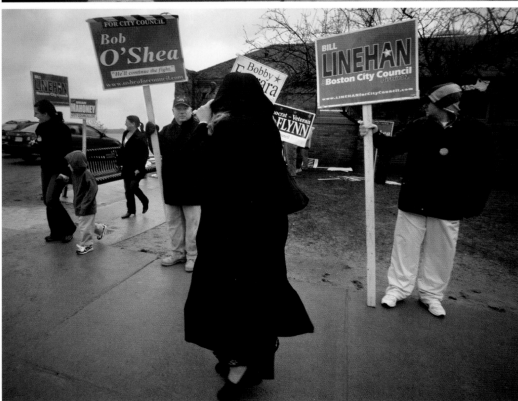

▲ **APRIL 16** Robert Cheruiyot looked like he hadn't worked up a sweat as he approached the Boylston Street finish line to win his third Boston Marathon, in 2007. The world-class Kenyan runner also showed no sign he was aware of the TV camera crew losing control and crashing behind him.

◄ **APRIL 17** Seven candidates entered a special election to fill the District 2 city council seat held for many years by James M. Kelly. The South Boston Democrat died in January 2007 after a long bout with cancer. Bill Linehan won the seat.

APRIL 18 When area schools are out for spring break, there's an immediate uptick in attendance at the Museum of Fine Arts. Among the exhibition halls that seem to attract the most attention from young museum goers are the antiquities and, of course, the mummies.

APRIL 19 Hundreds of people took to the streets downtown calling for reforms of criminal background checks under the state's Criminal Offender Record Information system. Supporters of the system said it protects rather than discriminates.

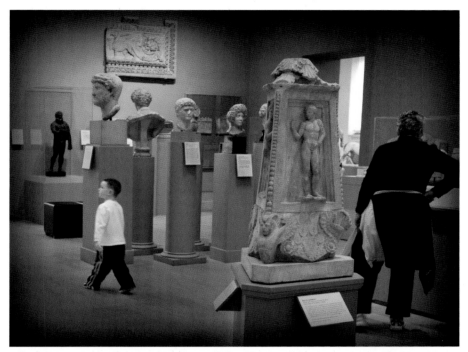

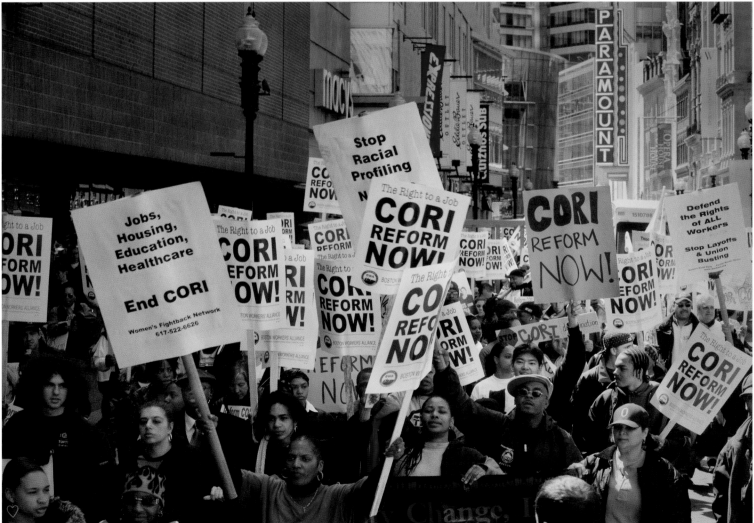

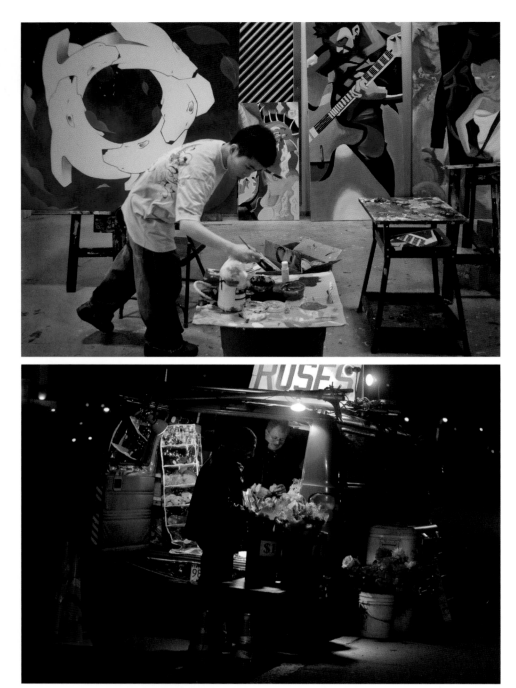

◀ **APRIL 20** While his fellow students may have used their school vacation for lighter pursuits, Dorchester's David Wang spent his time off in front of a canvas in the studios of Artists for Humanity in South Boston.

◀ **APRIL 21** It was just before midnight when Francisco Correra bought flowers from David Stadelhofer, who has been selling his colorful wares in Sullivan Square for fifteen years.

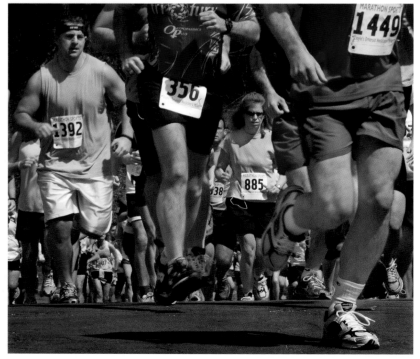

◀ **APRIL 22** Several thousand runners ran the five-mile course for the eleventh Doyle's Emerald Necklace Road Race. The event raised money to support Sister Jeanne's Kids Fund and the Boston Police Gaelic Column of Pipes and Drums.

▶ **APRIL 23** New England Conservatory senior jazz student Sean Hutchinson prepared for a concert in the garden courtyard at the Isabella Stewart Gardner Museum.

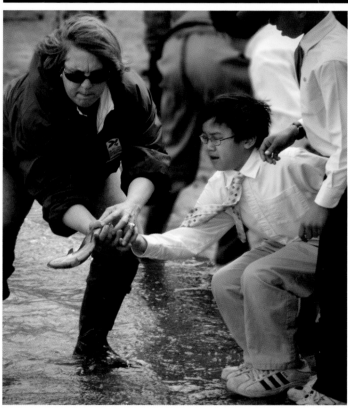

▶ **APRIL 24** Boston public school students helped Parks and Recreation Department commissioner Antonia Pollak restock the trout at Jamaica Pond. The program and the area's ponds are also supported by the Emerald Necklace Conservancy.

▶ **APRIL 25** This couple walking down the Commonwealth Avenue Mall was so focused on each other that they didn't seem to notice the canopy of spring beauty unfolding above them, as magnolia trees were in full bloom.

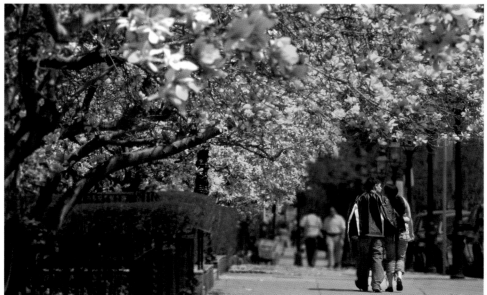

■ **APRIL 26** Former Red Sox pitcher Dennis "Oil Can" Boyd and his partner Lidan Liu took the ballroom challenge seriously, getting in several weeks of rehearsal at University of Massachusetts Boston in anticipation of a Fields Corner and Main Streets fund-raising performance that was almost a month away.

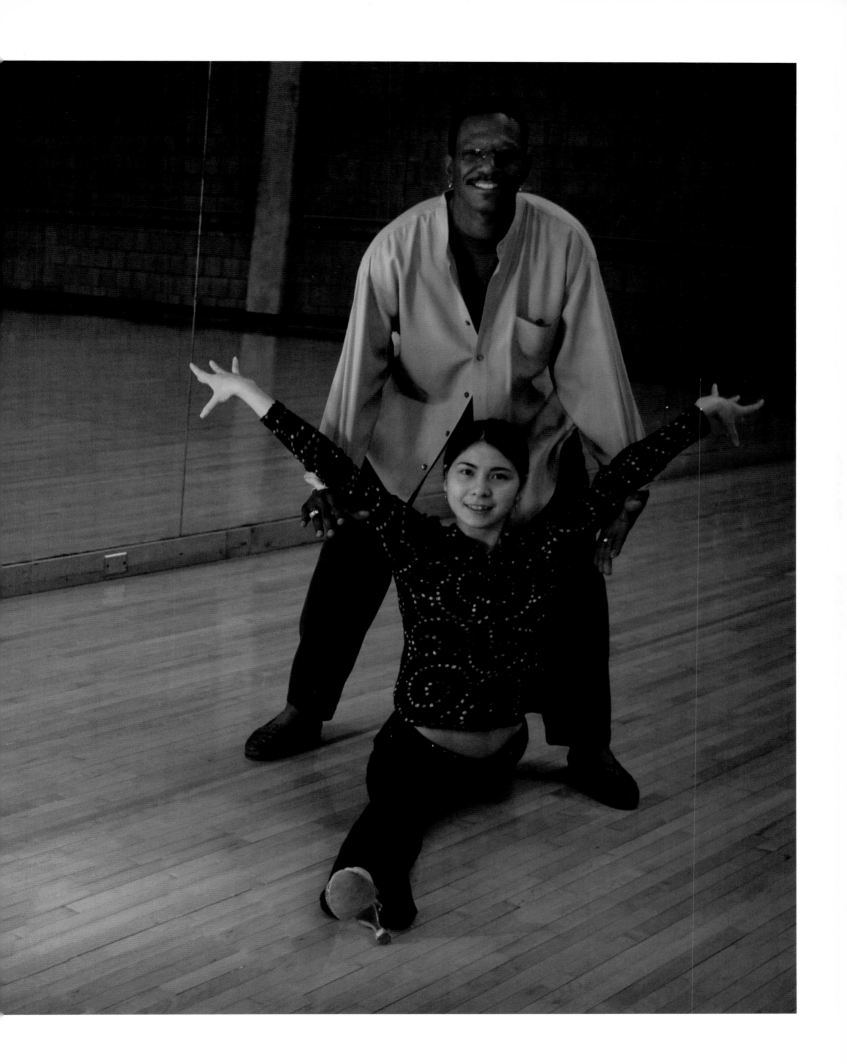

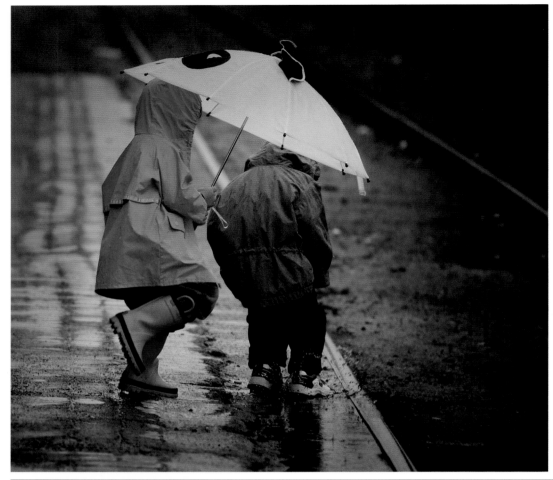

◀ **APRIL 27** A puddle and an umbrella were all two boys needed to stay occupied as they waited for a B Line train on Commonwealth Avenue in Brighton.

▼ **APRIL 28** Pope John Paul II Park in Dorchester hosted the first Dave Powers 5K Walk for Scholarships, which will be held annually to honor the late Dorchester community activist.

▶ **APRIL 29** Rebecca Smith stood while the rest of her fellow activists lay down on Boston Common during a "die-in" staged to call attention to the genocide in Sudan's Darfur region.

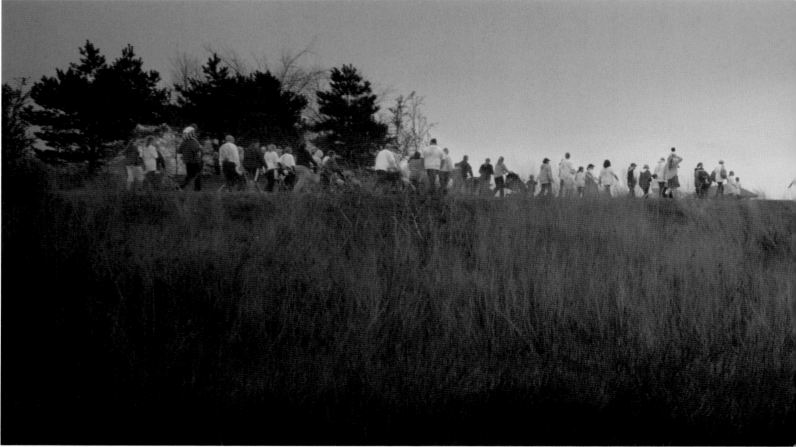

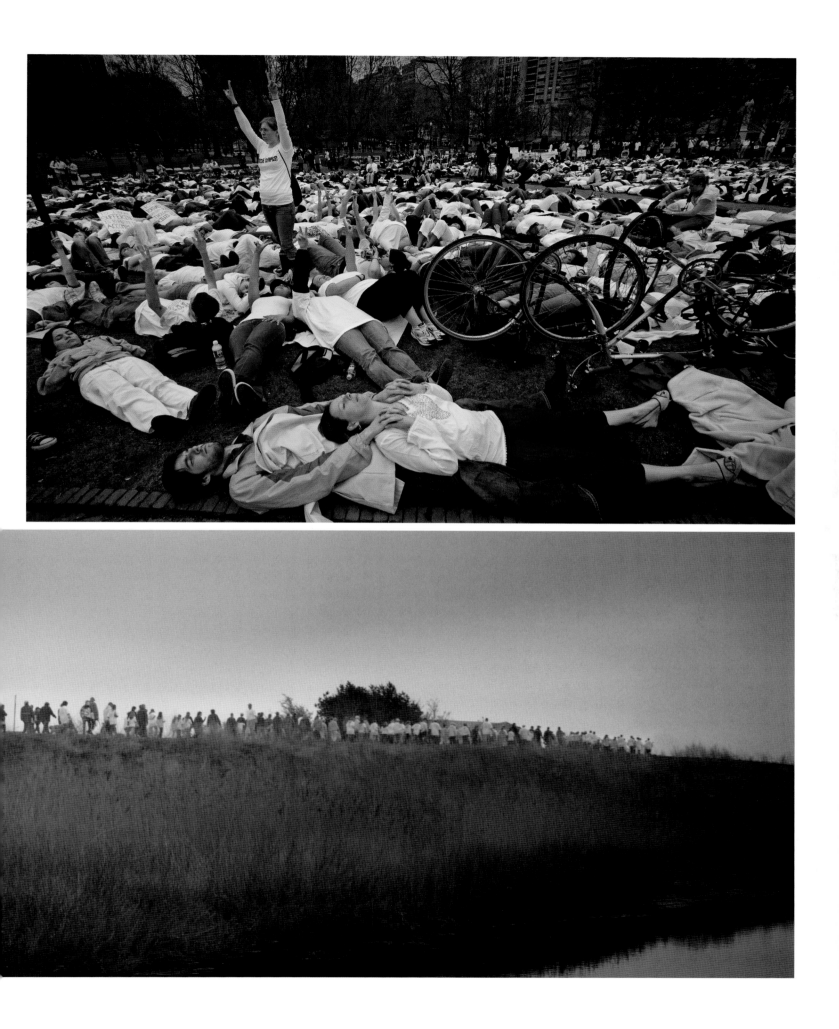

▶ **APRIL 30** Susan Marchionna, in town to visit her daughter, stopped at a café along Hanover Street in the North End to read her morning newspaper.

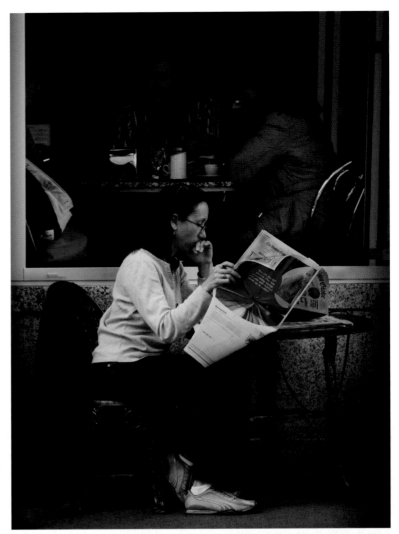

▼ **MAY 1** Boston Pops maestro Keith Lockhart was a conductor of a different sort as he guided the MBTA's Red Line train into Charles Street–MGH Station as part of a promotion for the new Charlie Card renewal-ticket system that replaced the old system of passes and T tokens. The MBTA sold its last token on December 6, 2006, ending eighty years of the coin's use.

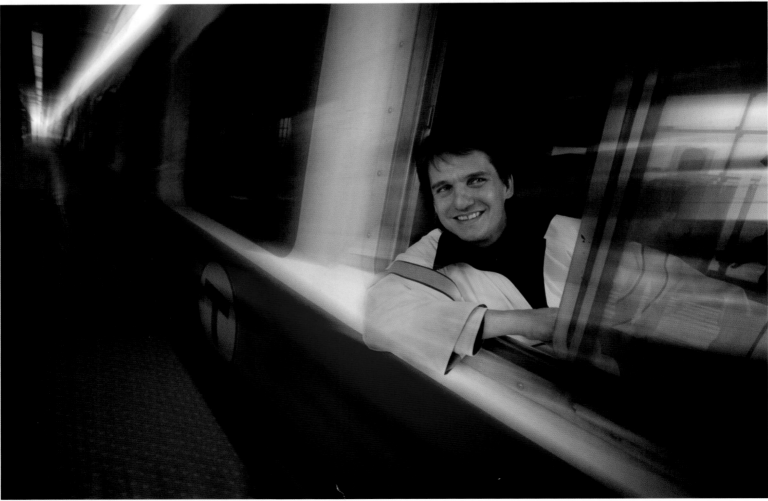

MAY 2 A crew from the Wakefield-based Testa Corporation repaired the Congress Street Bridge connecting downtown's bustling business areas to South Boston's channel district. Another Testa project nearby was the demolition of six miles of the elevated Fitzgerald Expressway to make way for the Rose Fitzgerald Kennedy Greenway.

MAY 3 Elton John performed for more than fourteen hundred philanthropists from twenty-two North American children's hospitals at a glittering gala for Children's Circle of Care at the Westin Boston Waterfront hotel. The special South Boston concert concluded the group's annual conference, hosted by Children's Hospital Boston.

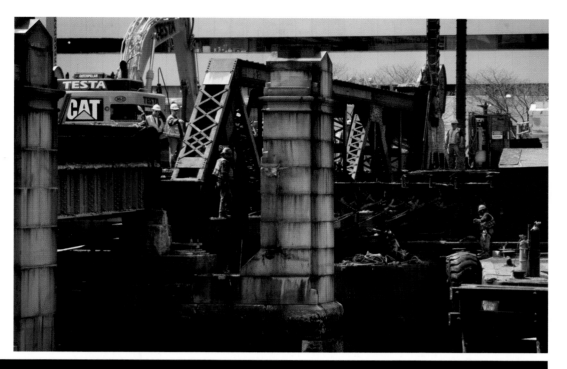

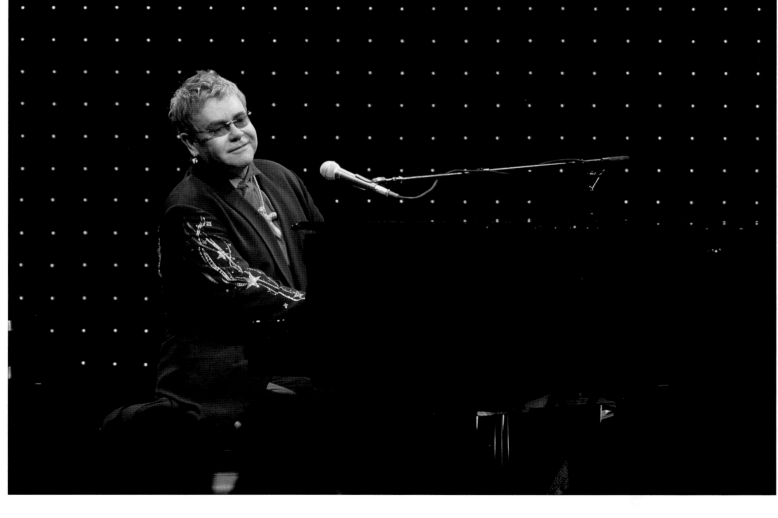

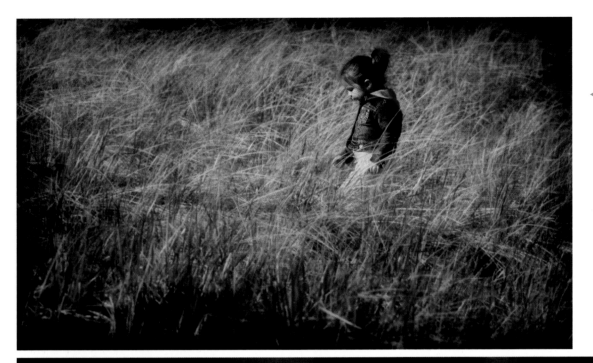

◀ **MAY 4** Aniessa Biba seemed lost in thought as she walked along the tall grass of Carson Beach in South Boston. Owned and maintained by the state's Department of Conservation and Recreation, Carson is one of the best swimming beaches in the area and provides some of the most dramatic views of Boston Harbor.

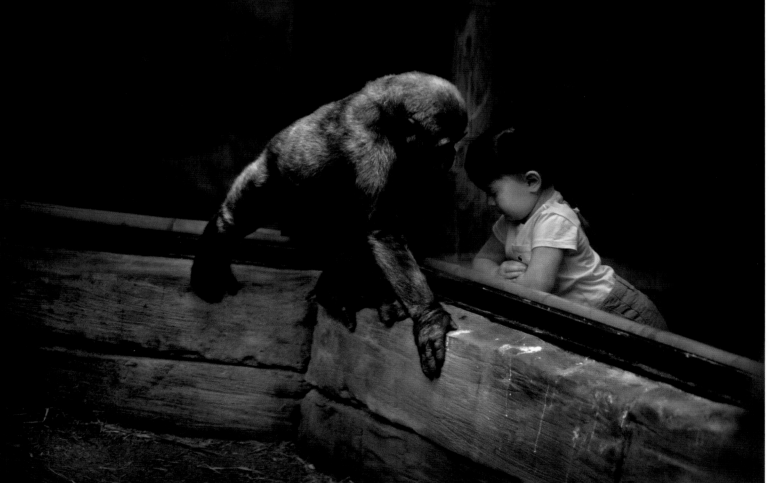

▲ **MAY 5** Glass might have separated Morgan Hurley from Kimani, one of the lowland gorillas at the Franklin Park Zoo, but these two didn't seem to have any trouble sizing one another up. When Kimani wandered off to check out some other visitors, Morgan did her best to get the young gorilla's attention.

MAY 6 Wait staff carrying trays of food and wine poured into the Faneuil Hall Marketplace reception marking the opening of the BIO International Convention, Biogen Idec, which brought some twenty thousand biotech industry executives, researchers, and salespeople to Boston.

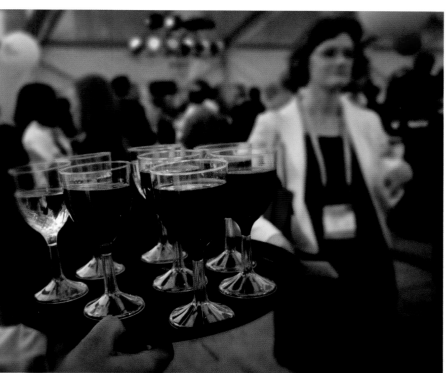

MAY 7 Governor Deval Patrick used the four-day biotechnology convention at the Boston Convention & Exhibition Center as a backdrop to announce a sweeping ten-year initiative to fund one billion dollars for scientific research in medicine and biotechnology.

MAY 8 Two little ones watched with delight as Mrs. Mallard and her eight babies made their home in the Public Garden—just as they do at the end of Robert McCloskey's *Make Way for Ducklings.* Nancy Schön's bronze tribute to the classic children's tale was installed on the Old Boston–style cobblestones on October 4, 1987.

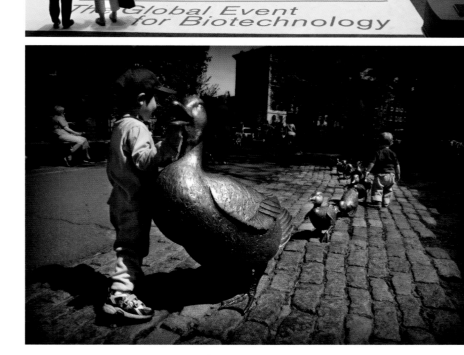

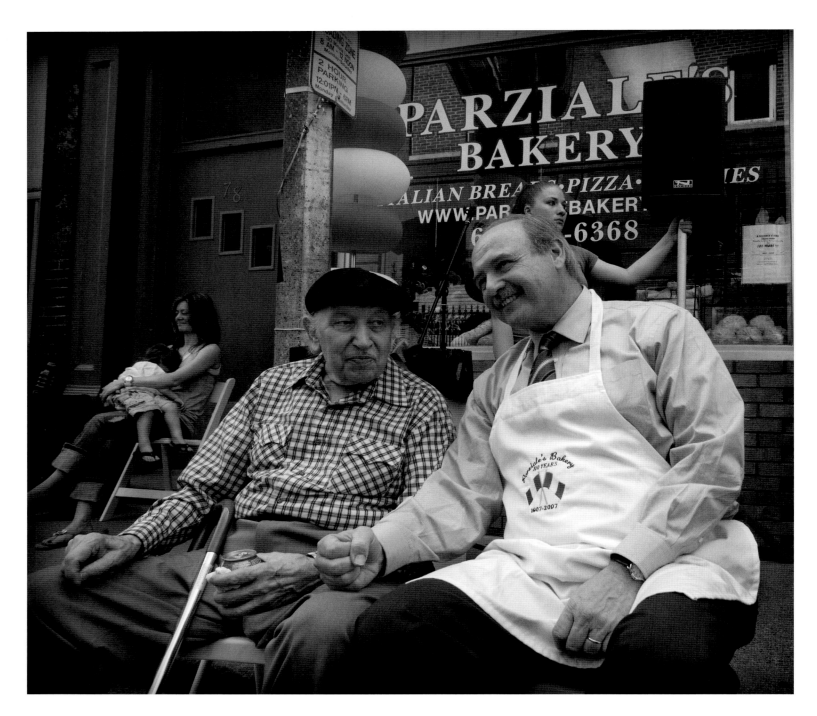

▲ **MAY 9** At eighty-five, Romeo Parziale has seen a lot of changes to the North End, but not with his family's bakery, which his father opened a hundred years ago. It remains a favorite stop for many in the area. Parziale reminisced with Speaker of the House Salvatore F. DiMasi, who remembered making the trip from his family's home around the corner to the Prince Street landmark to get freshly baked bread before school each morning.

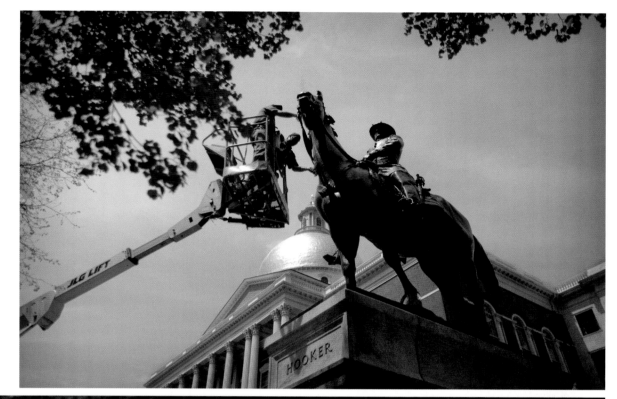

MAY 10 Joshua Craine and Rich Brown cleaned the statue honoring Civil War general Joseph Hooker. Erected for the Hadley native in 1910, the statue is one of several on the State House grounds, which include statesman Daniel Webster, educator Horace Mann, religious pioneer Anne Hutchinson, Quaker martyr Mary Dyer, and former president John F. Kennedy.

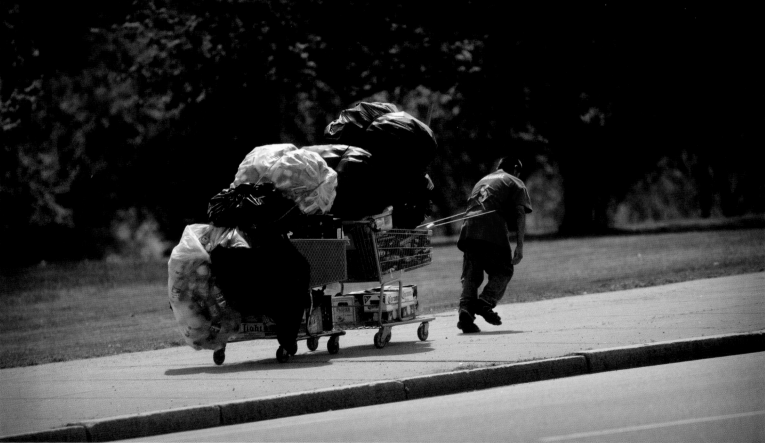

▲ **MAY 11** Pulling a jury-rigged caravan laden with bottles and cans, a man makes his way up Old Colony Avenue in South Boston toward Kosciuszko Circle.

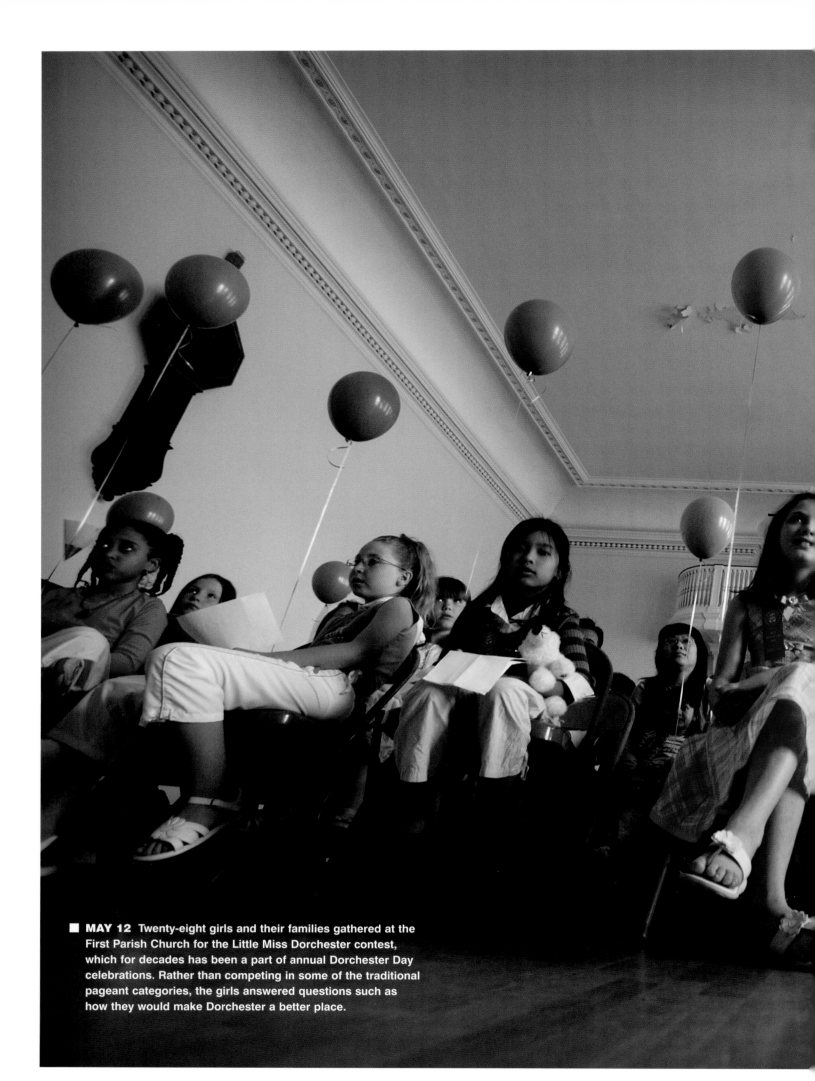

■ **MAY 12** Twenty-eight girls and their families gathered at the First Parish Church for the Little Miss Dorchester contest, which for decades has been a part of annual Dorchester Day celebrations. Rather than competing in some of the traditional pageant categories, the girls answered questions such as how they would make Dorchester a better place.

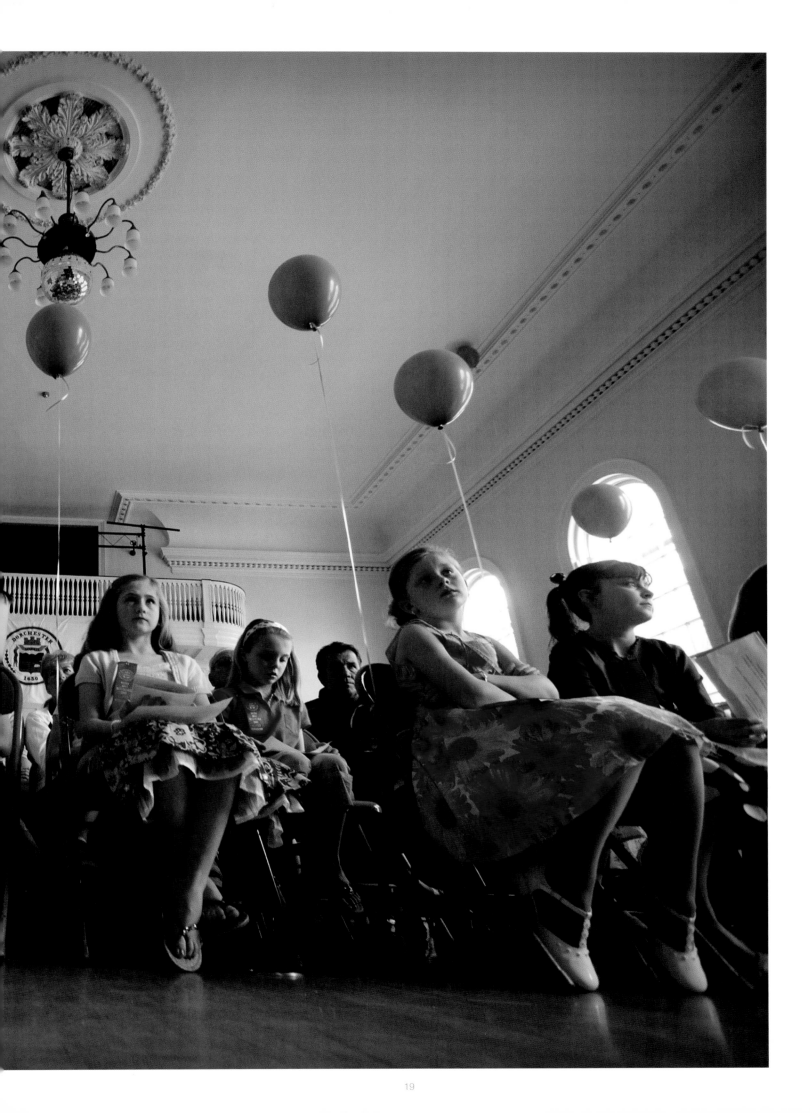

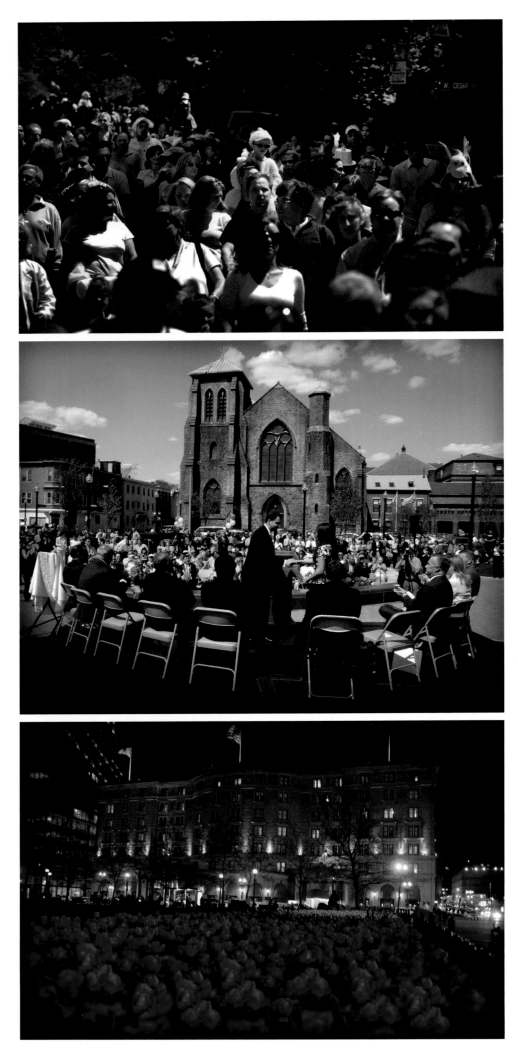

◀ **MAY 13** Hundreds of young fans of Robert McCloskey's *Make Way for Ducklings* flocked to the annual Duckling Day Parade that follows the route Mrs. Mallard took down Mount Vernon Street from Louisburg Square. As in the story in the Caldecott Award–winning book, the marchers are assisted by the Boston Police Department so that the wee ones cross Beacon Street safely and get to their "new home" in the Public Garden.

◀ **MAY 14** State senator Anthony W. Petruccelli beamed with pride at the ribbon cutting for a new park named for Albert "Junior" Lombardi, the last piece of the Maverick Landing project in East Boston. The 426-unit development replaced the blighted Maverick Gardens public housing project that had cut off the area from the rest of the neighborhood for decades.

◀ **MAY 15** Tulips in full bloom filled the flower beds on the plaza at Copley Square as the Fairmont Copley Plaza hotel glowed in the background.

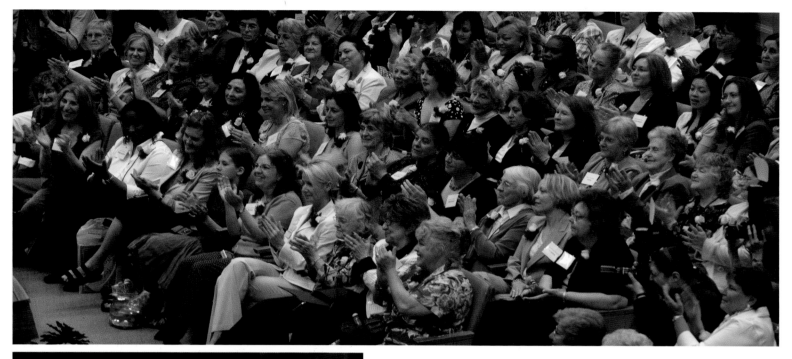

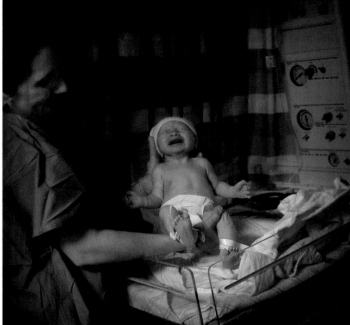

▲ **MAY 16** Two hundred and sixty-eight Unsung Heroines were honored by Massachusetts Commission on the Status of Women at a ceremony in the Gardner Auditorium in the State House. More than six hundred people attended the day-long event held to mark the progress of women's causes in the state and to chart a new course for future action.

◄ **MAY 17** Greyson James Gunter's arrival late in the evening marked the third generation of his family to call Boston home. Greyson, who was eight days late, came roaring into the world at six pounds, twelve ounces and measured twenty inches long.

▶ **MAY 18** Heavy rains meant the Atlanta Braves would have to wait another day to challenge the Red Sox at Fenway Park. The Sox would take two out of three against the National League team that once called Boston home.

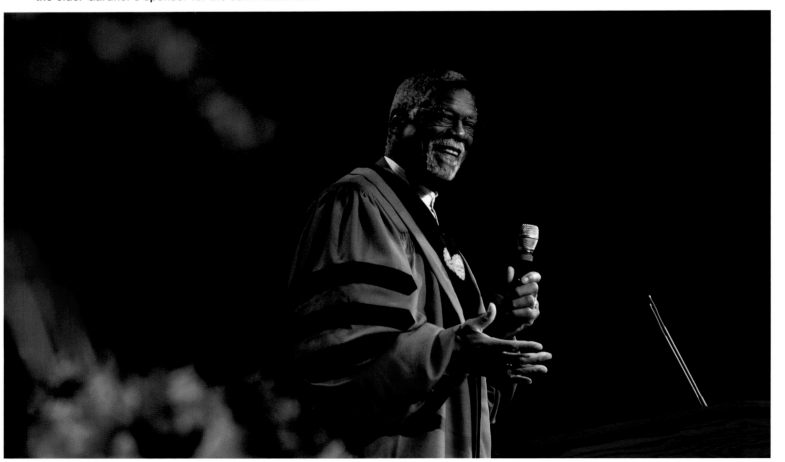

MAY 19 The Benjamin Franklin Institute of Technology's class of 2007 included graduates who trace their roots to more than four dozen countries, represented by flags circling the school's auditorium. Since opening its doors in 1908, the South End post-secondary institute has seen more than eighty-five thousand students benefit from its novel approach to technical education.

▼ **MAY 20** Legendary Boston Celtics center Bill Russell, the cornerstone of the team's dynasty of the 1960s, delivers the commencement address at Suffolk University's one-hundredth graduation at the TD Banknorth Garden. The university also recognized John J. Gardner, who at ninety-nine years of age was the university's oldest alumnus, with an honorary doctor of laws degree. Joining Gardner on stage were his son Eliot Gardner and Suffolk trustee Deborah Marson, who served as the elder Gardner's sponsor for the commencement.

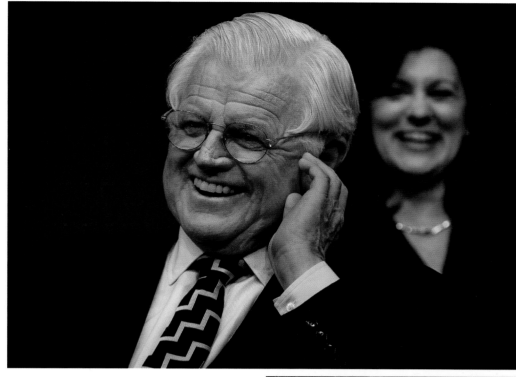

◀ **MAY 21** Senator Edward M. Kennedy and his wife Victoria enjoyed a light moment at the annual Profile in Courage Awards at the John F. Kennedy Presidential Library and Museum. The 2007 winners were Doris Voitier, superintendent of schools of Louisiana's St. Bernard Parish; and Houston mayor Bill White. Both were honored for their responses in the aftermath of Hurricane Katrina.

▶ **MAY 22** Former Boston mayor Kevin White, who is credited with transforming the face of the city during his four terms at City Hill (1968–1984), posed with a ten-foot-high bronze statue of his likeness that stands just outside Faneuil Hall, one of the areas revitalized during White's administration.

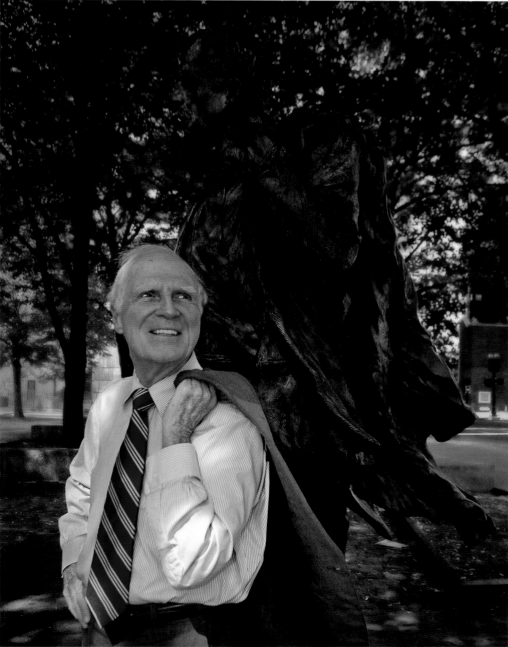

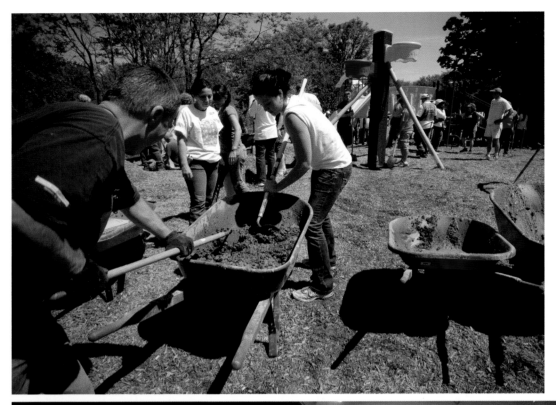

◀ **MAY 23** Scores of volunteers came together to build a playground for Joelyn's Family Home on Long Island in Boston Harbor. Run by the Victory Programs, the home is a state-of-the-art, short-term, transitional home for up to twenty-five women in recovery and their children.

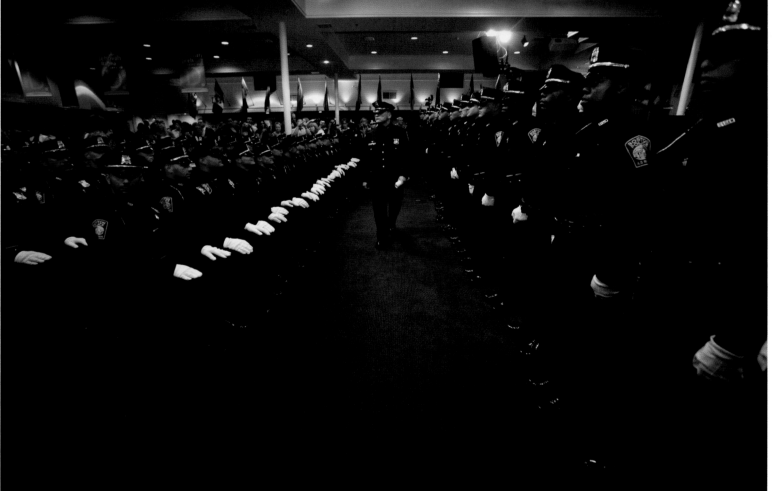

▲ **MAY 24** Eighty-two men and women were welcomed into the ranks of the Boston Police Department at a midday ceremony held at the Jubilee Christian Church on Blue Hill Avenue in Mattapan. The graduation, presided over by superintendent Robert Harrington, was Boston police commissioner Edward F. Davis's first swearing-in ceremony and the last official ceremony for superintendent-in-chief Al Goslin, who retired after forty years of service.

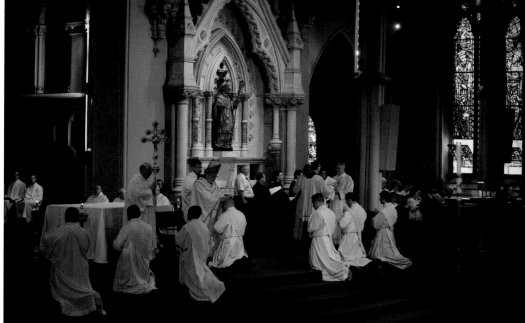

◀ **MAY 25** A record-breaking high temperature of 92 degrees drove thousands of tourists and locals indoors to the food vendors at Faneuil Hall Marketplace in search of a place that was air-conditioned, or at least cooler than the searing heat of the city's streets.

▶ **MAY 26** Cardinal Seán P. O'Malley ordains seven men to the priesthood at the Cathedral of the Holy Cross. The archdiocese's new priests were Fathers Robert J. Blaney, Christopher J. Casey, Andreas R. Davison, Martin G. Dzengeleski, Daniel J. Kennedy, Charles Madi Okin, and Matthew J. Westcott. On January 27, 2008, Father Kennedy, 34, died of a heart attack while visiting with family in Connecticut. The athletic priest, who had run nine marathons and was training for the 2008 Boston Marathon, died of an undiagnosed heart defect.

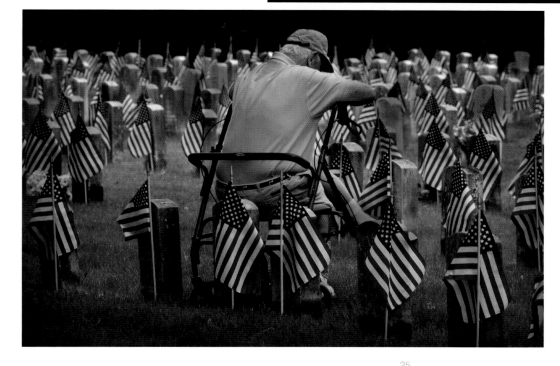

◀ **MAY 27** With a flag neatly posted at the headstone of every veteran in Mount Hope Cemetery in Mattapan, Edwin Crowley, a ninety-two-year-old Mashpee resident, sat by the grave of his brother James, who was twenty-three when he was killed during World War II.

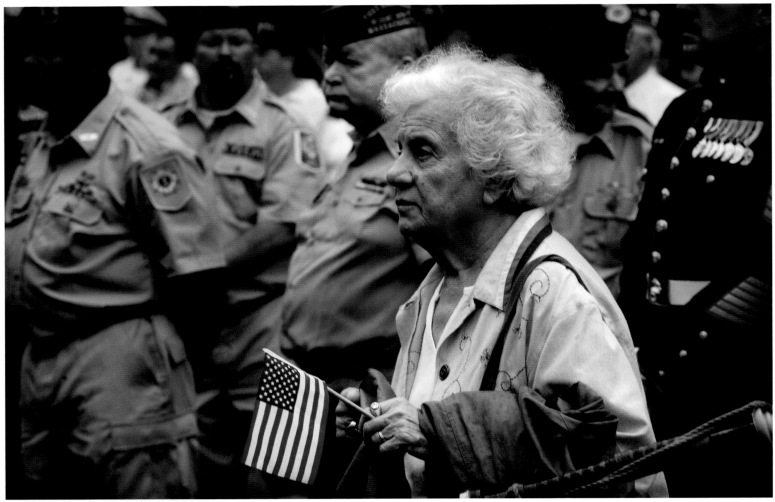

▲ **MAY 28** Memorial Day is more than just a three-day weekend for many in the area, including those gathered at the Cedar Grove Cemetery in Dorchester.

▼ **MAY 30** The young students of the ABCD Chinese Church's Head Start program gathered at Boston Common for their annual Great Dance.

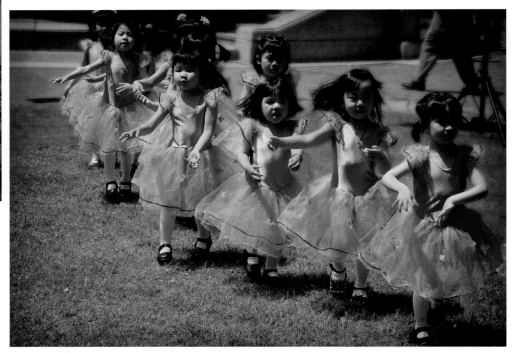

▲ **MAY 29** When the city's valedictorians gathered for a celebration, Boston Latin School's Shuang Wu of West Roxbury sported a smile matched by his headmaster, Cornelia Kelley, who has been at the helm of the country's oldest public school since 1998.

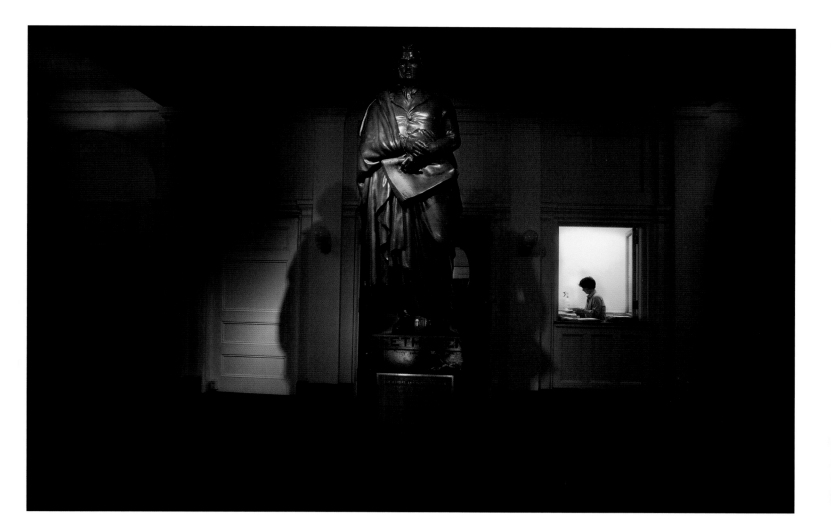

▲ **MAY 31** The bronze statue of the irascible but brilliant composer Ludwig van Beethoven watches over the lobby of the New England Conservatory's famed Jordan Hall. Originally created by sculptor Thomas Crawford for the Boston Music Hall, the statue was later moved to Jordan Hall, which is renowned for its spectacular acoustics as well as for its intimacy.

<div style="text-align:right">JUNE</div>

▶ **JUNE 1** His stewardship of the New England Patriots already had brought three Super Bowl championships and Lombardi trophies to Boston, but it was Robert Kraft's philanthropic work that got the attention of the University of Massachusetts Boston. Kraft, the team's chairman and CEO, was given an honorary degree by the college's then chancellor, Dr. Michael F. Collins, left, as Jack M. Wilson, University of Massachusetts president, and governor Deval Patrick, who delivered the keynote address, offered their congratulations.

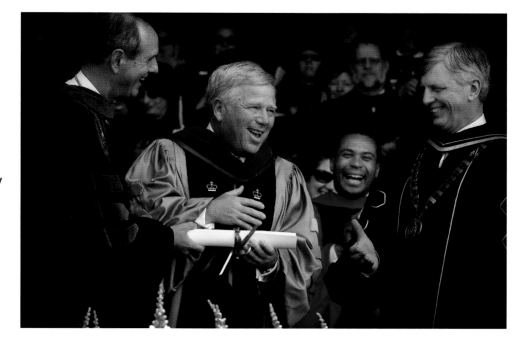

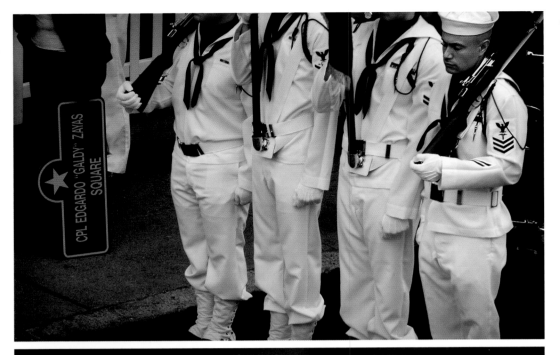

JUNE 2 A Navy honor guard was at the ready for the dedication of an Adams Street corner, Corporal Edgardo "Galdy" Zayas Square. One of more than 1,225 such "hero squares" in the city, this corner was named for the twenty-nine-year-old Dorchester resident killed by a makeshift bomb on August 26, 2006, while deployed in Baghdad. One of five Iraqi War casualties to have a square named for him, Zayas left behind his wife, Suheil Campbell Zayas, and two small children. The tradition of naming corners dates back to Mayor James Michael Curley, who after World War II wanted to memorialize those city residents who had given their lives in service to their country.

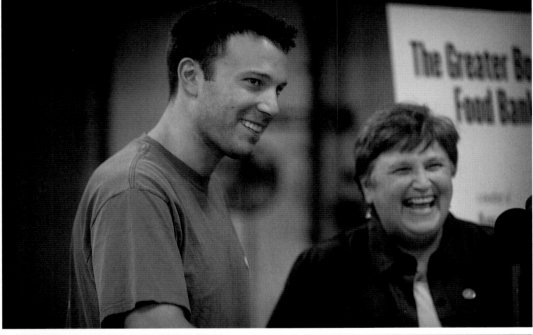

JUNE 3 It was while scouting in city neighborhoods for locations to film his directorial debut, Gone Baby Gone, that Ben Affleck got to see the effects of hunger in Boston first hand. "We did a lot of location scouting . . . and you knock on a lot of doors and you go into a lot of homes . . . and I saw the need," the Oscar-winner said while working with volunteers at the Greater Boston Food Bank in Roxbury. After getting a tour from Catherine D'Amato, the food bank's president and CEO, Affleck talked with those distributing the food through local food pantries, including one that serves his former neighborhood in Cambridge.

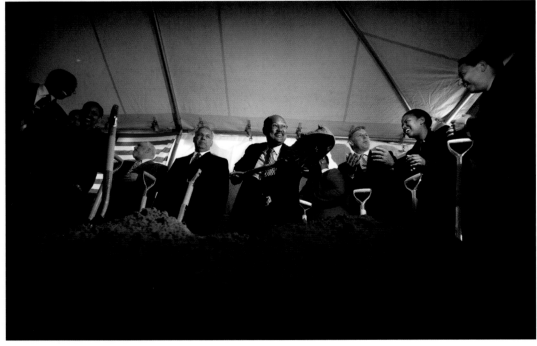

JUNE 4 The groundbreaking for a new branch library in Mattapan was a proud moment for city and state officials lined up on the site at the corner of Blue Hill Avenue and Babson Street. Only the second new branch facility for the city's library system in two decades, the Mattapan branch replaced an antiquated, smaller library nearby.

▲ **JUNE 5** St. Dominic Savio Preparatory High School had several lives and a few name changes in its forty-nine-year history. But on this day, the Roman Catholic school held its traditional last-day-of-school barbecue one final time. Headmaster Anders Peterson and dozens of parents and community supporters spent most of the year trying to find a way to keep the school open, but no permanent solution could be found and the school's lease wasn't renewed. "Our students have persevered in the classroom, they have persevered in the community," Peterson told *The Boston Globe*, "and they have absolutely persevered on the athletics fields."

▼ **JUNE 6** Roberto Coelho of Schumacher's Nursery in West Bridgewater put up baskets of cascading petunias on light posts along Boylston Street.

▼ **JUNE 7** Moments after the Boston Pops Orchestra played its last notes of the night, Massachusetts Avenue teemed with audience members pouring out of Symphony Hall. On this night, Maestro Keith Lockhart conducted a program of award-winning music from Broadway and Hollywood.

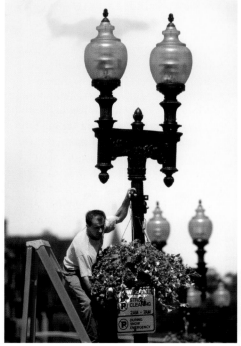

JUNE 8 A few dozen people gathered outside the Massachusetts Affordable Housing Alliance offices at 1803 Dorchester Avenue as the grassroots organization held a groundbreaking ceremony for its Homeownership University. Among those on hand were Thomas Callahan and Bob Sheridan. When the $3.5 million "green" construction project is complete, the not-for-profit will expand its education programs that have already taught more than thirteen thousand people how to buy their own homes.

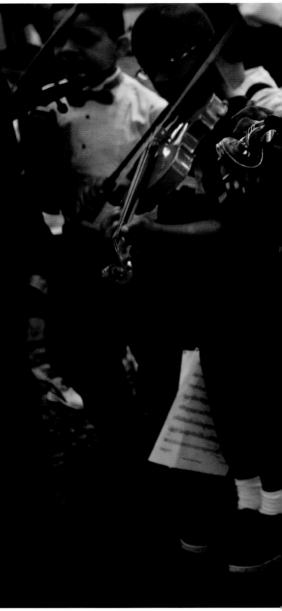

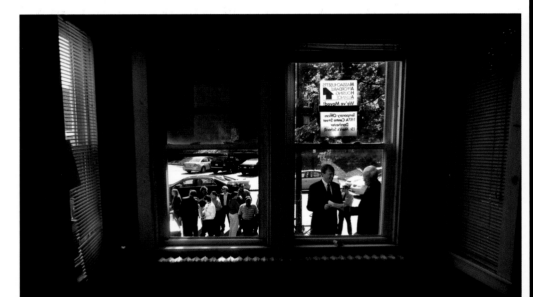

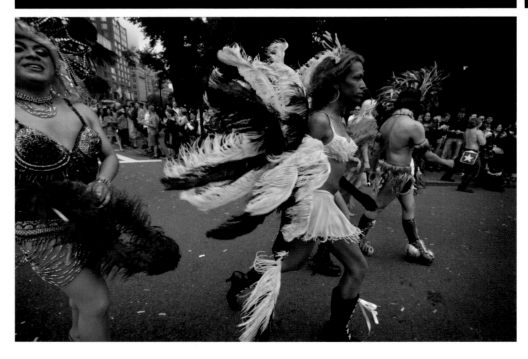

JUNE 9 Boston's Gay Pride Parade always provides a colorful, wide-ranging display of the region's gay, lesbian, bisexual, and transgendered communities. This Saturday outing featured one hundred floats and 180 marching groups—some six thousand marchers, in all—as the parade took a new route that included marching in front of the State House.

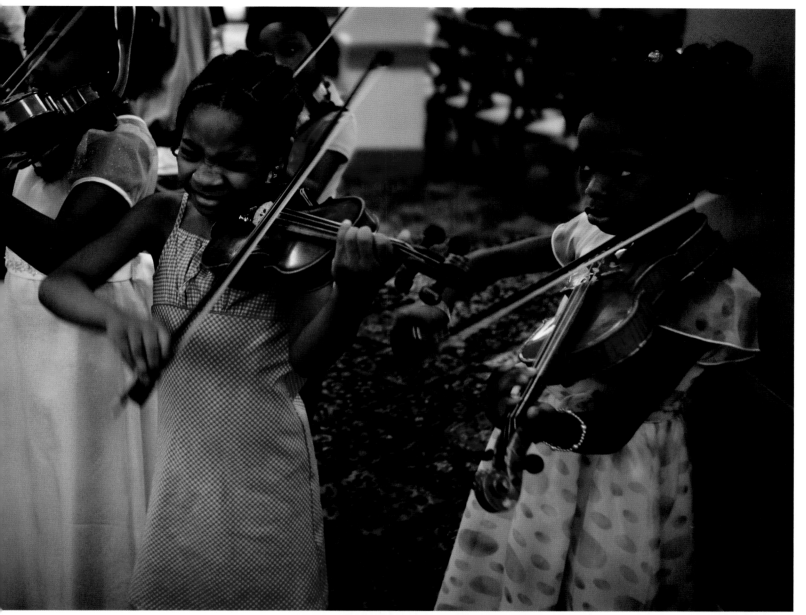

▲ **JUNE 10** Seven-year-old Nijioma Grevious put her all into a performance at Project STEP's twenty-fifth-anniversary concert at Symphony Hall. Founded in 1982, the charitable organization was started by the Boston Symphony Orchestra, Boston University College of Fine Arts, and New England Conservatory to address what was seen as historic under-representation of musicians of color in the classical music world.

▶ **JUNE 11** Talk about an enviable track record! The Boston Latin School in The Fenway is the oldest public school with continuous service in the United States; it even pre-dates Harvard College by a year. Ninety-nine percent of students in the Class of 2007, gathered here for graduation ceremonies at the Bank of America Pavilion in South Boston, were accepted to four-year colleges.

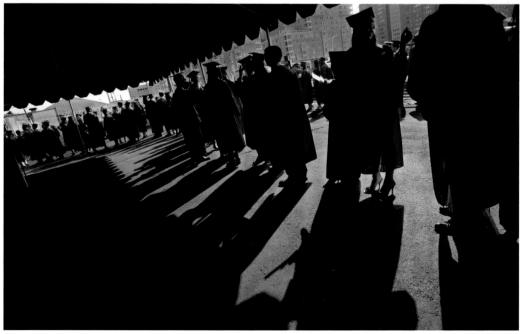

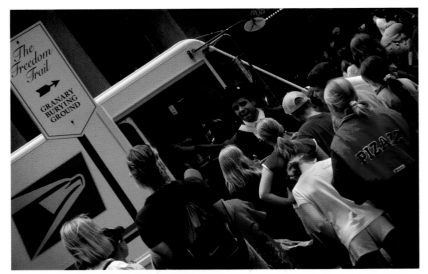

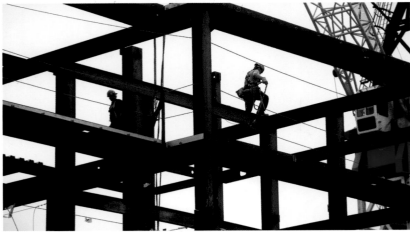

◄ **JUNE 12** The Walk Into History tour stopped along the Freedom Trail on Tremont Street to listen to John Ferrera portraying Dr. Joseph Warren, a physician who fought and died at the Battle of Bunker Hill. On the walk, Ferrara spins the tale of the dashing doctor who was the darling of the city—young, handsome, and committed to the Revolution. Many of Warren's contemporaries begged him not to fight and risk his life for the new country.

◄ **JUNE 13** Just two weeks before the scheduled "topping off" ceremony—a deadline they would make—members of the Iron Workers Union Local No. 7 worked straight through each day building out the luxury hotel and residences of Regent Boston at Battery Wharf. The 150-room hotel and 104-unit residential condominium project includes a marina, a Coast Guard Museum, and a 7,500-square-foot restaurant by three-star Michelin chef Guy Martin.

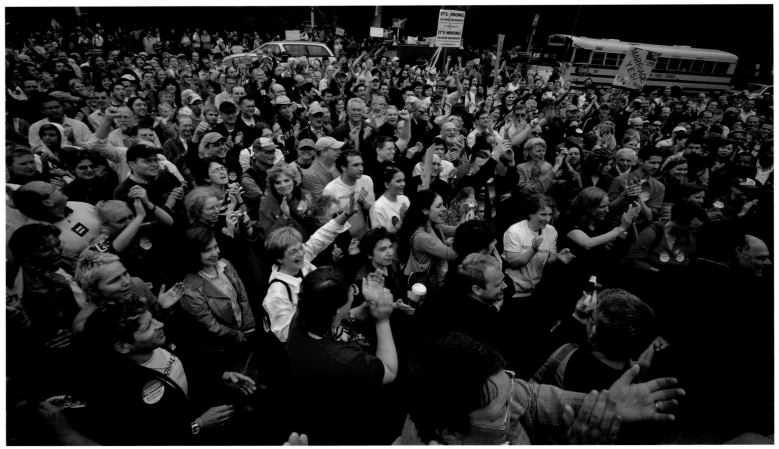

▲ **JUNE 14** Scores of supporters of same-sex marriage in Massachusetts flooded Beacon Street in front of the State House as word came that lawmakers had rejected a proposal that would have let voters decide whether same-sex marriage should be banned. Gay-marriage opponents had collected about 170,000 signatures on a petition to allow voters to change the state's constitution to define marriage as a union between a man and a woman.

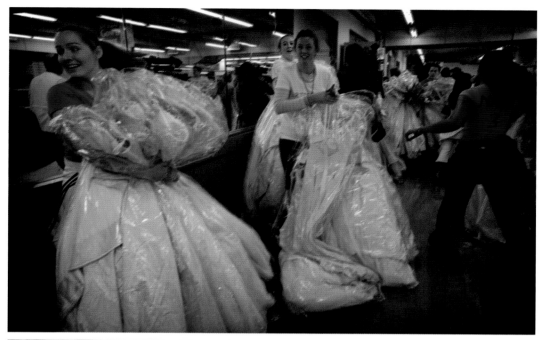

▶ **JUNE 15** It was all about speed, strategy, and having some help at the "Running of the Brides," as the Filene's Basement annual sale of bridal gowns is often called. The best dresses go to the fleet of foot, but tough elbows and a keen eye can be big helps. This morning was special for another reason. With the complete overhaul of the former Filene's store at Downtown Crossing, the bridal gown sale would not return to the original Filene's Basement until at least 2009.

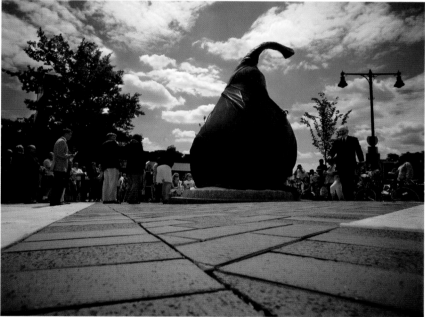

▶ **JUNE 16** Yes, it was a pear that caused the double—and even triple—takes at busy Edward Everett Square. Why was there an eleven-foot-tall tribute to fruit at that overflowing intersection? The humble Clapp pear was first cultivated in the 1840s just a few blocks north of the bronze statue, still wrapped this morning as it awaited the formal dedication ceremony. The statue was created by Somerville artist Laura Baring-Gould, who after several years of research designed eleven pieces of art to commemorate Dorchester's rich history.

▶ **JUNE 17** On an otherwise quiet Sunday afternoon, families, colleagues, and friends gathered to remember nine firefighters who lost their lives on this day in 1972 when a horrific fire engulfed the Hotel Vendome. It was the worst tragedy in the history of the Boston Fire Department and remains one of the dozen most deadly events in the history of US firefighting. The service is held annually at a memorial on the Commonwealth Avenue Mall across the street from the former hotel that has been redeveloped into office and residential condominiums. Among those gathering on the thirty-fifth anniversary of the tragic fire was Mary Magee, who lost her husband, Richard B. Magee. With her were grandchildren Joe, twelve, and Micalea, eight.

JUNE 18 Dr. Edward J. Benz Jr. isn't just the president and CEO of the Dana-Farber Cancer Institute. He's a physician who also teaches at the Harvard Medical School. So his enthusiasm was no surprise at the ceremonial groundbreaking for the new $150 million, 275,000-square-foot Yawkey Center for Cancer Care on Brookline Avenue. The center is slated to open to patients in 2011. Located in the heart of the Dana-Farber campus, the center will house both outpatient care and clinical research, and will include 100 exam rooms and 150 infusion beds.

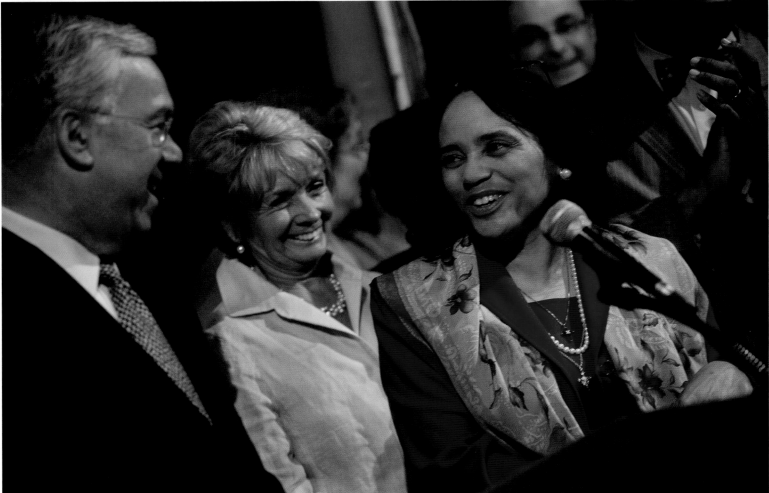

▲ **JUNE 19** Dr. Carol Johnson, the new superintendent of Boston's public schools, was introduced to the city by mayor Thomas M. Menino and school committee chairwoman Dr. Elizabeth Reilinger. Johnson was recruited from Memphis, Tennessee, to run the oldest public school system in the United States and the largest school district in the region.

▶ **JUNE 20** City gardening fore-person Mary Walsh moved some flowers in a potting shed at the city's greenhouses in Jamaica Plain. The city grows many of the flowers it uses to decorate the Public Garden and other city parks.

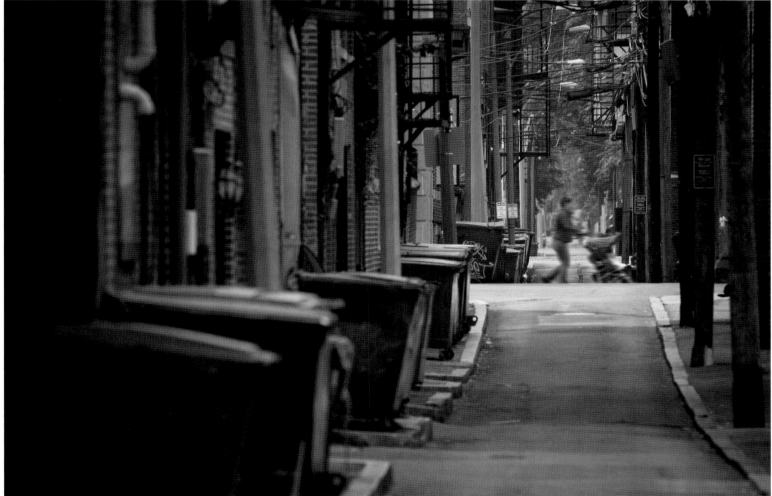

▲ **JUNE 21** The man pushing this baby stroller seemed to know one of the older tricks in the Back Bay: alleys often provide the shortest routes. Public Alley No. 426 starts at Arlington Street and runs west between Newbury Street and Commonwealth Avenue, connecting some of the most coveted real estate in the city.

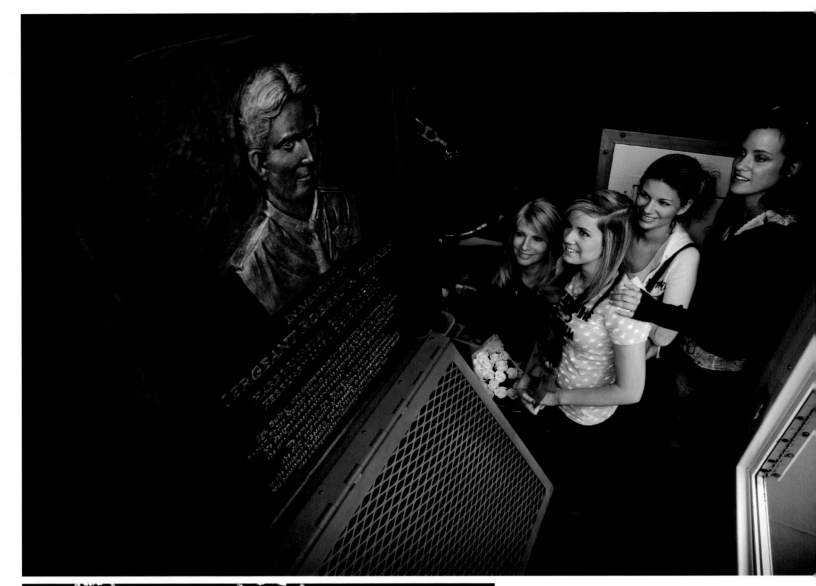

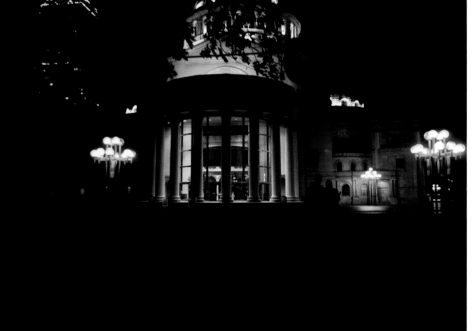

▲ **JUNE 22** A plaque commemorating the accomplishments of the late Boston Police harbormaster Sergeant Robert P. Guiney was placed on the *Guardian,* a fifty-seven-foot floating command post used to provide security in Boston Harbor, including the waters off Logan International Airport. On hand for the ceremony were Guiney's widow, Tami, and their children Jennifer, Madeline, and Kaylie. A dedicated Boston cop who served on the dive team and motorcycle units before becoming harbormaster in 2003, Guiney died from colon cancer in 2004 at age 49.

▲ **JUNE 23** With a fourteen-acre campus featuring I.M. Pei architecture, a reflecting pool that seems to stretch for a mile, and easy access that invites daily commuters and visiting tourists to walk through its grounds, the world headquarters of the Church of Christ, Scientist, is a modern Boston landmark. The Back Bay site houses the offices of the church that was founded by Mary Baker Eddy, as well as the *Christian Science Monitor* newspaper, a broadcasting center, the Mapparium, and the Mary Baker Eddy Library. The original church was built in 1894 in the Romanesque style and features stained glass windows illustrating Bible stories. An extension was added in 1906 and the building can now seat three thousand. The monumental portico was added in 1975.

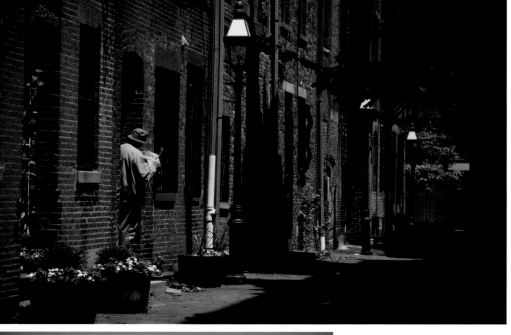

▶ **JUNE 24** Archway Street in the North End lives up to its name and provides the perfect place to get out of the sun.

▶ **JUNE 25** Celia McAnulty took her Irish setter Shannon out for a walk along Castle Island in South Boston. Attached to South Boston's mainland since the 1930s, Castle Island was once freestanding. It is home to Fort Independence, a five-pointed castle-like granite structure.

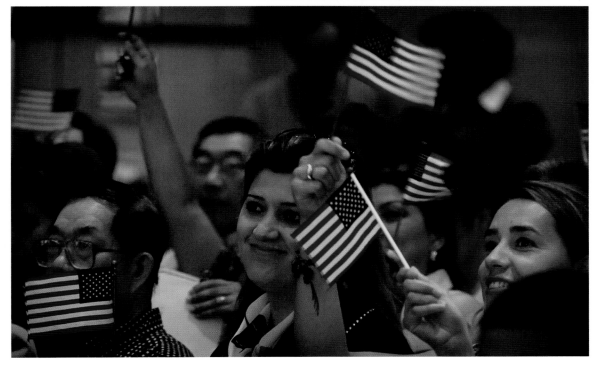

▲ **JUNE 26** The country's newest citizens proudly displayed their pride in their new country just after a swearing-in ceremony at the John F. Kennedy Presidential Library and Museum.

■ **JUNE 27** Not long after retiring from Hill, Holliday, Connors and Cosmopulos, the Boston-based advertising giant he cofounded, Jack Connors, left, set out to bring to life an idea he had been mulling for awhile: Camp Harbor View on the city-owned Long Island. On this afternoon, Connors and Suffolk Construction Company president and CEO John Fish went over plans for the camp giving inner-city children ages eleven to fourteen a safe place to play as well as three meals a day. Some of Suffolk's employees camped out in tents on the island so that the project could be completed in 109 days.

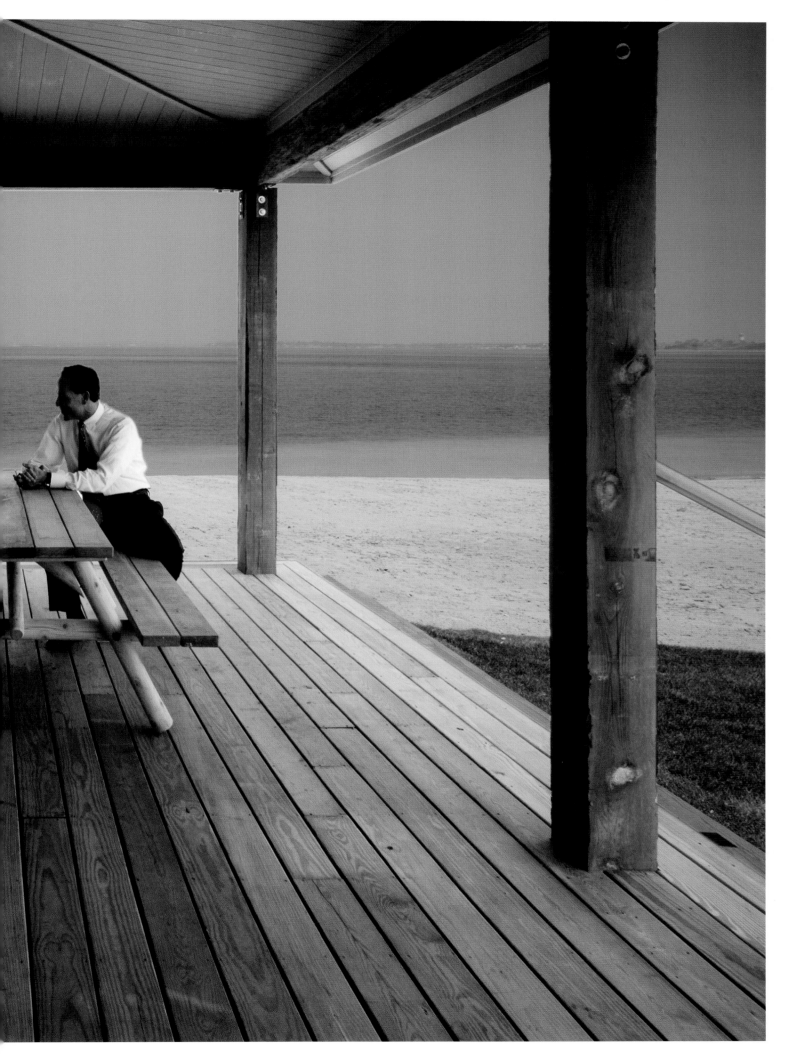

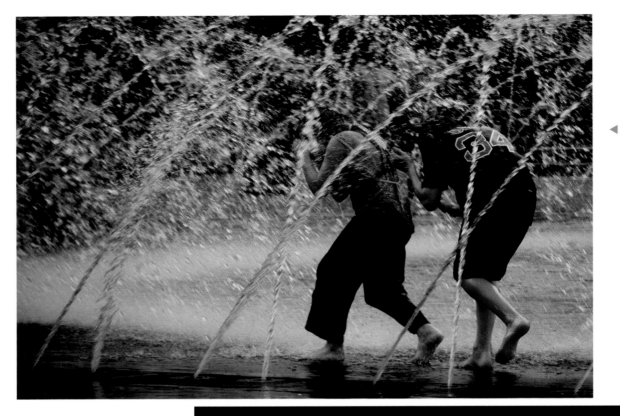

◄ **JUNE 28** The Christian Science Center and its magnificent reflecting pool and spectacular fountains have long drawn thousands of daily visitors—particularly when the temperature climbs—including these young visitors who jumped right into the spray.

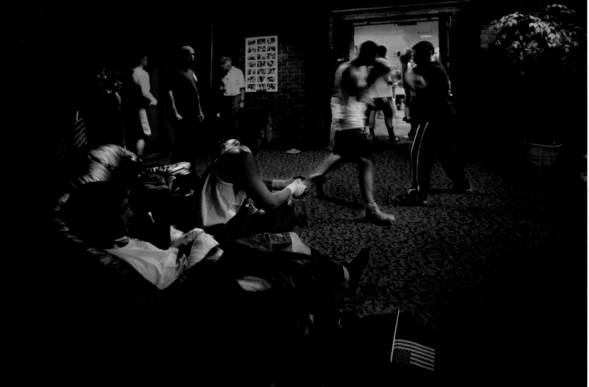

▲ **JUNE 29** Boxing has a long and proud tradition in certain neighborhoods, but some of the city's clubs have been dormant for years. The South Boston Boxing Club came back stronger than before in late 2004 after mayor Thomas M. Menino made good on a 1997 promise to that community. When the club challenged the Connemara Boxing Club of Ireland it was as if there had never been a gap in the program. The excitement was palpable when a sold-out crowd gathered on this Friday night at the International Brotherhood of Electrical Workers hall on Freeport Street in Dorchester for the sixteen-bout card featuring some of the best amateurs from Boston and western Ireland.

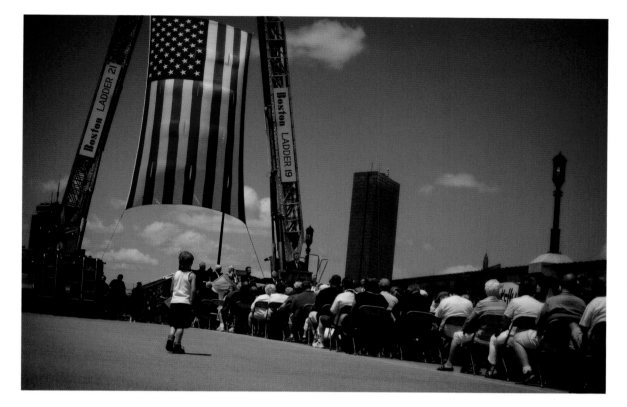

◀ **JUNE 30** Just about six months after his death, city councilor James M. Kelly was memorialized with a bridge named in his honor. The Broadway Bridge, as it was called during the Big Dig construction, is now named for the late official who was a dogged representative for the parts of the city in his district. The bridge also is a pivotal link in Boston, finally reconnecting South Boston with the South End.

▼ **JULY 1** Not even the heat of City Hall Plaza could deter eleven thousand people from attending the twenty-sixth annual Chowderfest kicking off Boston Harborfest, which annually leads up to the city's Fourth of July celebrations. After years of Boston stalwarts grabbing the prize, it was Bill Cunningham's Maynard restaurant Christopher's that took first place in the chowder competition.

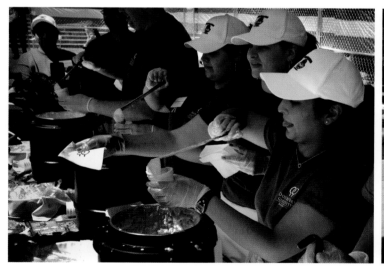

▲ **JULY 2** Eschewing the traditional ribbon cutting, the Hard Rock Cafe went with something more suited to its style to mark the eatery's move from the Back Bay to near Faneuil Hall: a guitar smashing. Among the musicians with local ties on hand were Bellevue Cadillac's Doug Bell, Damone vocalist Noelle LeBlanc and her bandmate Mike Wood, Run-DMC rapper Darryl "DMC" McDaniel, Blues harmonica player James Montgomery, Damone drummer Dustin Hengst, and Barry Goodreau, guitarist for the rock band Boston.

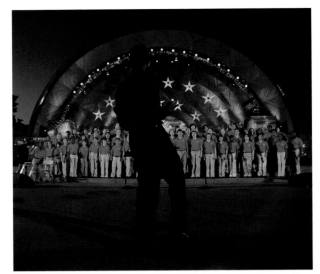

▶ **JULY 3** Don't tell Boston Children's Chorus artistic director Anthony Trecek-King that this concert at the Hatch Memorial Shell at the Esplanade was just a dress rehearsal; every performance is important. The preholiday concert, one of those secret joys of the city's denizens, featured the chorus, singer John Mellencamp, and CBS late-night talk-show host Craig Ferguson joining the Boston Pops Orchestra.

▼ **JULY 4** You'd be hard-pressed to find anyone at the Esplanade who wasn't waving a flag, singing along, cheering, or saluting by the time Keith Lockhart and his Boston Pops hit the first goose bump–inducing notes of "The Stars and Stripes Forever" at the end of the annual holiday concert and fireworks spectacular.

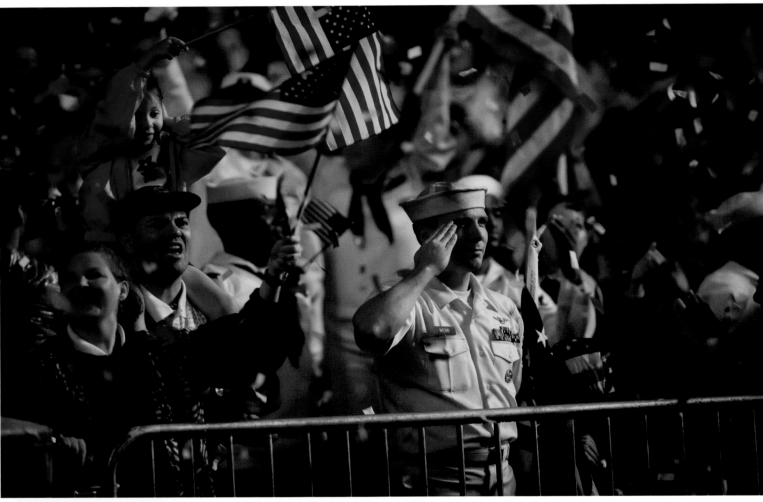

◀ **JULY 5** The first Thursday of each month is a big deal along Centre and South Streets in Jamaica Plain, where artists hold open houses, musicians give concerts, and restaurants and stores extend their hours.

JULY 6 A swan boat glided under the foot-bridge as it headed toward the dock in the Public Garden Lagoon. Created in 1837, this was the country's first public botanical garden. It has been maintained by the city and a number of private groups over the years. The famed swan boats, which use only human power to make the fifteen-minute tour of the lagoon, have been operated by the Paget family for more than a century.

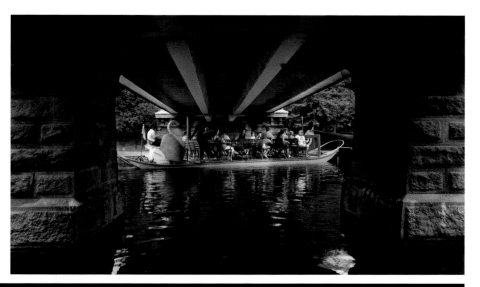

JULY 7 After getting married in South Boston, Lucas and Agnieska Novak headed to the Public Garden to have their photographs taken.

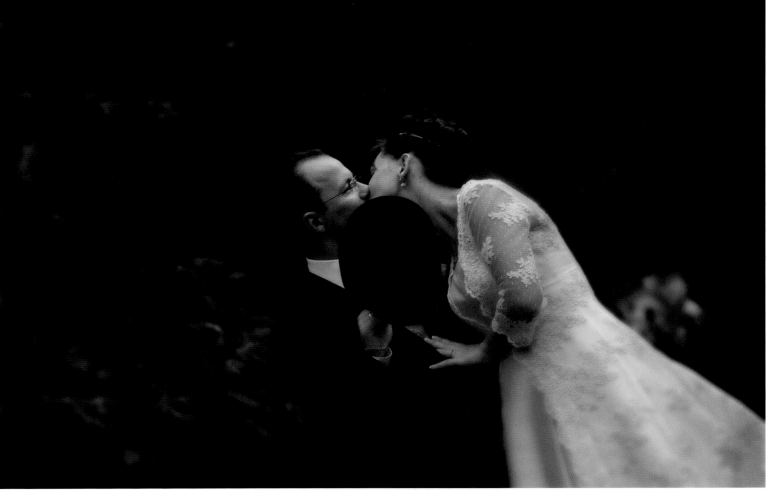

JULY 8 Bill Kenney grabbed a nap while waiting to take down a stage at Fenway Park following the annual Latino Family Festival sponsored by the newspaper *El Mundo*, which brought thousands to the old ball-yard on Yawkey Way.

JULY 9 Commissioner Edward F. Davis, speaker of the house Salvatore F. DiMasi, governor Deval Patrick, and mayor Thomas M. Menino were all on hand for a ceremony marking the first time the Boston Police Department swore in officers from other departments across the state. The addition of fifty-five officers was made possible through funding from the Patrick administration.

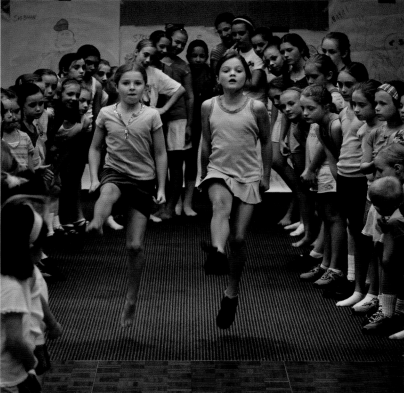

JULY 10 Young students gave it their all at a special summer Irish step-dancing class hosted by Peggy Woods and her Woods School of Irish Dance in South Boston. The day-long program was held at the Bayside Expo Center in Dorchester.

JULY 11 They are the self-proclaimed Liars Club and they meet on Wednesdays at the Long Island Firehouse. There's only one thing needed for admission to the club: you must be retired from the Boston Fire Department. It was estimated that the former jakes gathered on this day represented more than five hundred combined years of service to the department. On that point, they swore they weren't lying.

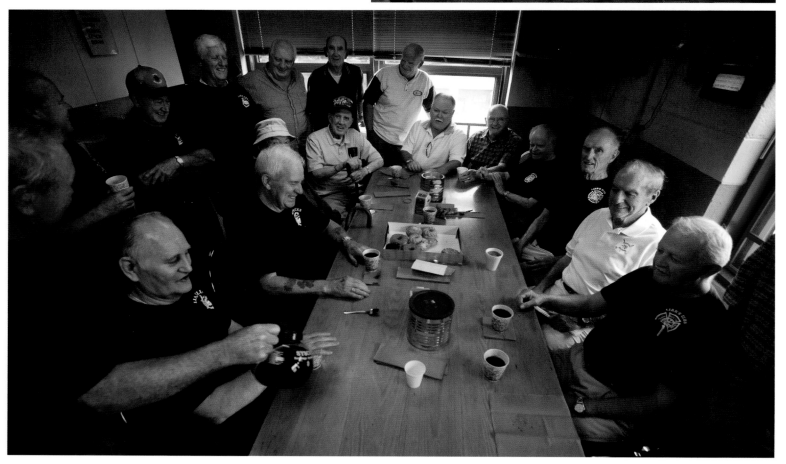

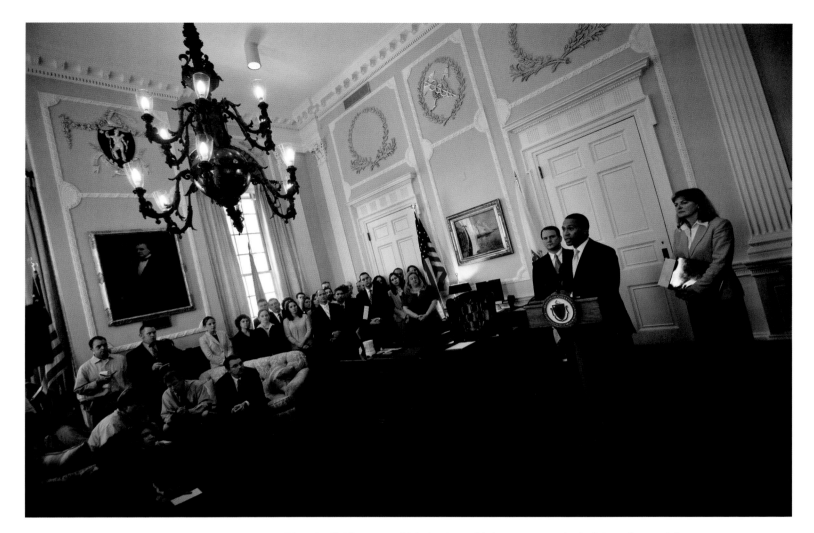

▲ **JULY 12** Flanked by lieutenant governor Timothy P. Murray and his budget chief, secretary of administration and finance Leslie A. Kirwan, governor Deval Patrick announced the details of a $26.8 billion budget, the first he had signed since taking over the corner office. Although Patrick's budget included millions for initiatives he talked about during the campaign including education, health, and public safety, the governor also vetoed $41 million in spending that had been approved by the legislature.

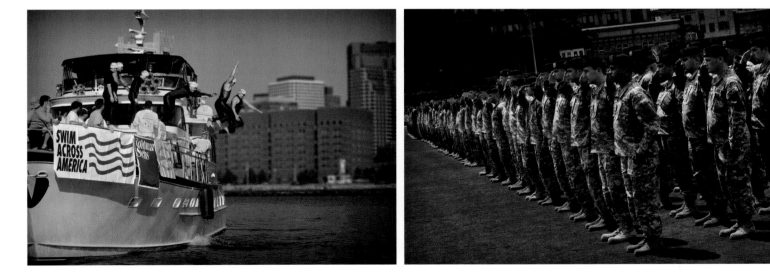

▲ **JULY 13** Swimmers, including seven former Olympians, showed no fear as they jumped into Boston Harbor for a twenty-two-mile relay around the harbor islands. Sponsored by Swim Across America, the annual event benefits the David Perini Quality of Life Clinic to support pediatric cancer survivorship programs at Dana-Farber Cancer Institute.

▲ **JULY 14** The 972nd Military Police Company of the Massachusetts National Guard gathered at Nickerson Field before their fifteen-month deployment to Iraq. These soldiers were carrying on a tradition that dates back to December 1636, when the Massachusetts Bay Colonial Militia was founded.

JULY 15 A couple of young Red Sox fans played cards on Lansdowne Street while waiting for the box office to open at Fenway Park and a few precious tickets to be released by the team. Sox pitcher Josh Beckett gave up only two runs over eight innings, but was outdone by the Toronto Blue Jays who won the game 2–1, denying the ace his thirteenth win of the season. That would come five days later when Beckett and his teammates beat the Chicago White Sox 10-3.

JULY 16 Yierol Germin of Mattapan, a driver for Crystal Transport, took a break from his route and got in a little practice on his saxophone while his bus was parked at Harbor Point.

JULY 17 For many in Mattapan, the renovations at the Morton Street Commuter Rail station and the Uphams Corner station were a welcome end to the first phase of the $37 million Fairmount line project. The only commuter rail line that services the city exclusively, the Fairmount line runs from South Station through Dorchester and Hyde Park before ending in the city's Readville section.

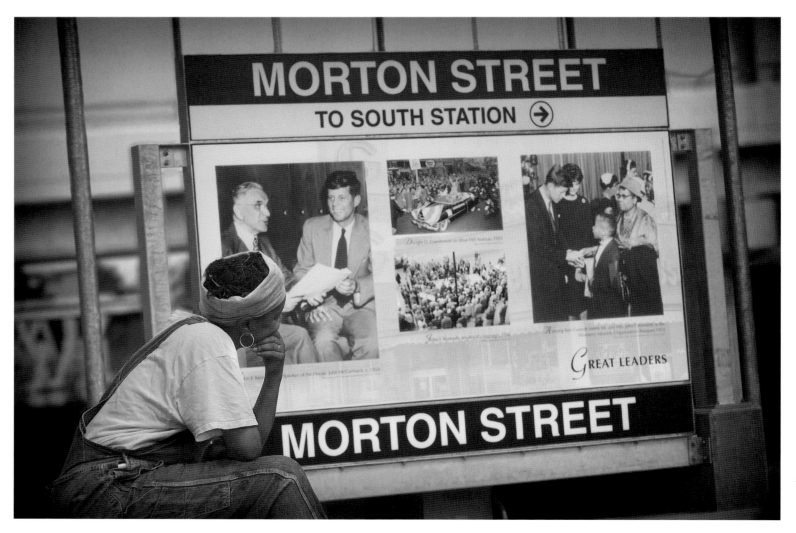

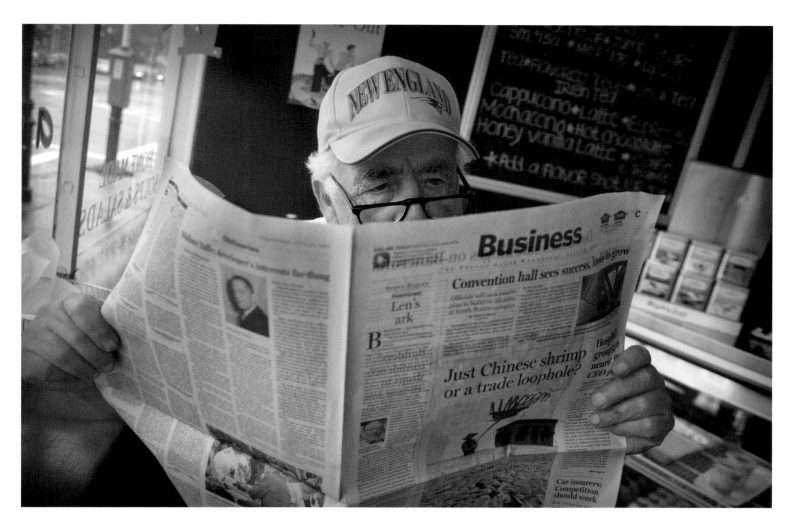

▲ **JULY 18** Tom McIntyre enjoyed his morning paper while staying out of the rain at the Cranberry Café on East Broadway in South Boston.

▶ **JULY 19** Senate president Therese Murray, eleven-year-old Amy de Silva of Middleborough, and governor Deval Patrick listened as Dr. Craig Mello, a University of Massachusetts Medical School scientist who won the Nobel Prize for discovering a gene-silencing technique, addressed the legislature. De Silva was asked to sing the national anthem before Dr. Mello's speech because his research is seen as important to curing her disease, Charcot-Marie-Tooth, a neurological disorder that prevents her from using her arms fully. And de Silva left an impression. The State House News Service reported that several legislators were moved to tears by her rendition of "The Star Spangled Banner."

▶ **JULY 20** The Mashpee Wampanoag's

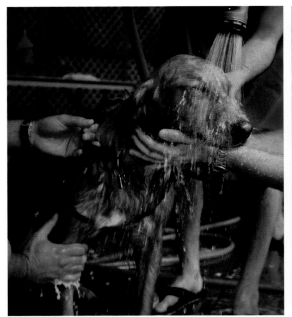

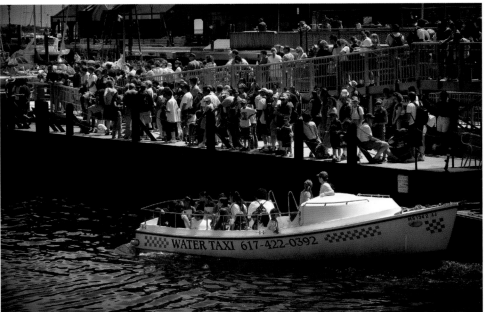

▲ **JULY 21** Harry, a golden retriever, did his best to behave at a charity dog wash hosted by the Kimpton Hotels. The pooch-washing pros from LaundroMutt cleaned up each canine for a ten-dollar donation. All of the proceeds were turned over to The Trust for Public Land's efforts to make land available for public use—including dogs.

▲ **JULY 22** Dozens waited at Long Wharf for a space on one of the water taxis.

▼ **JULY 23** Leo Garrigan cleaned up at Old City Hall on School Street, which is now an office building for a host of private firms, not-for-profit organizations, and even a restaurant, Ruth's Chris Steak House, which occupies the former Maison Robert space. Built in 1865 as Boston's third city hall, the building on School Street served thirty-eight mayors.

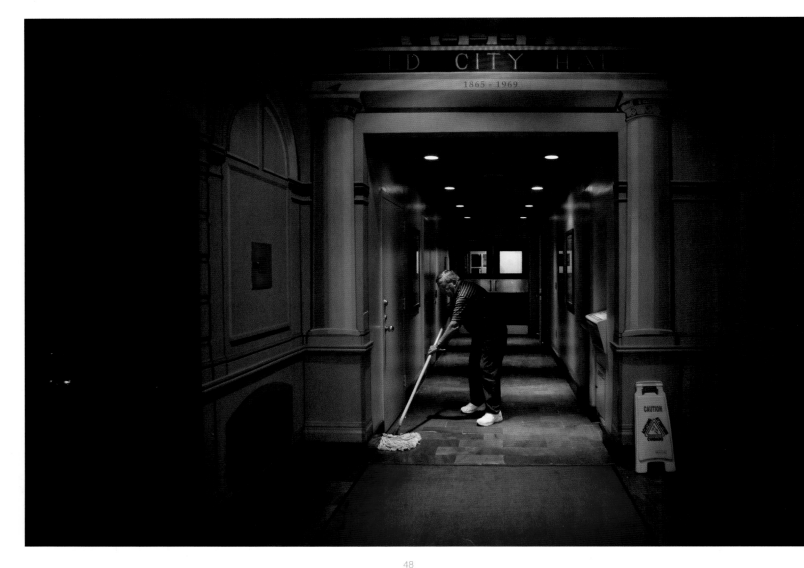

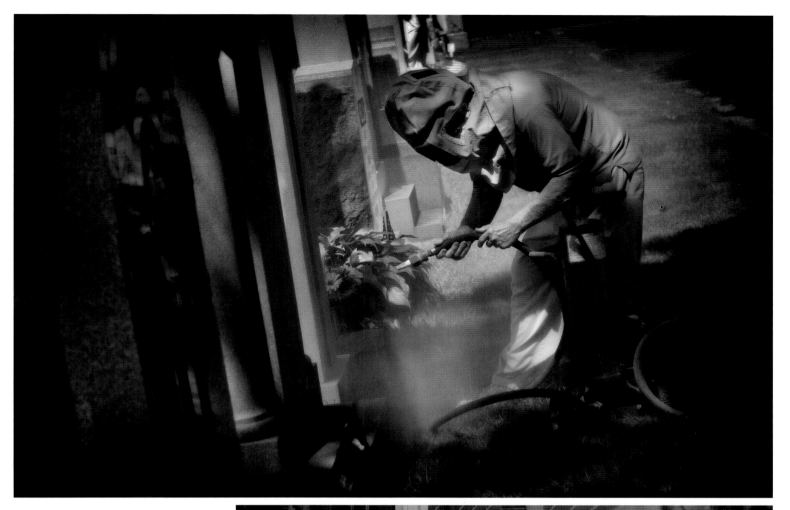

▲ **JULY 24** As he has for sixty years, James Canniff cleaned tombstones at St. Michael Cemetery in Roslindale.

▶ **JULY 25** A determined four-teen-month-old Jack Sullivan got himself up the front steps of his home on Washington Street in Charlestown. The tyke wasn't far from help, as his dad was unloading the car just across the sidewalk.

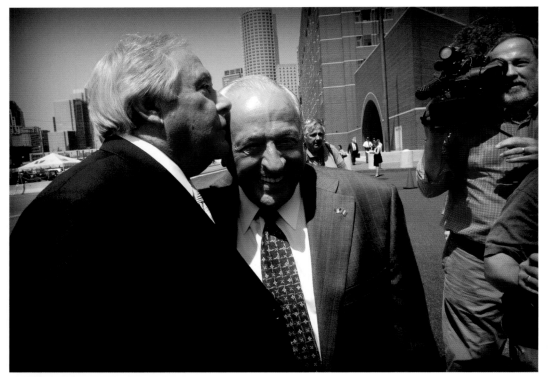

JULY 26 Joseph Salvati gives a congratulatory kiss to Peter Limone outside the John Joseph Moakley U.S. Courthouse after learning that they and the families of their two deceased coplaintiffs were awarded $101.7 million for a wrongful conviction that led to decades in prison. US District Judge Nancy Gertner ordered the government to pay after it was determined that FBI agents in Boston framed Salvati, Limone, Louis Greco, and Henry Tameleo for a 1965 mob-related murder in Chelsea that they did not commit.

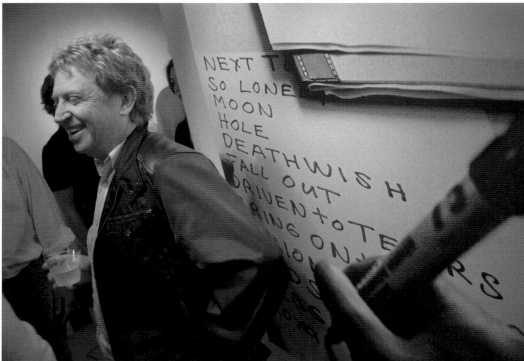

JULY 27 During all of his years touring with his rock band, Police guitarist Andy Summers carried a camera and found in bandmates Sting and drummer Stewart Copeland a couple of very willing subjects. Summers opened "I'll Be Watching You: Inside the Police 1980–1983,"an exhibition of his black-and-white images at the Newbury Fine Arts gallery, the night before the Police would play the first of two sold-out shows at Fenway Park.

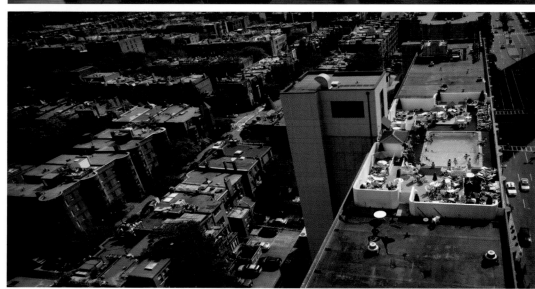

JULY 28 Space to soak up the sun or just relax is always at a premium on the roof of the Colonnade Hotel in the Back Bay, particularly during the long hot days of summer.

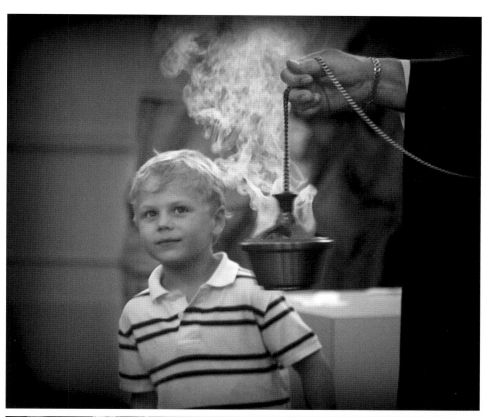

JULY 29 Five-year-old Dylan Mullin watched intently as Father J. A. Loftus said the final mass at Immaculate Conception Church at the Jesuit Urban Center in the South End. The Roman Catholic religious order decided to close the center, home to a predominantly gay congregation, because of the cost of needed renovations and the lack of priests available to service the center. The Harrison Avenue building was put up for sale.

JULY 30 Summer Mencher seemed unfazed by the abundant graffiti on a truck parked near the Berklee College of Music.

JULY 31 No, it wasn't a swanky gathering at Malibu Pier in Southern California, but the "Best of Boston" party at South Boston's Carson Beach. *Boston* magazine's annual soiree lived up to its name this night as scores turned out to celebrate those selected as being the "best" of what the city has to offer.

AUGUST

◄ **AUGUST 1** Hundreds packed St. Brendan Church in Dorchester to pay their final respects to the Reverend James H. Lane, a Roman Catholic priest who in 1972 became the first chaplain of the Boston Police Department. The affable priest, who served in parishes in Dorchester and South Boston, including thirty-four years at St. Brendan, also was chaplain of the Boston Juvenile Court, Roxbury Juvenile Court, the Boston Police Patrolmen's Association, the Retired Boston Police Officer's Association, and the South Boston Irish American Society.

▲ **AUGUST 2** Boston's street signs—or the lack of them in certain parts—have long been debated, voted on, and even joked about. But when you see a new sign or an old one being replaced these days you can thank Jody Luongo, the city's one-man sign painting operation who works out of the Transportation Department's Southampton Street facilities in Roxbury.

▶ **AUGUST 3** Not even heading right into a sprinkler at the new Camp Harbor View on Long Island could help this youngster escape from the heat, which topped 94 degrees this day. But nothing seemed to stop the day campers from having a great time.

■ **AUGUST 4** As she has for the past twenty years, Nilda Cordova fed the pigeons and other birds on Boston Common—occasionally allowing a squirrel to get in on the action. The avian residents are known to spot their bene-factor as soon as she enters the park carrying many bags of popcorn and bread.

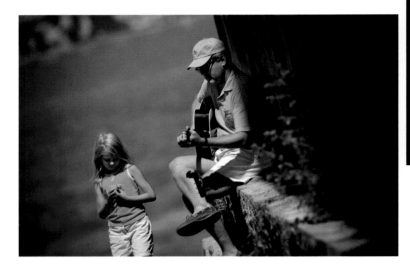

▲ **AUGUST 5** Castle Island is a favorite for Logan Chandler and his daughter Juliette, who seemed more interested in the flower she picked than what her dad was playing on the guitar.

▲ **AUGUST 6** Governor Deval Patrick was very serious when he called together some of the state's best known business and education leaders to work on a plan to ensure that every child would have access to a life of learning, but the newly appointed members of Patrick's Readiness Project found at least one moment to smile. The council members—from left, Grace Fey, Ed Dugger, Dana Mohler-Faria, Paul Sagan, Andrea Silbert, Jackie Jenkins-Scott, and Henry Thomas—were charged with developing a ten-year strategic plan to continuously improve the state's public education systems.

▲ **AUGUST 7** It has been said that if you don't like Boston's weather, just wait a few minutes—it'll change. This day it was ultimately too foggy and overcast for swimming, frolicking, or even walking along the beach at Pleasure Bay in South Boston. Known for its sandy beach and calm, enclosed lagoon, Pleasure Bay is one of the city's most popular beaches—on a nicer day, of course.

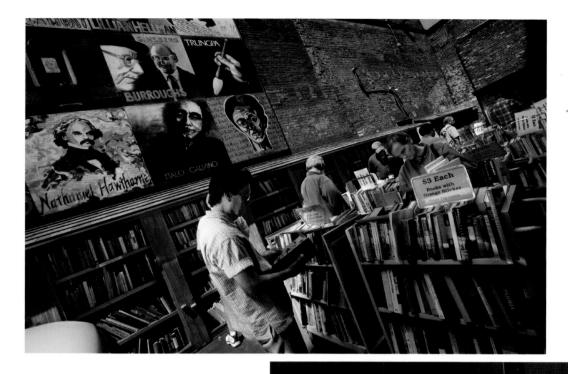

◀ **AUGUST 8** The Brattle Book Shop attracted dozens of people out on their lunch breaks or just passing, all stopping to check out what titles might be found on the bargain shelves. What treasures the bibliophiles unearth at this West Street landmark depends on the weather allowing outside browsing and on what owner Ken Gloss and his staff have culled from the quarter-million pieces in their collection.

▶ **AUGUST 9** Felice Pomeranz of the Gilded Harps of Boston performed during Boston fashion doyenne Marilyn Riseman's eightieth birthday party at the Taj Hotel on Arlington Street.

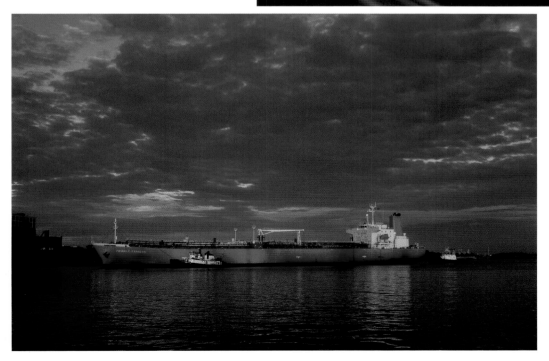

◀ **AUGUST 10** The old mariner's adage seemed to ring true—"Red sky at night, sailor's delight." A calm Boston Harbor welcomed the *Twinkle Express* as tugboats guided the tanker into Chelsea where her cargo would be off-loaded.

■ **AUGUST 11** The sailboats were out in force at the edge of Boston Harbor for the fifth annual two-day Flip Flop Regatta to benefit the Ally Foundation. Named for the late Ally Zapp, who loved the water and was a regular on the local charitable circuit, the foundation's mission is to prevent opportunities for violent sex offenses and to educate the public and advocate for changes in culture, attitude, and policy.

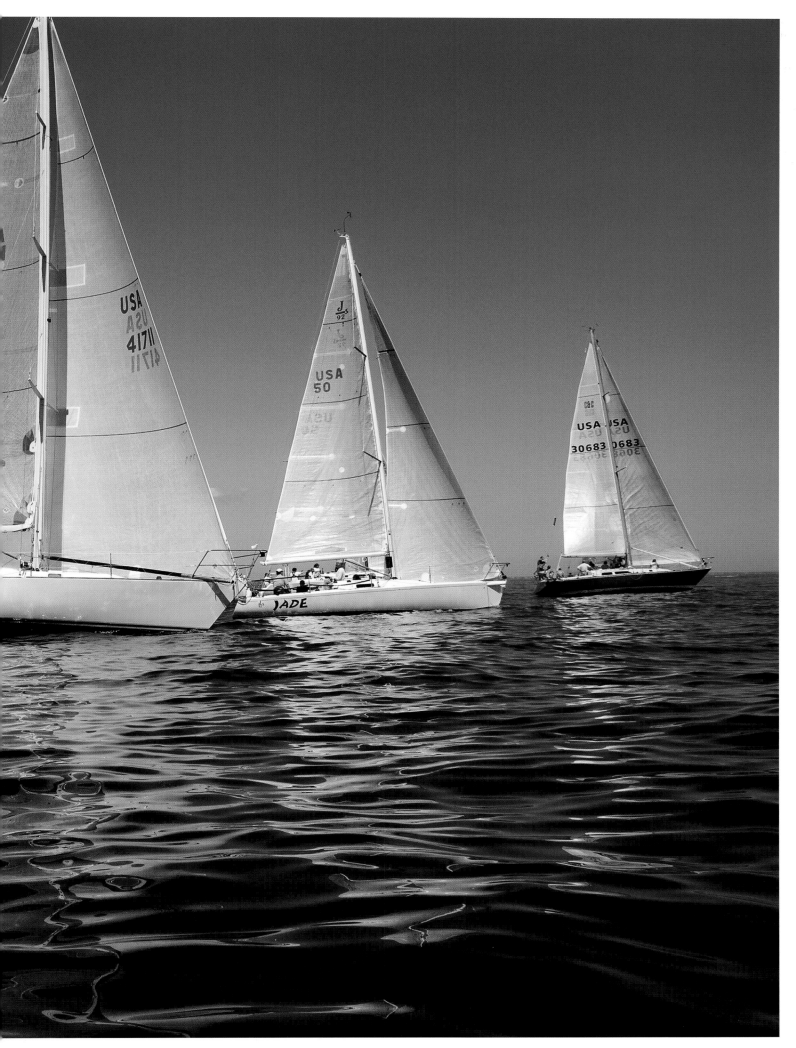

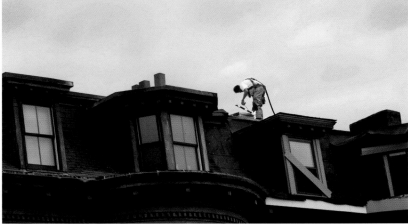

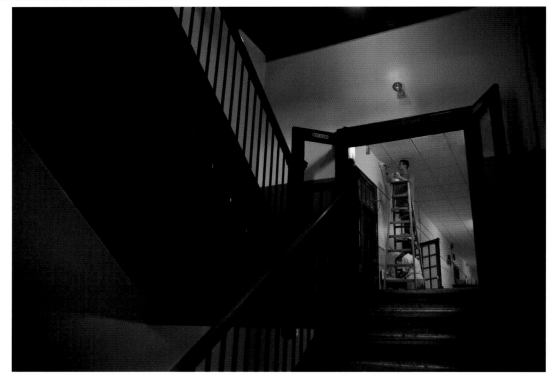

▲ **AUGUST 12** Maestro Charles Ansbacher led the Boston Landmarks Orchestra, which he founded in 2000, at an outdoor concert in Dorchester Park as part of a city-sponsored series.

◄ **AUGUST 13** A worker wearing a safety harness installed a skylight on the roof of a house on Massachusetts Avenue at Shawmut Avenue. The six-story building, right at the South End–Roxbury line, was one of several in that area undergoing a complete renovation.

► **AUGUST 14** Robert Kane, a third-year student at Catholic Memorial High School, helped out with some painting at St. Patrick School, a Roman Catholic elementary school on Mount Pleasant Avenue in Roxbury. Kane was joined in the day of sprucing up the school by dozens of others including crews from Blue Cross Blue Shield of Massachusetts, Loomis-Sayles, and WCVB-TV's morning anchor team of Heather Unruh, David Brown, and J.C. Monahan.

▶ **AUGUST 15** Angelo Picardi has been performing at City Hall Plaza for thirty-five years, bringing a fresh spin on some classics. Picardi is contracted by the city to run the plaza concert series on Wednesdays in the summer.

▼ **AUGUST 16** Despite having just returned to Boston from a performance on ABC's "Good Morning America," Lori McKenna seemed to be enjoying herself while promoting the major-label release of her CD "Unglamorous" at the Borders at Downtown Crossing. The Stoughton-based mother of five got her big national break when country couple Tim McGraw and Faith Hill recorded a few of McKenna's songs and then asked her to join them on their "Soul2Soul 2007" summer tour.

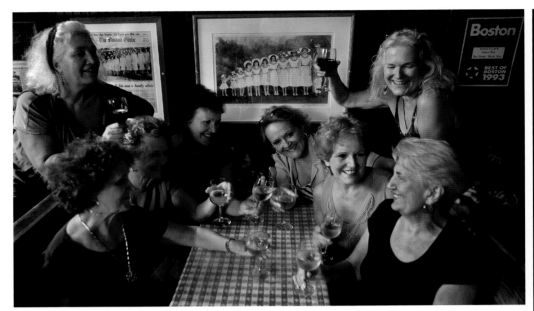

▲ **AUGUST 17** Eight of the famed O'Neil sisters, ten young women from Jamaica Plain who graced the covers of magazines around the world in the late 1940s and early 1950s, and who marched in New York's Easter Parade and appeared on "The Ed Sullivan Show," gathered once again. The siblings returned to their old neighborhood for a birthday fête at Doyle's Café to mark sister Jane Deery's seventy-fifth birthday. Pictured clockwise from front left are Maureen Cloonan, Julie O'Neil, Diane Nessar, Danielle McGreal, Evelyn Kiley, Fran Cummings, Ginny O'Neil, and Deery. Behind them is a watercolor of the sisters as young girls with their two brothers Lawrence, the oldest, and Danny, the baby of the family.

▶ **AUGUST 19** The closing of the Fisherman's Feast, which draws tens of thousands to the North End over four days, is marked each year by the Flight of the Angel over North Street. The ninety-seventh annual festival included entertainment, street booths with crafts and food vendors, and, most importantly to those who keep the tradition alive, the procession of the statue of the Madonna.

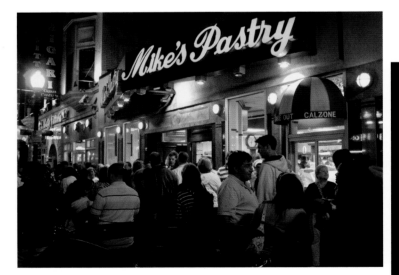

▲ **AUGUST 18** Fisherman's Feast is not a time for a casual stroll to Mike's Pastry on Hanover Street in the North End. The neighborhood's oldest continuously running Italian festival, the four-day annual celebration traces its roots to Sciacca, Sicily, where the fishermen honored the Madonna del Soccorso.

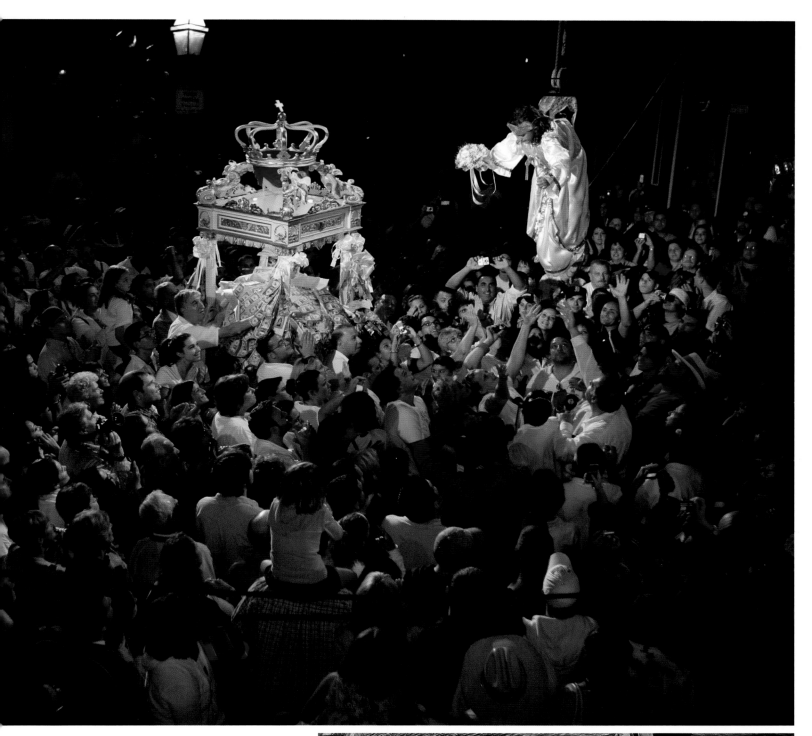

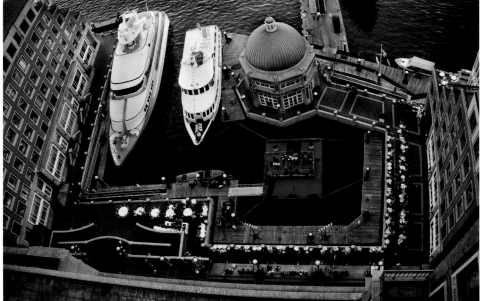

◄ **AUGUST 20** Given the amount of traffic passing by and through the Transportation Building, it is not an easy job to keep the windows and doors of the Starbucks clean.

▶ **AUGUST 21** The yachts, public and private, seemed to be as focused on the band outside the Boston Harbor Hotel as the lucky dozens who scored tables for a jazz concert. The patio area behind the hotel, along the Boston HarborWalk, is among the busiest spots during after-work hours on summer weeknights.

AUGUST 22 The Bank of America Pavilion glows on the South Boston waterfront, a former industrial area that now boasts some of the city's most vibrant nightlife. On this night, G. Love and Special Sauce headlined a lineup that included Slightly Stoopid and Ozomatli. Although G. Love's music brought applause, he got his biggest cheer when he congratulated the city on the Boston Celtics' recent acquisition of Kevin Garnett.

◄ AUGUST 23 Boston businessman and long-time Police Athletic League supporter Gerald Ridge, who founded the city's branch of the national young services organization, chatted with mayor Thomas M. Menino just before a meeting of the PAL's board at the Parkman House on Beacon Hill.

► AUGUST 25 When Katie Lynch and Palash Misra decided to get married, they faced all the usual planning for a ceremony, and then some. Several hundred attendees flew in from around the world to the InterContinental Boston Hotel where the couple started their union with a Hindu ceremony and concluded the formal ceremonies with the blessing of a Roman Catholic priest.

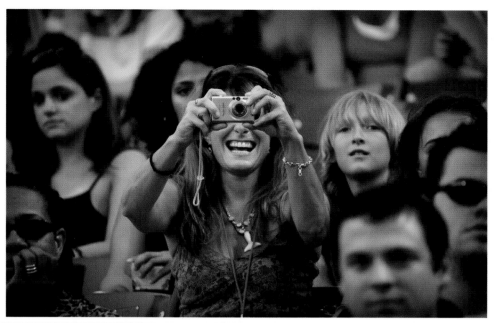

AUGUST 24 Several thousand packed a corner of Fenway Park for the third summer edition of the Hot Stove, Cool Music concert headlined this year by John Legend. More than $300,000 was raised for The Foundation to Be Named Later, which was started by Red Sox General Manager Theo Epstein and his brother, Paul.

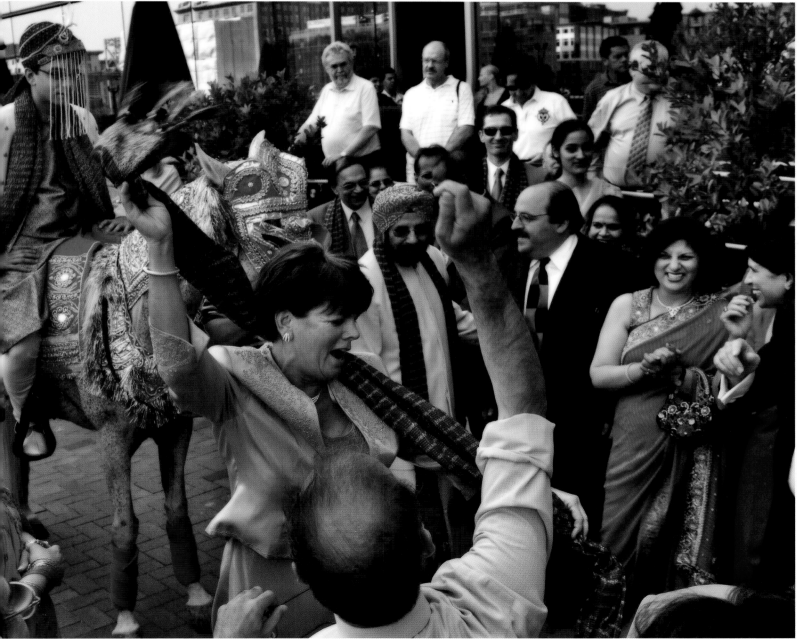

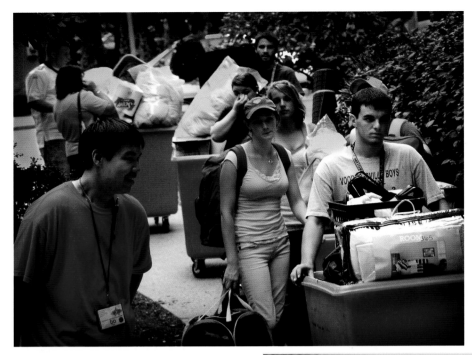

◀ **AUGUST 26** Some parts of New England mark the arrival of fall by the crisp air and the warm hue of the leaves. In Boston, you know the summer is over when college campuses come back to life, as was the case with these Wentworth Institute of Technology students.

▶ **AUGUST 27** For years the students in theatrical performances at Boston College High School in Dorchester had to put on their shows wherever they could find open space. With a gift from Gregory Bulger (left, with school president William Kemeza) B.C. High was able to open a $3.1 million, 350-seat performing arts center.

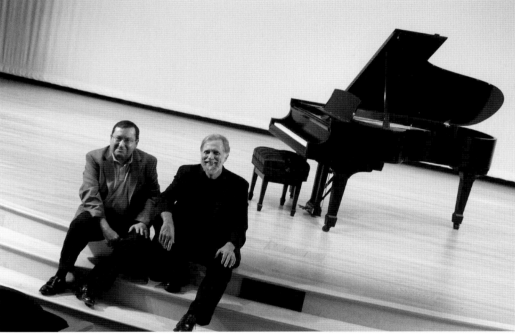

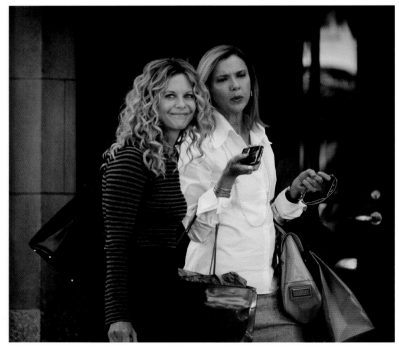

◀ **AUGUST 28** They seemed like any other shoppers strolling along Newbury Street near Berkeley Street, but Meg Ryan and Annette Bening were actually filming a scene for writer/director Diane English's remake of *The Women.*

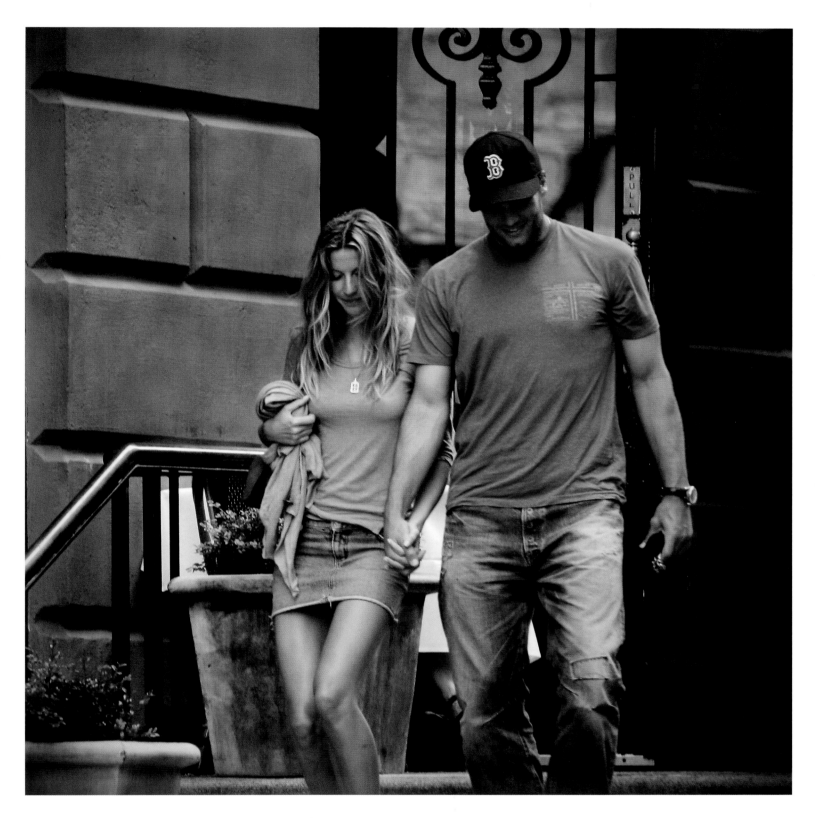

▲ **AUGUST 29** In this first photograph taken in Boston of them as a couple, New England Patriots quarterback Tom Brady and his supermodel girlfriend, Gisele Bündchen, took a walk after an intimate lunch at chef Pino Maffeo's Boston Public.

▲ **AUGUST 30** Developer Norman Leventhal was greeted by former Massachusetts Institute of Technology president Howard Johnson, one of some 350 well-wishers who turned out to mark Leventhal's ninetieth birthday. The celebration was held at the Boston Harbor Hotel, just one of several iconic projects Leventhal has developed in Boston.

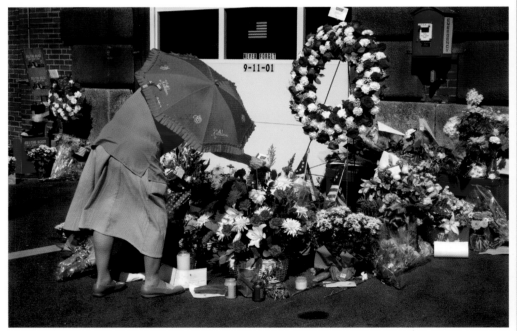

▲ **AUGUST 31** Paul J. Cahill and Warren J. Payne, both veteran Boston firefighters, were killed when a smoldering grease fire erupted at Tai Ho Chinese restaurant in West Roxbury. While crews were still cleaning up the block of businesses gutted by the deadly blaze, neighbors were already paying their respects at the station that Engine 30 and Ladder 25 call home.

▶ **SEPTEMBER 2** Drivers of moving trucks had to fold in mirrors and use extra eyes to squeeze by each other on Ashford Street in Allston. A steady stream of college students returning to the neighborhood continued throughout Labor Day weekend.

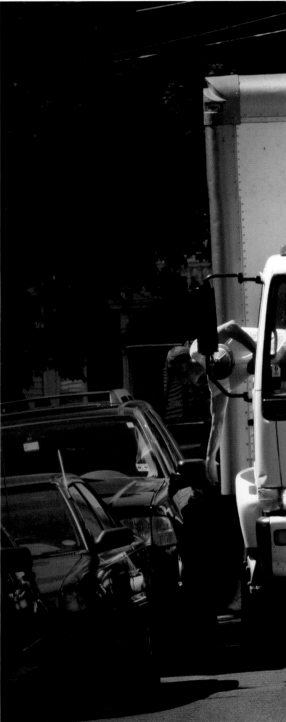

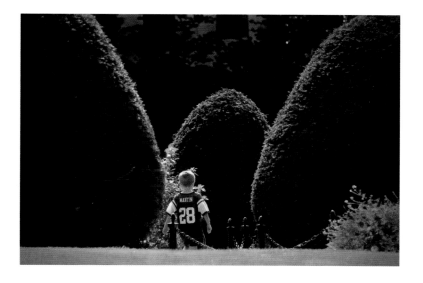

◀ **SEPTEMBER 1** A clear Saturday at the Boston Public Garden usually means crowds of visitors, but this tiny fan of retired New York Jets (and New England Patriots) running back Curtis Martin seemed to have the whole park to himself.

SEPTEMBER

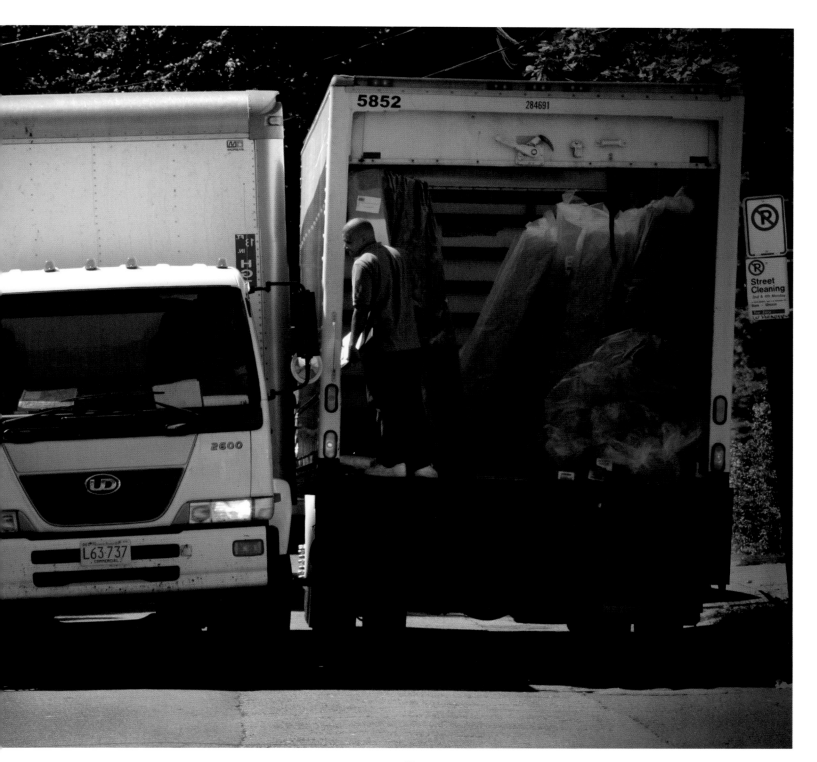

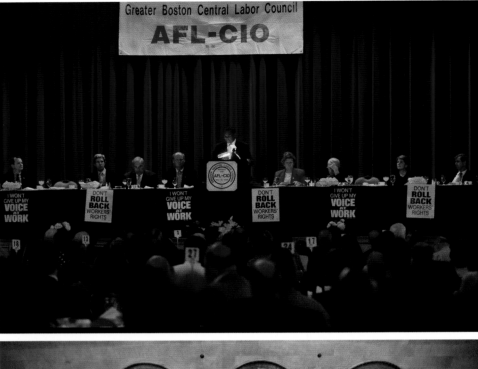

SEPTEMBER 3 Most of the state's politicians start their Labor Day at the Massachusetts AFL-CIO's Greater Boston Labor Council breakfast. In 2007, more than five hundred union supporters packed the Park Plaza Hotel & Towers in Park Square to hear a cadre of speakers.

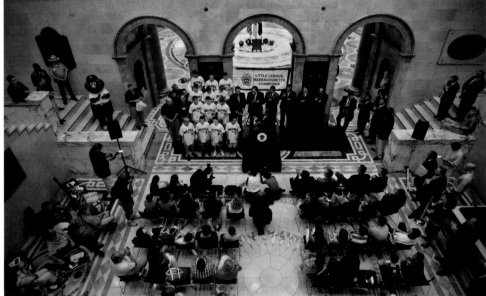

SEPTEMBER 4 Like their professional counterparts, the young players of the Walpole Little League champions were welcomed as returning heroes at a State House ceremony. The team won the Massachusetts title and represented New England in the Little League World Series in Williamsport, Pennsylvania.

SEPTEMBER 5 After years of sitting dormant, the former Charles Street Jail opened to the public as the tony Liberty Hotel, which counted actress Eva Mendes, rocker Mick Jagger, and former president Bill Clinton among its early guests. Joining developer Richard L. Friedman for the ribbon cutting—actually, a lock breaking—were chef-restaurateur Lydia Shire and her partner, Patrick Lyons, who would open their eatery Scampo a couple months later in what was the former jail's in-take area.

SEPTEMBER 6 Engine 30 carried the casket of fallen Boston firefighter Paul Cahill along Centre Street in West Roxbury as thousands of firefighters from around the country lined the route before a funeral Mass at Holy Name Church.

SEPTEMBER 7 It was a second day of unspeakable sadness for the city as scores of firefighters in their crisp dress uniforms parted their blue sea of brotherhood outside the United House of Prayer for All People on Seaver Street in Dorchester. The family of Warren J. Payne watched as the fallen Boston firefighter's casket was placed on Ladder 25.

SEPTEMBER 8 Gary Sandison walked to greet an arriving bride at Trinity Church Boston. A lay eucharistic minister, Sandison also is an assistant to the mayor of Boston. Founded in 1733, the parish is part of the Diocese of Massachusetts in the Episcopal Church and a member of the worldwide Anglican Communion. There are more than three thousand families in the congregation.

▲ **SEPTEMBER 9** Lindsay Morris of Foxborough struggled to pull open the door at Anthony's Pier 4 where she was one of dozens to attend a breakfast for the Simon of Cyrene Society. Co-founded by Monsignor Thomas J. McDonnell, the former pastor of historic St. Augustine's South Boston, the society works with people with disabilities and their families through a broad spectrum of social and spiritual activities.

▲ **SEPTEMBER 10** Phil Giffee, the executive director of the East Boston-based Neighborhood of Affordable Housing organization, welcomed city leaders at a ceremony to mark the completion of new condominiums for low-income, first-time homebuyers. The not-for-profit organization, which originally operated from the basement of Our Savior's Lutheran Church, has expanded its reach to include much of greater Boston. The mission, however, remains the same: to provide safe, affordable housing to the economically disadvantaged.

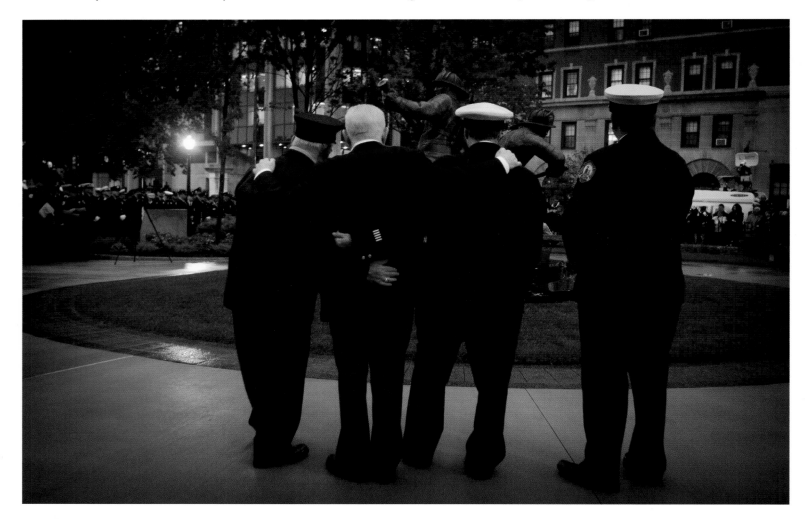

▲ **SEPTEMBER 11** The Massachusetts Fallen Firefighters Memorial near the State House served as the gathering spot for those honoring the fire fighting personnel who risk their lives daily at incidents both historic and small. Leading the 9/11 remembrance were Massachusetts Fallen Firefighters Memorial board members: A. Michael Mullane, third district vice president, International Association of Fire Fighters; Norman Knight, president and founder of The Hundred Club of Massachusetts; Ken Donnelly, secretary-treasurer, Professional Fire Fighters of Massachusetts, I.A.F.F.; and Robert B. McCarthy, president, Professional Fire Fighters of Massachusetts, I.A.F.F.

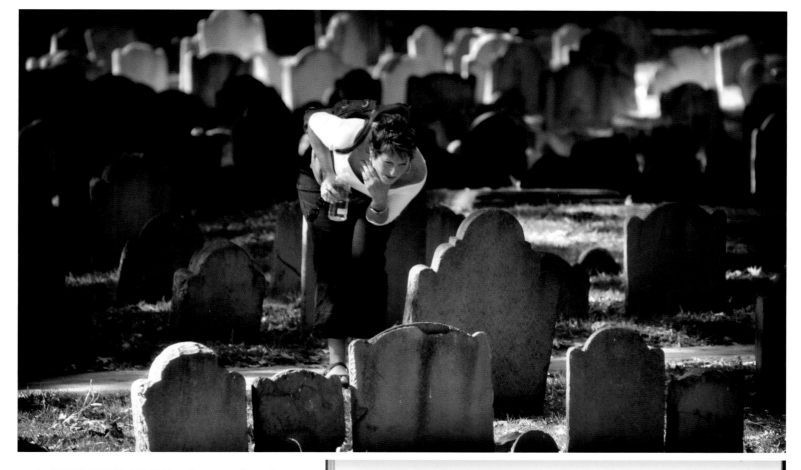

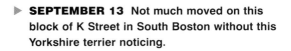 **SEPTEMBER 12** Taking its name from the building that first occupied the current site of the Park Street Church, the Granary Burying Ground contains 2,345 gravestones and tombs, although it has been estimated that more than five thousand people are buried at the site. Millions have walked through the crooked paths to read the slate markers for some of the area's most famous forebears including Massachusetts governors, mayors, clergymen, Patriot and craftsman Paul Revere, Revolutionary War orator and lawyer James Otis, five victims of the Boston Massacre, Benjamin Franklin's parents, and three signers of the Declaration of Independence: Samuel Adams, John Hancock, and Robert Treat Paine.

▶ **SEPTEMBER 13** Not much moved on this block of K Street in South Boston without this Yorkshire terrier noticing.

▲ **SEPTEMBER 14** The Victorian era is sometimes overlooked in telling Boston's rich history, but not by this guide who showed a visitor some nuances of the State House.

◀ **SEPTEMBER 15** SoWa Open Studios + Open Market, a two-day celebration of art and crafts in the South End area along Harrison Avenue and Washington Street, was started in 2003 by Mario Nicosia, a long-time South End developer and resident. Once considered among the city's rougher areas at night, SoWa (the area South of Washington) now houses dozens of galleries and artist work spaces, and several of the city's best restaurants including Rocca and Gaslight Brasserie du Coin.

SEPTEMBER 16 Lieutenant general Robert F. Foley spoke before a crowd gathered at the South Boston Vietnam Veteran's Memorial in M Street Park at the twenty-sixth annual gathering to remember those from the neighborhood who died in the conflict. Foley, a Vietnam War veteran, was invited by the memorial's organizer, Tom Lyons.

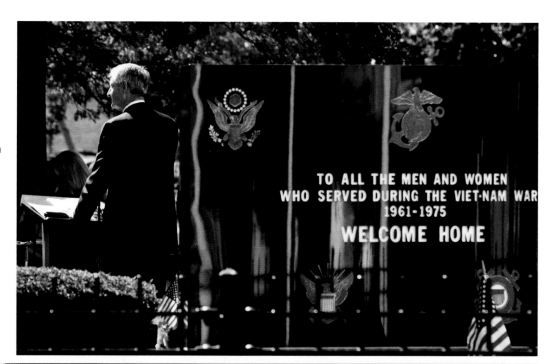

SEPTEMBER 17 It was standing room only at the State House as governor Deval Patrick ended months of speculation, debate and study and unveiled a proposal for three destination resort-style casinos that the Patrick administration said would create twenty thousand jobs and generate $2 billion in economic activity.

▲ **SEPTEMBER 18** The Boston Stock Exchange on Franklin Street is no longer
open to the public, but its patriotism was on display to those passing by the
economic center in the financial district.

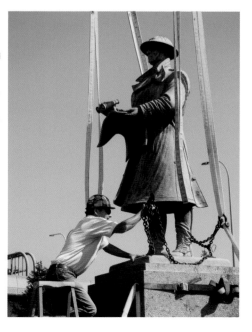

▲ **SEPTEMBER 19** It was officially Patrolman Peter Giannopoulos Day in Boston and no one could have been happier than Alexandria Atencio. Just the day before Giannopoulos had been driving in Allston when the Boston Police officer spotted Atencio struggling with a man who held her at knifepoint. The police eventually caught the man and arrested him and the city honored Officer Giannopoulos with his own day to thank him for his bravery.

▲ **SEPTEMBER 20** CBS Corporation president and chief executive officer Les Moonves kept the Boston College Chief Executives Club tradition of national heavy-hitters speaking to a room full of the biggest names in the city. In his luncheon address, given at the Boston Harbor Hotel, Moonves talked about leadership in difficult times.

▶ **SEPTEMBER 21** General Edward Lawrence Logan was not an aviator, yet the statesman for whom Boston's airport is named was an unwavering champion of extending veteran benefits to the nation's earliest pilots. Born in Boston in 1875, Logan served in the Massachusetts legislature, was chairman of the Metropolitan District Commission, and served as a judge in the South Boston district court. Here, Joseph Coletti's statue of General Logan was put back in place after completion of a $4 billion modernization project.

■ **SEPTEMBER 22** Jockey Willie Martinez kept Brass Hat steady as the six-year-old (number 8, far left) held on to win the sixty-fifth running of the Massachusetts Handicap at Suffolk Downs. The bay gelding, which had disappointed in his two previous races, also won the coveted $500,000 prize and secured his place in local racing lore. The 2007 race drew 19,191, the largest crowd to watch live racing at Suffolk Downs since Cigar won the 1996 MassCap.

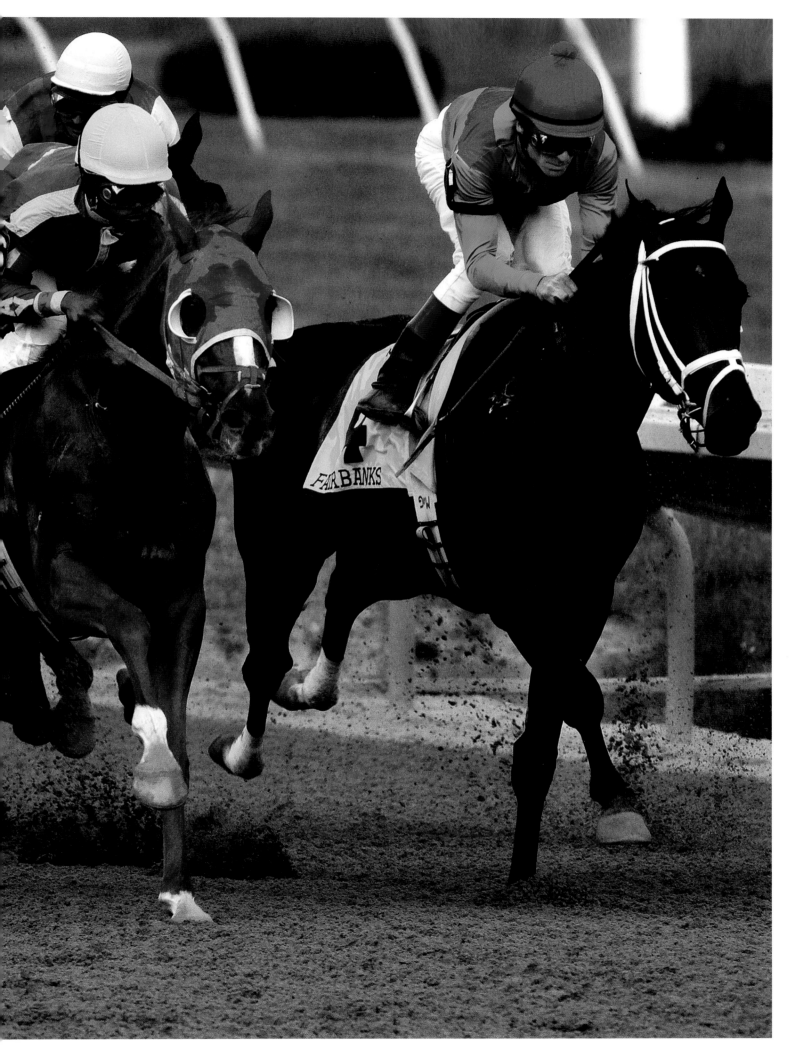

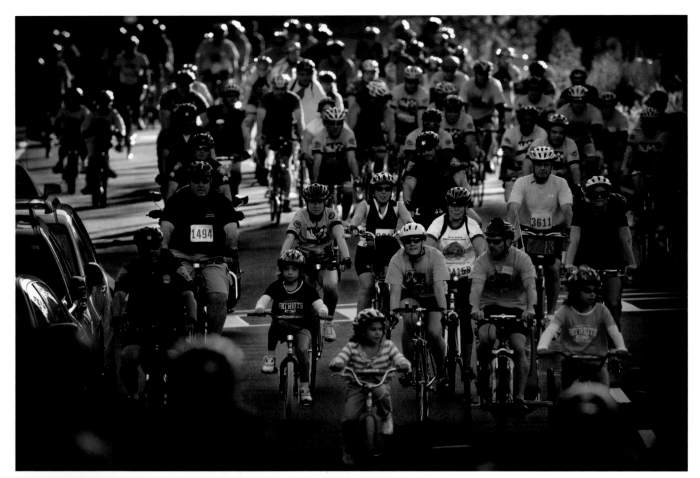

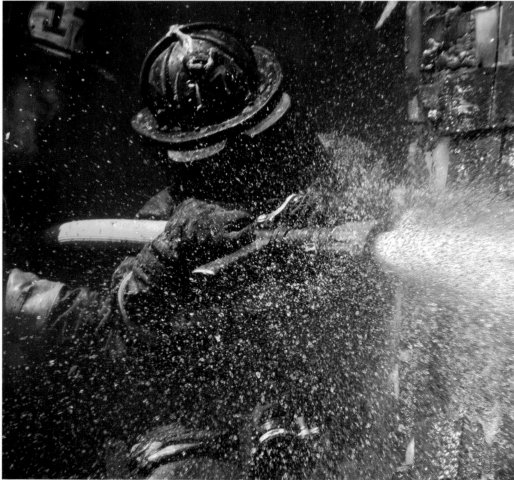

▲ **SEPTEMBER 23** Boston police commissioner Edward F. Davis joined several other members of the department in pedaling the route for the "Hub on Wheels" fund-raiser. The event supports the nonprofit Boston Digital Bridge Foundation, which provides technology training and computer equipment to underserved communities.

◄ **SEPTEMBER 24** Firefighters from Engine 17 and Ladder 7 worked to quell a blaze at 32 Melbourne Street in Dorchester. It would take the crews several hours to clean up the fire before they could return to their Parish Street firehouse.

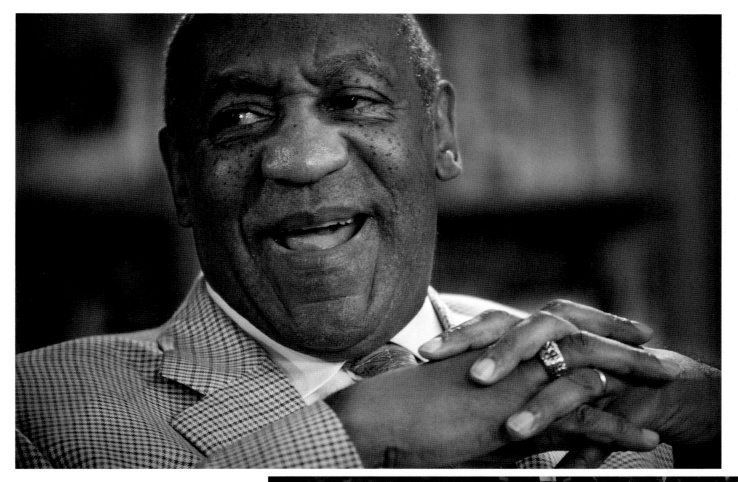

▲ **SEPTEMBER 25** Bill Cosby and his co-author and long-time collaborator Alvin Poussaint were at a book-signing at Borders Downtown Crossing to promote *Come on People: On the Path from Victims to Victors.* The comedian and commentator was his usual charming self as he spoke about the book and his vision for strengthening America.

▶ **SEPTEMBER 26** Confetti and smiles greeted the groundbreaking for a mixed-use development on the South Boston waterfront. Developer Joseph F. Fallon was able to get the project rolling after several groups failed over more than two decades to build on the site popularly known as Fan Pier.

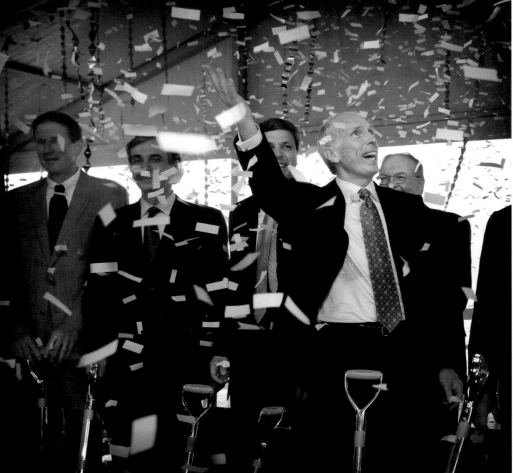

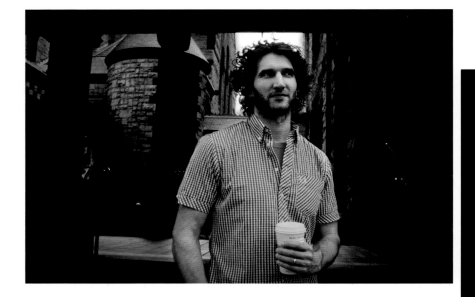

▲ **SEPTEMBER 27** Writer David Benioff enjoyed a few moments' break in Copley Square. Benioff penned the screenplay for the big-screen adaptation of Khaled Hosseini's best-selling novel *The Kite Runner.*

▼ **SEPTEMBER 28** Under a tent near the Caritas Carney Hospital, the Dorchester Park Association gathered for a gala to establish a fund for the maintenance and improvement of Dorchester Park. Established in 1891, the park has changed size over the years, but it remains a beautiful and important part of Dorchester.

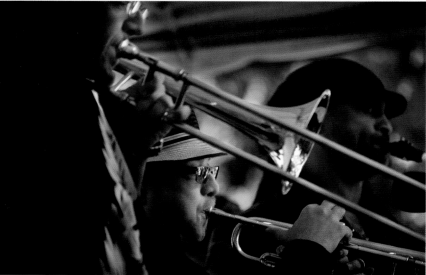

◀ **SEPTEMBER 29** The seventh annual BeanTown Jazz Festival drew more than seventy thousand music lovers for a free afternoon of outdoor music in Boston's South End. The three days of entertainment kicked off Friday night at Symphony Hall with "A Celebration of Jazz and Joyce," an all-star lineup assembled by jazz impresario George Wein, with proceeds benefiting the Berklee College of Music scholarship fund named in honor of his late wife, Joyce Alexander Wein.

▲ **SEPTEMBER 30** Maureen Dahill, Melody Fortier, Marianne
Chisholm, Rene Martin, and Julie Iveska participated in a fashion
show at the University of Massachusetts Boston campus center
to celebrate Catholic Charities Labouré Center's hundredth year
as a social service agency in South Boston. The fashion show
included four designers and their latest pieces, but the day's
events got started with a vintage fashion walk depicting styles of
the last century.

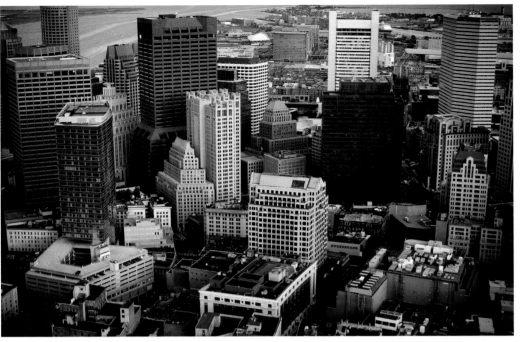

OCTOBER 1 Like a parent hearing the call of a child over the din of a crowd, denizens of Boston know the profile of the city's skyline and have no trouble picking out the layout of our much-maligned (and admittedly confusing) streets from thousands of feet away.

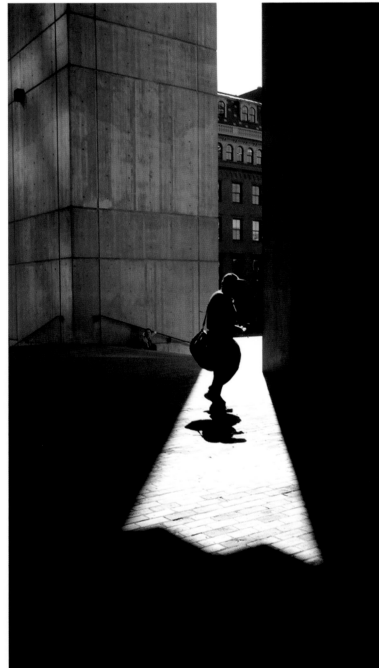

▲ **OCTOBER 2** Althea Cesarini celebrated her hundredth birthday on Adams Street in Dorchester, a block she has called home for most of her life.

◄ **OCTOBER 3** A man crossed City Hall Plaza on his way to the Government Center stop on the MBTA's Green Line. The plaza is an eight-acre open space often used for parades and rallies; most notably, it has hosted championship rallies for the region's sports teams, including the Celtics, Bruins, Patriots, and Red Sox.

▶ **OCTOBER 4** Not even the most aggressive Boston driver dared to challenge this pachyderm parade as the Ringling Bros. and Barnum & Bailey Circus unloaded from its trains and prepared for its annual run at the TD Banknorth Garden.

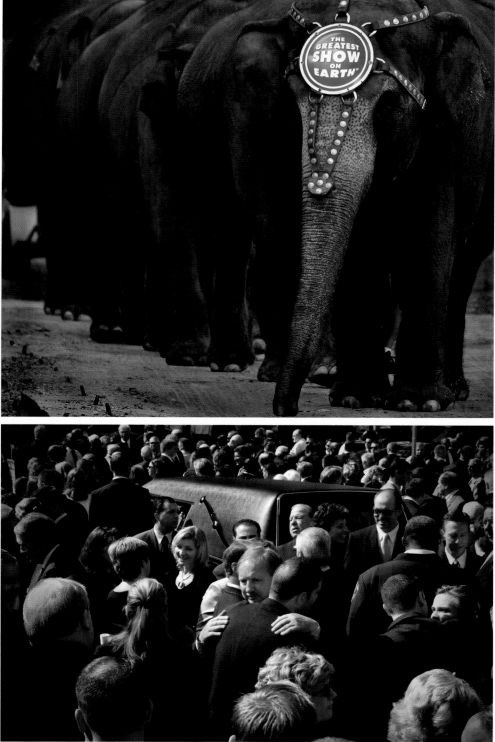

▲ **OCTOBER 5** The Basilica of Our Lady of Perpetual Help Mission Church was filled to overflowing for the funeral of former state Representative Kevin Fitzgerald, the House sergeant-at-arms who died of cancer at age fifty-seven. Among the throng who filled the church were mayor Thomas M. Menino, US senator John F. Kerry, governor Deval Patrick, former Massachusetts House speaker Thomas Finneran, and congressmen Stephen L. Lynch and Edward J. Markey. Fitzgerald's oldest son, John, gave an upbeat and joy-filled eulogy.

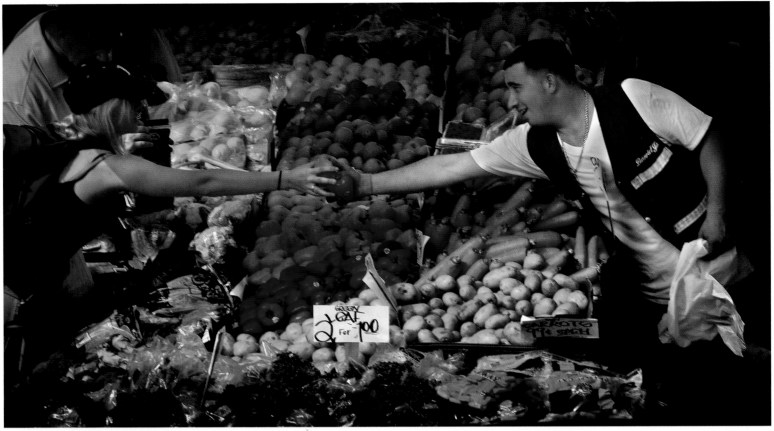

▲ **OCTOBER 7** Boston police patrolman Mario Santillana enjoyed a laugh with a clown who took part in the Columbus Day Parade. The cold weather put a slight damper on the festivities, which started at City Hall Plaza and headed to the North End.

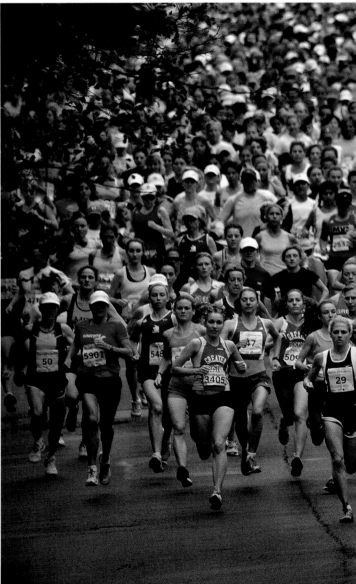

OCTOBER 6 For a dozen years, David Forlizzi has worked as a vendor at the Haymarket Square fruit and vegetable stands. The area has survived the Big Dig construction, redevelopment of the neighborhood, and numerous other challenges in what was Boston's first commercial area.

OCTOBER 9 Madison Park Technical High School science teacher Matthew Dugan got a surprise as the whole school gathered in Cardinal Hall. As his students chanted "Dugan! Dugan!" it was announced that the quiet educator was one of two Boston teachers selected nationally for a Milken Award and the $25,000 cash prize that comes with it.

OCTOBER 8 It wasn't a great day to be a spectator cheering your loved one on from the sidelines, but for the seven thousand runners and walkers the conditions were perfect for the thirty-first Tufts Health Plan 10K for Women. The race had a deep field, including several elite U.S. runners, after the race was designated by USA Track & Field as the national 10K championship. The race and the day belonged to Deena Kastor, who led from start to finish.

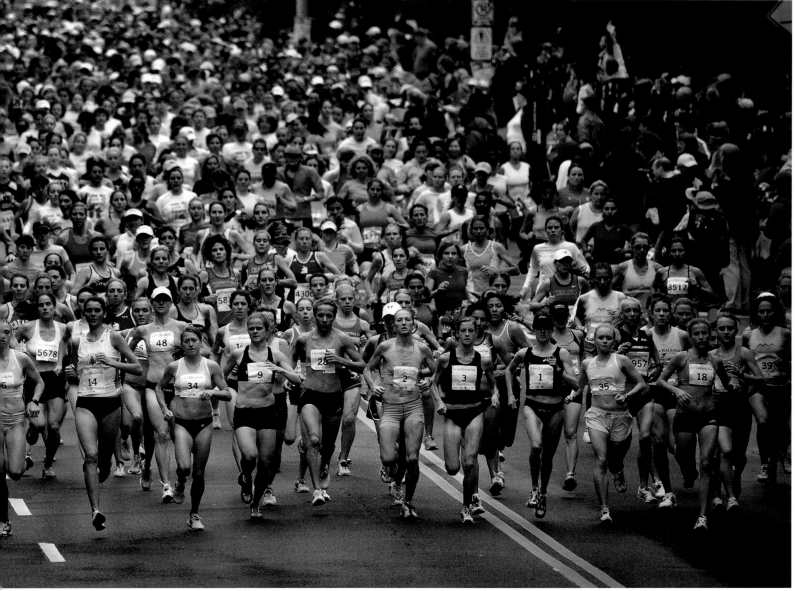

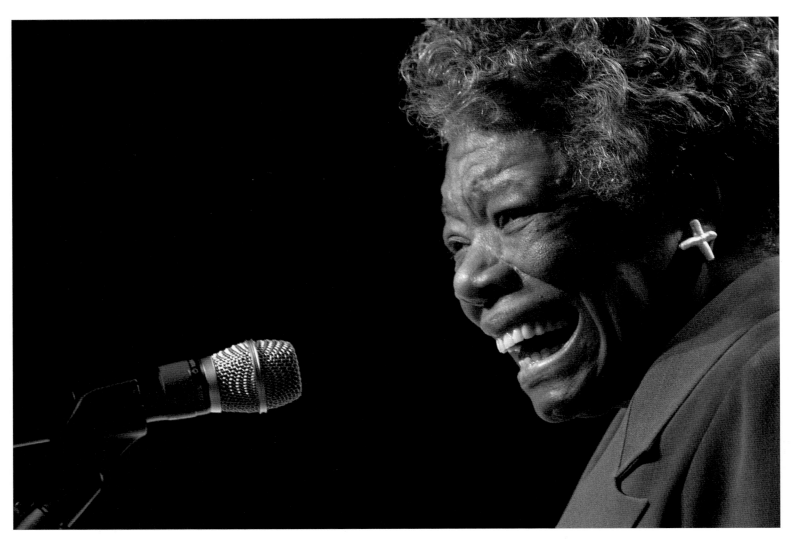

▲ **OCTOBER 10** Poet Maya Angelou gave the keynote address at the ninth annual Women's Breakfast at the Hynes Convention Center. The benefit for Horizons for Homeless Children, drew sixteen hundred people and raised more than $700,000.

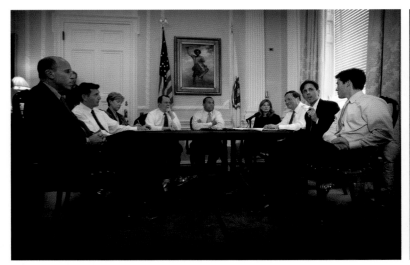

▲ **OCTOBER 11** Governor Deval Patrick prepared to file a casino gambling bill with a proposal for three resort casinos in the state. As submitted, the bill would legalize gambling activity not previously allowed in the state while giving the governor control of the seven-member gaming authority that would auction off the licenses and regulate the casinos. The bill also named the three regions where casinos could be built.

▲ **OCTOBER 12** The National Grid gas tank on Dorchester Bay flashed a "No. 1" salute above the Red Sox logo as Boston opened the American League Championship Series at Fenway and began their quest for the pennant with a decisive 10-3 win over the Cleveland Indians.

▶ **OCTOBER 13** Danny Maimaron of Rockland received a hardy greeting from Mary Choukas of Dorchester as more than one thousand guests gathered for a reunion of St. Peter Roman Catholic Parish in Dorchester. Established in 1872, the Bowdoin Street church and school has alumni around the world.

▶ **OCTOBER 14** A young woman found a peaceful place to do some studying nestled between the fountain and flowerbeds of Copley Plaza.

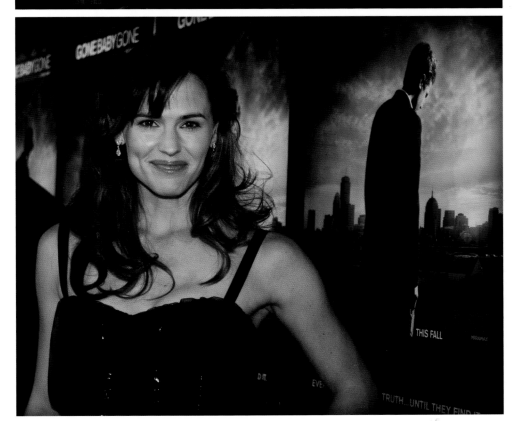

▶ **OCTOBER 15** Jennifer Garner beamed with pride at the Boston premiere of *Gone Baby Gone,* the directorial debut of her husband, Oscar-winning writer-actor Ben Affleck. The Cantabrigian filmed the drama, based on Dennis Lehane's best-seller of the same name, entirely in Boston for several months in 2006.

◀ **OCTOBER 16** With scaffolding mounting to the historic bell tower, the Park Street Church underwent a $10 million renovation.

▼ **OCTOBER 17** Members of the Berklee College Gospel Choir got the twentieth anniversary celebration of the Family-To-Family Project off to an exultant start at the Boston Center for the Arts Cyclorama. Psychiatrist and philanthropist Paul Buttenwieser asked his friends to join in the festivities and raised $700,000 for the Boston-based non-profit, which helps families avoid becoming homeless.

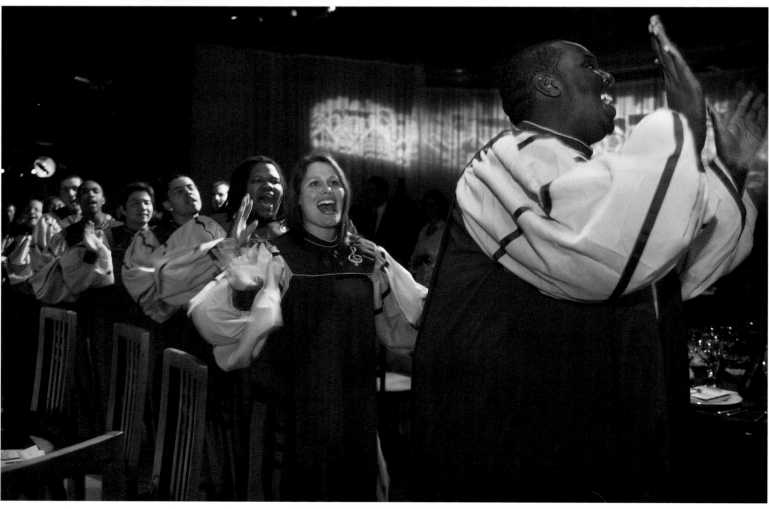

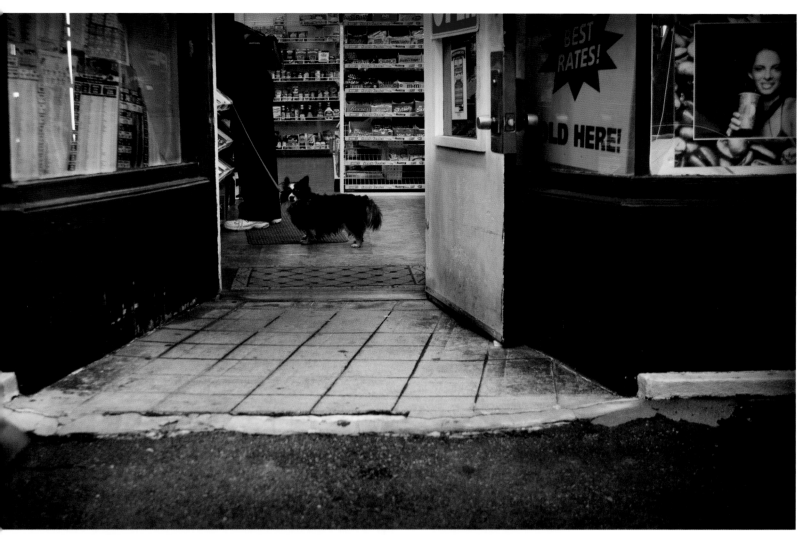

▲ **OCTOBER 19** A dog seemed to be the only one paying attention to the goings on on Kilmarnock Street as Fenway Convenience kept its doors open to foot traffic just a couple of blocks away from the Red Sox ballyard.

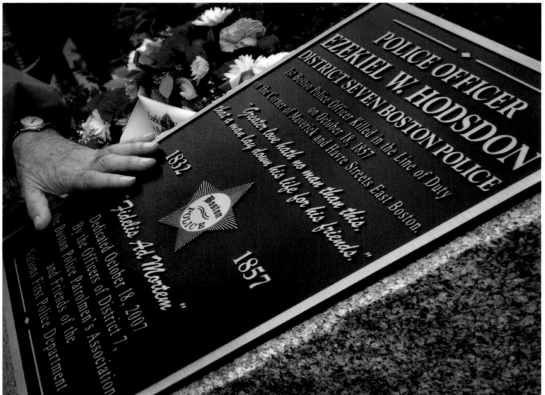

▲ **OCTOBER 18** Boston police captain Robert Cunningham and officers of District A-7 in East Boston convened to unveil a memorial honoring Ezekiel W. Hodsdon, the first Boston police officer killed in the line of duty. The tragedy occurred at the corner of Maverick and Havre streets on October 18, 1857.

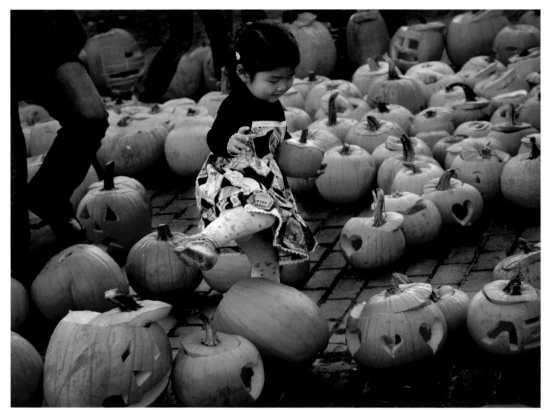

▶ **OCTOBER 20** Two-and-a-half-year-old Michelle Yi had a hard time picking out her favorite jack-o-lantern among nearly three thousand carved pumpkins stacked on staging at City Hall Plaza. The fifth Camp Sunshine Pumpkin Festival featured pumpkin carving and a seed-spitting contest.

▼ **OCTOBER 21** Tens of thousands lined the shores of the Charles River for the forty-third outing of the Head of the Charles Regatta, the world's largest two-day rowing event. More than 7,500 athletes competed in fifty-five events.

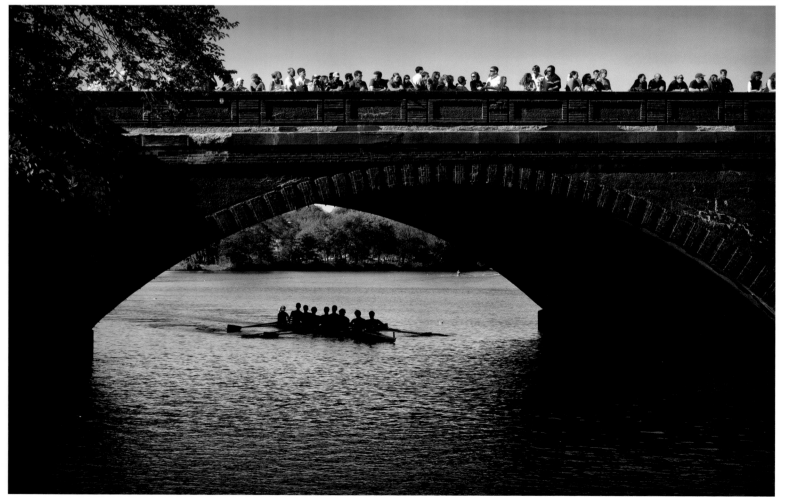

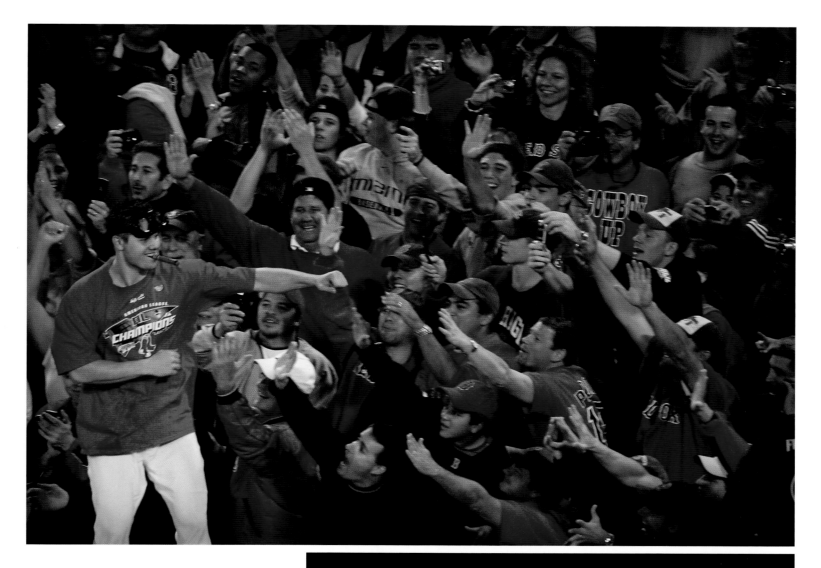

▲ **OCTOBER 22** Shortly after midnight, Red Sox relief pitcher Jonathan Papelbon worked his magic as the Sox beat the Cleveland Indians 11–2 in game 7 to win the 2007 American League pennant. The wee hours of this glorious day for Sox fans also saw the Papelbon jig, which he showed off on the Sox dugout.

▶ **OCTOBER 23** Sudbury-raised comedienne Paula Poundstone took the title of a "Funny Women, Serious Business" luncheon to heart, cracking wise for the benefit of the city's homeless women. The gathering at the Hynes Convention Center drew fifteen hundred guests and raised $400,000 for Rosie's Place, founded by activist Kip Tiernan

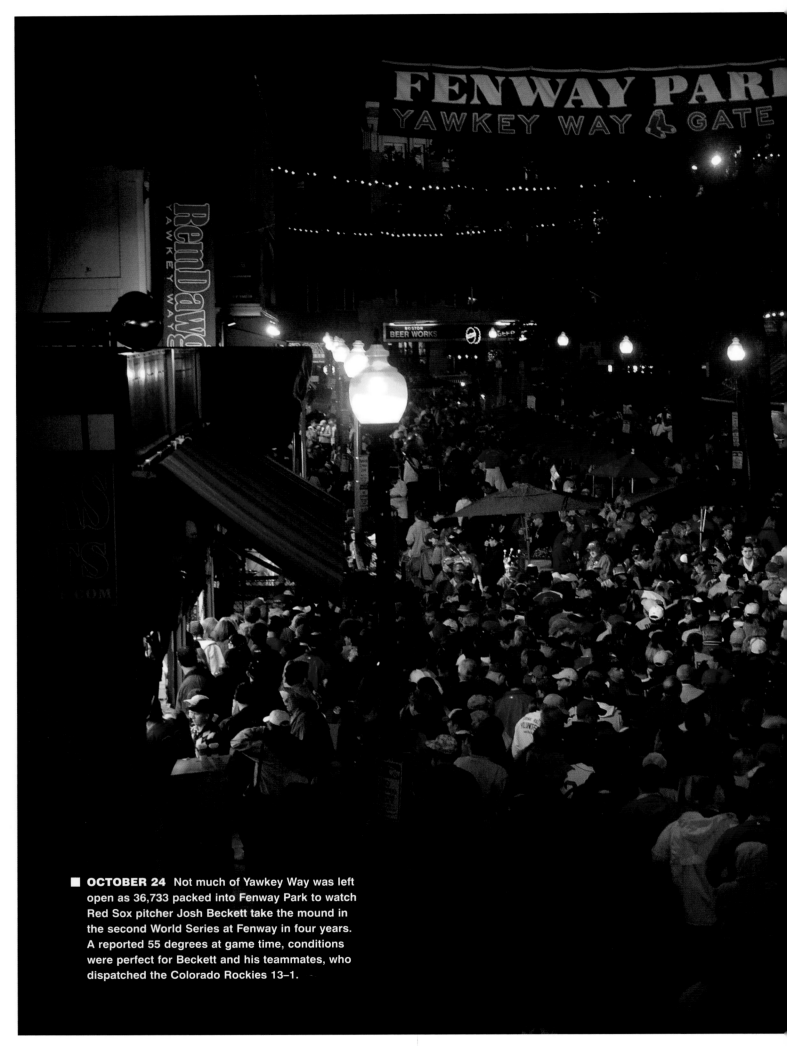

■ **OCTOBER 24** Not much of Yawkey Way was left
open as 36,733 packed into Fenway Park to watch
Red Sox pitcher Josh Beckett take the mound in
the second World Series at Fenway in four years.
A reported 55 degrees at game time, conditions
were perfect for Beckett and his teammates, who
dispatched the Colorado Rockies 13–1.

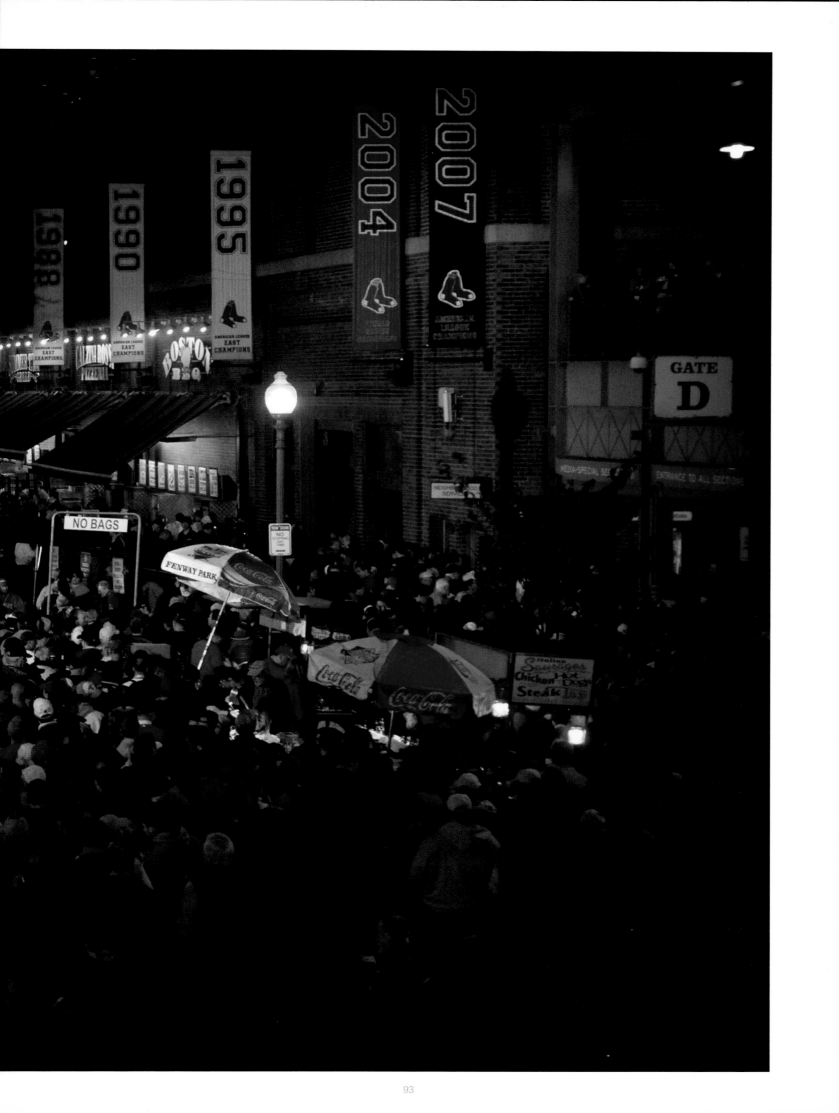

▼ **OCTOBER 25** The hunter's moon, as Native Americans called a full moon of October, hung in the sky as the Prudential Center burst with team pride. The heavens were in perfect alignment for the Red Sox, and the city, just before game 2 of the 2007 World Series.

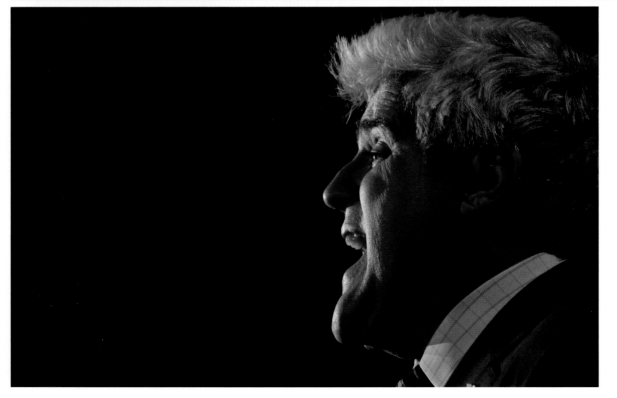

◄ **OCTOBER 26** Jay Leno returned to Boston to host a fete for the National Braille Press at the InterContinental Boston Hotel, an event that raised $1.4 million for the Boston-based nonprofit. In addition to his thirty-minute stand-up routine, the Andover native emptied the pockets of locals through the auction and got General Motors to donate a Cadillac for a raffle. Then it was back to Los Angeles, he said, for work.

▶ **OCTOBER 27** Who says moms can't juggle it all? This mother managed to make her way up the sidewalk outside South Station with two suitcases, a backpack, her baby's car seat on her shoulder, and yes, her little one in a stroller in front of her.

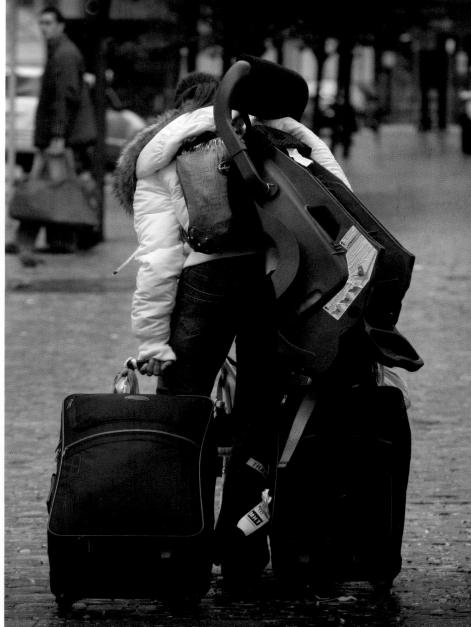

▶ **OCTOBER 28** A pair of draft horses got ready for duty at Cedar Grove Cemetery. Started in the mid-nineteenth century by residents of the town of Dorchester, the cemetery is famous for having a railroad bisect the grounds, one that has its own stop, Cedar Grove Station. The burial ground is the only cemetery in the country with a trolley running through it.

▶ **OCTOBER 29** A boat from the Boston Fire Department's marine unit gave a watery welcome to a ship entering Boston Harbor under a rainbow that appeared not long after the clouds cleared.

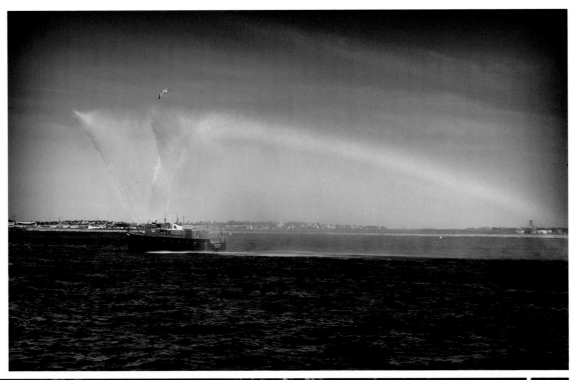

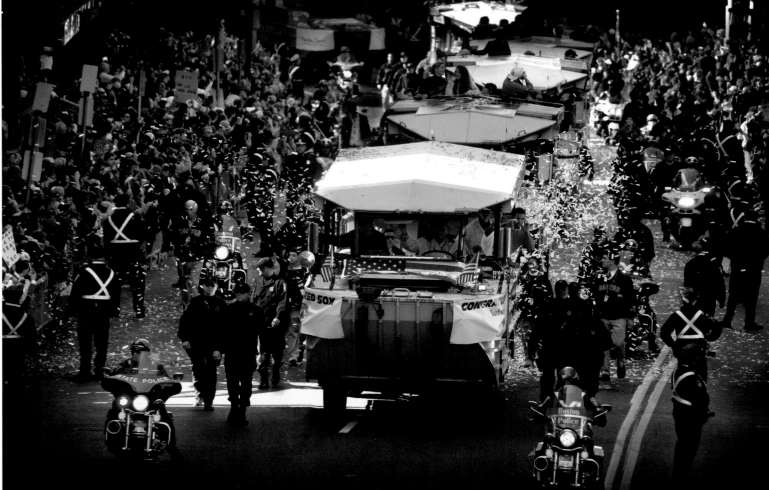

▲ **OCTOBER 30** Smaller but no less meaningful than 2004's victory parade, the 2007 Red Sox "rolling rally" skipped the trip along the Charles River but snaked its way from Fenway Park to City Hall Plaza as an estimated one million members of Red Sox Nation celebrated the team's four-game sweep of the Colorado Rockies. Fans, fifteen deep in places, yelled and cheered as Duck Boats carrying rookie phenom Dustin Pedroia, Series MVP Mike Lowell, Curt Schilling, Manny Ramirez, David Ortiz, and other players passed by.

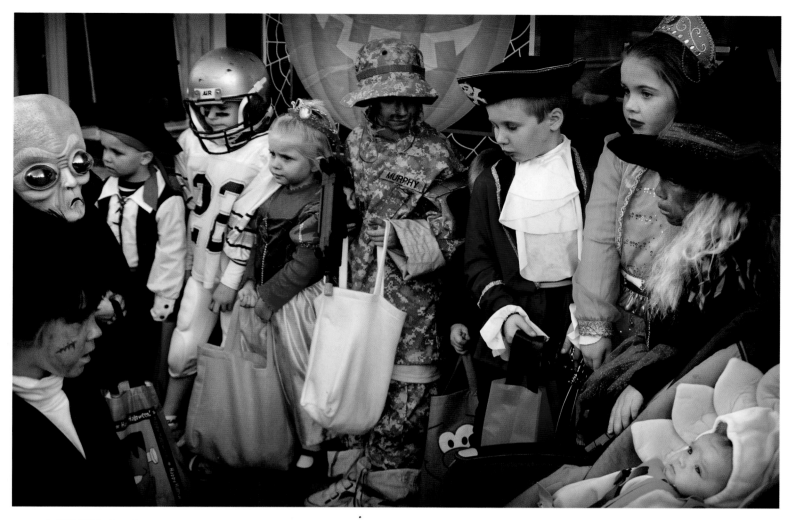

▲ **OCTOBER 31** Swashbuckling pirates rubbed shoulders with heroes, princesses, and some pretty scary characters as young trick-or-treaters gathered at Flood Square in South Boston early on Halloween night.

NOVEMBER

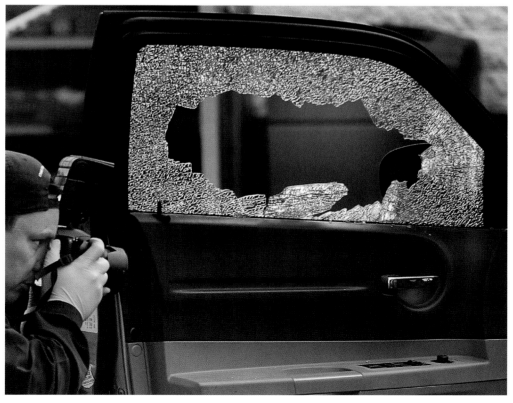

▶ **NOVEMBER 1** The crime scene investigation unit of the Boston Police Department usually goes about its business of documenting incidents and collecting evidence far from the glare of the spotlight. Officer Michael Connolly photographed a crime scene on Freeport Street in Dorchester where two people were wounded.

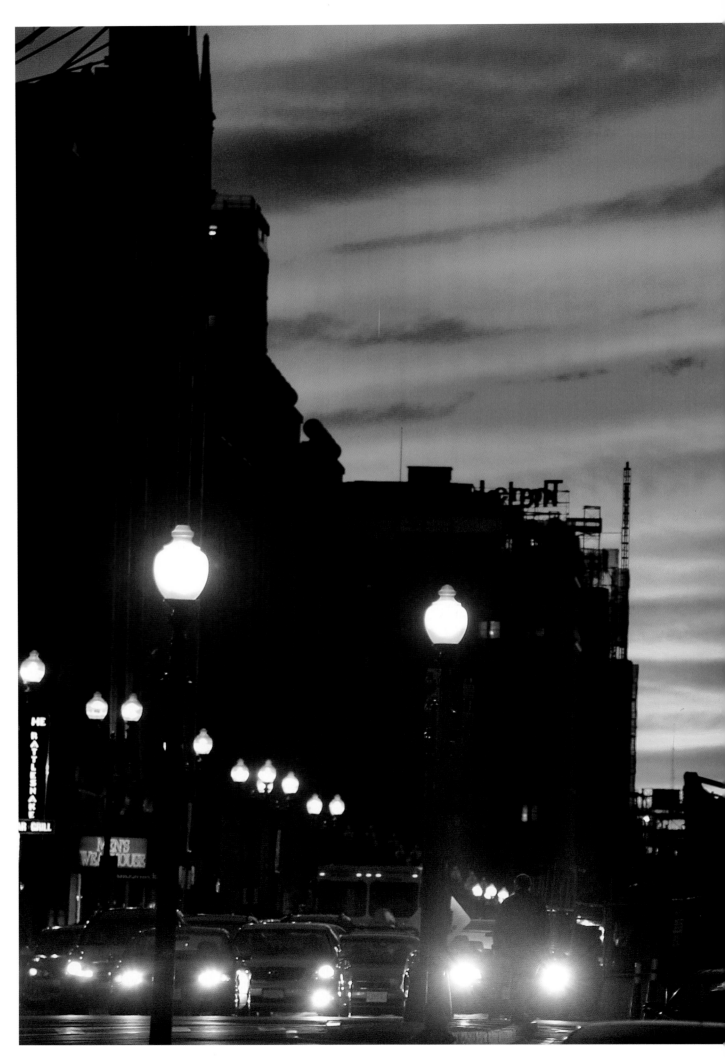

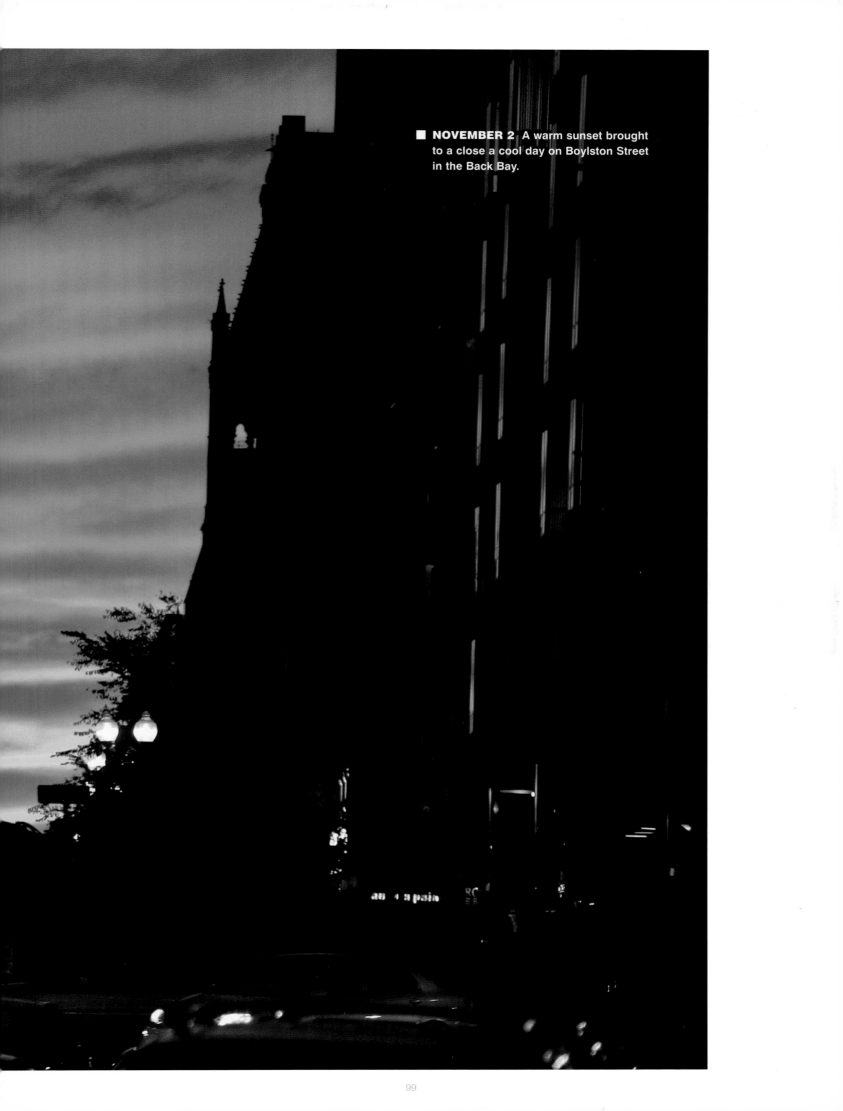

■ **NOVEMBER 2** A warm sunset brought to a close a cool day on Boylston Street in the Back Bay.

◄ **NOVEMBER 3** The Cross Border Orchestra of Ireland, under the direction of conductor Gearóid Grant, performed at Symphony Hall to celebrate the "culture and connections" of Ireland and Northern Ireland. The evening honored construction magnate Jay Cashman and featured performances by the five hundred Boston school students of Cross Border Boston Choir, tenor Emmanuel Lawler, "Shamrock Idol" 2007 winner Tatum Harvey, and IBEW local 103's Electrician's Pipe & Drum Band.

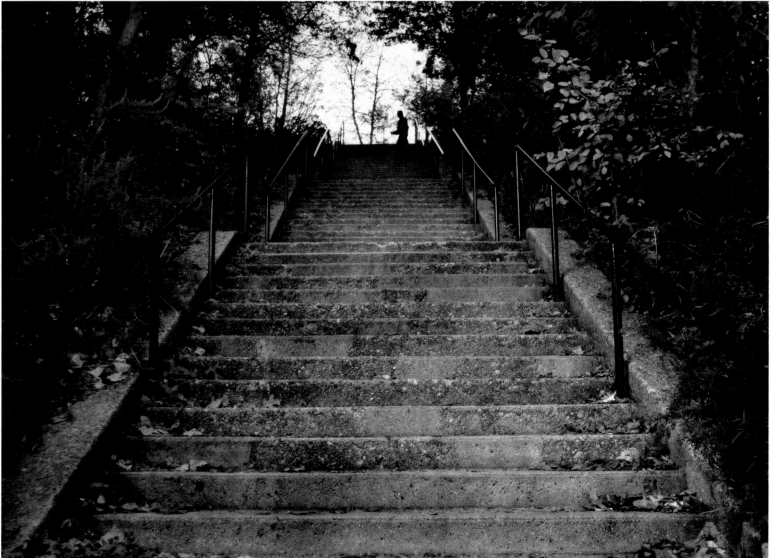

▲ **NOVEMBER 4** The steps at Fisher Avenue leading up to McLaughlin Playground provide access to a great 11.5-acre park and one of the more interesting views of Boston's skyline. The park is also home to a wild orchard that includes a number of fruit trees and bushes, including pears, currants, and apples.

NOVEMBER 5 "Teaming Up For Kids," to benefit the Boston Celtics Shamrock Foundation, provided many of the team's biggest supporters and season ticket-holders their first close-up glimpse of newly acquired star forward Kevin Garnett. Hundreds of guests packed the ballroom at the InterContinental Boston Hotel to support the team and the charity serving young people in the city.

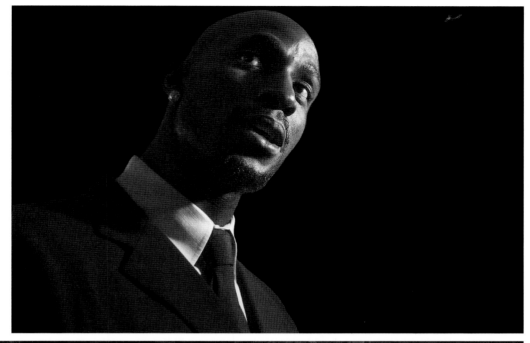

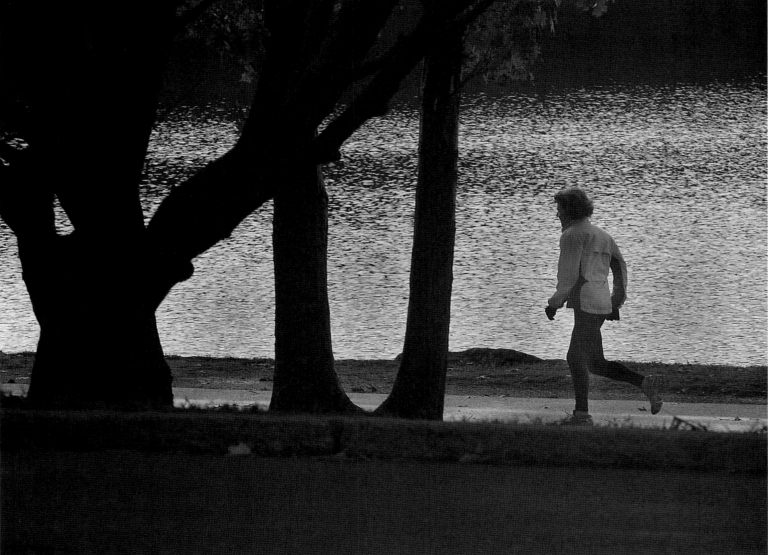

NOVEMBER 6 A woman enjoyed a run along the footpaths at Jamaica Pond, which is part of the Emerald Necklace, a linked system of parks designed by Frederick Law Olmsted. The pond, which borders the town of Brookline and once served as a reservoir, covers 68 acres and is 53 feet deep in the center.

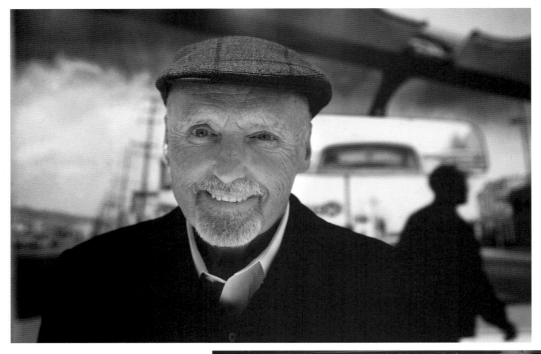

NOVEMBER 7 Most famous for the roles he has brought to the big screen, actor Dennis Hopper has been quietly turning his 35mm camera on others for decades. When the *Easy Rider* star, who has appeared in more than 140 films, arrived at the Museum of Fine Arts to deliver the Karsh Lecture in Photography, he said he was taken aback by the standing-room-only crowd gathered to hear him speak about his photography, which includes portraits of Paul Newman, Ike and Tina Turner, and Andy Warhol.

▶ **NOVEMBER 8** Billy Starr, founder of the Pan-Massachusetts Challenge, prepared to hand an over-sized check for a whopping $33 million to the Dana-Farber Cancer Institute's Jimmy Fund. The two-day cycling event draws more than five thousand partici-pants who pedal courses connecting Sturbridge, Wellesley, Bourne, and Provincetown. It has raised more than $200 million for cancer research.

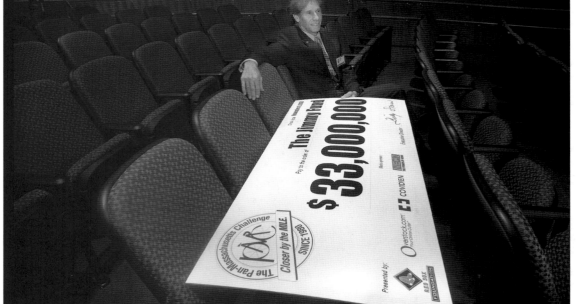

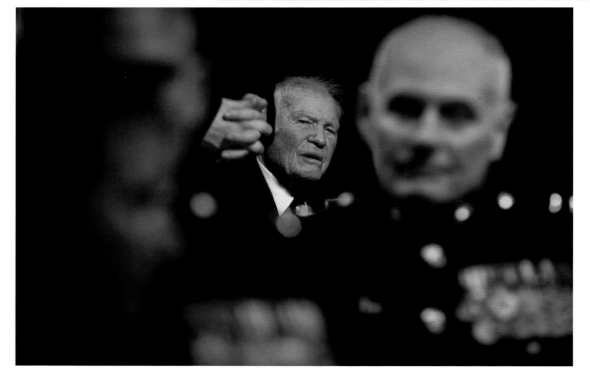

◀ **NOVEMBER 9** Richard Hill was among those gathered at the Hynes Convention Center for a local celebration mark-ing the 232nd anniversary of the United States Marine Corps.

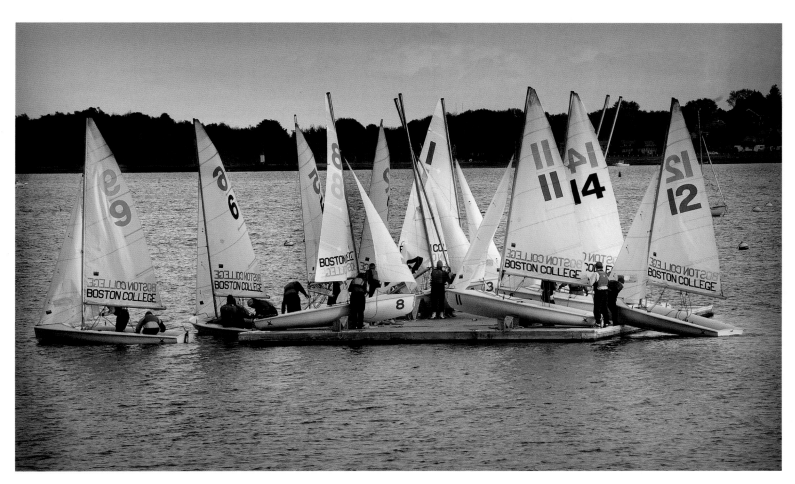

▲ **NOVEMBER 10** Boston College's sailing team checked the rigging on their boats at a dock near the Savin Hill Yacht Club.

▼ **NOVEMBER 11** William M. Bennett was one of the five surviving members of the Tuskegee Airmen honored at a State House ceremony by senator John F. Kerry, governor Deval Patrick, and lieutenant governor Tim Murray. Also honored for their service in the first group of African-American fighter pilots allowed into the United States Army Air Corps, during World War II, were: Charles Diggs, George W. Giddings, James McLaurin, and Willis Saunders. The state's Veterans Day remembrances featured a tribute to women veterans led by United States Air Force captain Jenny D'Olympia.

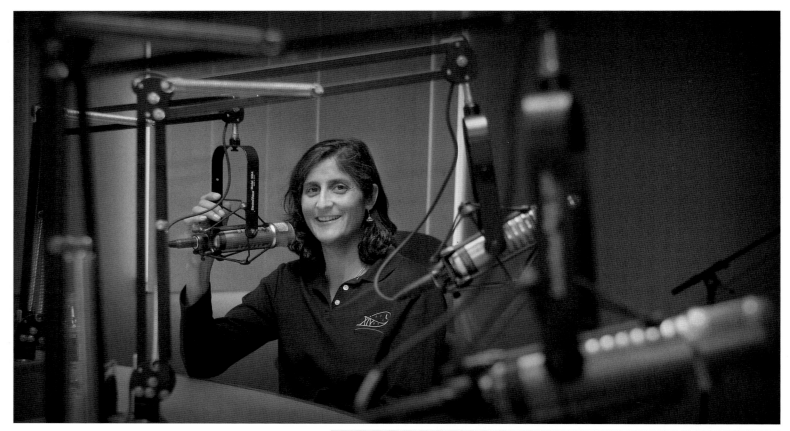

▲ **NOVEMBER 12** NASA astronaut and former Needham resident Sunita Williams stopped by the William T. Morrissey Boulevard studios of FM radio station Magic 106.7 to talk with Gay Vernon for the "Exceptional Women" show.

▲ **NOVEMBER 13** Stylists from Newbury Street's Salon Marc Harris shaved off the familiar goatee of Red Sox first baseman Kevin Youkilis. When the World Series winner was clean shaven, Gillette handed over $5,000 for his Kevin Youkilis Hits for Kids charity.

◄ **NOVEMBER 14** The Salvation Army's Drew Forster and his coronet welcomed the holiday season with a tune played for passersby in Downtown Crossing. A fifth-generation Salvationist, Forster is the planning director for the Army's new Ray and Joan Kroc Corps Community Center, a six-acre facility under construction in Dorchester.

NOVEMBER 15 Anetsis Ramos, nine, of Hyde Park and her "Big Sister" Susan Andrzejewski were two of the dozens of pairs of women and their Little Sisters at the Big Sister Association of Greater Boston's dinner. More than five hundred supporters attended the gala at the Fairmont Copley Plaza that raised $500,000 to support the nonprofit, which is the largest mentoring organization in the region exclusively serving girls.

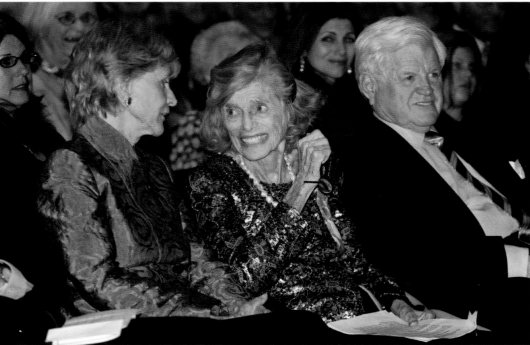

NOVEMBER 16 It was quite the night at the John F. Kennedy Library and Museum on Columbia Point, when hundreds turned out to pay tribute to Eunice Kennedy Shriver. On hand were her brother, senator Edward M. Kennedy, and sister, Jean Kennedy Smith, as were Eunice's five children, Robert, California first lady Maria, Timothy, Mark, and Anthony.

◄ **NOVEMBER 17** Dominic Luberto strung up his lavish display of Christmas lights, complete with a giant golden crown, on his house on the Arborway. Luberto would put the 8,514-square-foot house on the market in late February for $2.2 million. Lights were extra.

▼ **NOVEMBER 18** A helicopter landed on City Hall Plaza after moving a new air conditioner onto the roof at 1 Devonshire Place during the early morning hours, before crowds and tourists filled the area.

NOVEMBER 19 As they have for more than thirty years, the people of Nova Scotia sent a giant evergreen tree to the people of Boston to be used as the city's official Christmas tree. The gesture was started as a way to thank the city's residents for Boston's assistance after the tragic 1917 explosion in Halifax Harbor in which two thousand were killed and some nine thousand were injured. This forty-six-foot white spruce came from Christopher and Lisa Hamilton's backyard in Granville Centre, Annapolis County, Nova Scotia.

NOVEMBER 20 The Table of Friends dinner feeds more than seven hundred of the city's poorest who otherwise would not get a hot holiday meal. The Thanksgiving spread is hosted by the TD Banknorth Garden through its neighborhood charities program and Friends of Boston's Homeless.

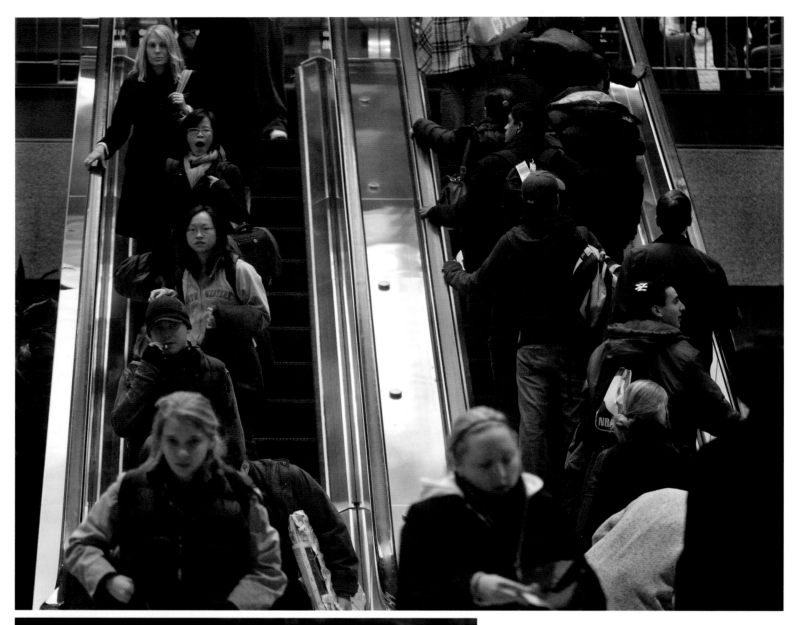

▲ **NOVEMBER 21** It has been estimated that more people travel into and out of Boston's transportation centers on the Wednesday before Thanksgiving than on any two other days of the year. You have to step lively and pay attention while using the escalators at South Station that connect the MBTA's Red and Silver lines with the Amtrak and commuter rail lines, and with services out of the bus terminal.

◄ **NOVEMBER 22** Boston Latin may have been winless going into its tilt against Boston English, but the Latin Wolfpack ended its season with a stunning 33–6 win. The game, played at Harvard Stadium, was the 121st installment of the nation's oldest continuous Thanksgiving Day rivalry.

NOVEMBER 23 Carpenter foreman Armando Adeira and carpenter steward Frank Mastrorilli helped guide a panel to the floor of the TD Banknorth Garden. The "bull gang" are the folks who get the Garden ready for basketball, ice hockey, and concerts, which can mean several switches a week when the Bruins and Celtics are playing.

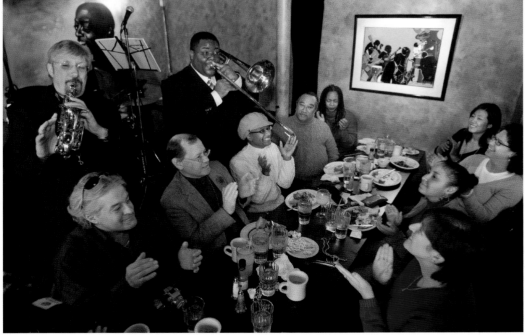

NOVEMBER 24 Like a lighthouse on the shore, the familiar glow of DeLuca's Market spills onto the red brick sidewalks of Charles Street and serves as a marker for those who travel through Beacon Hill.

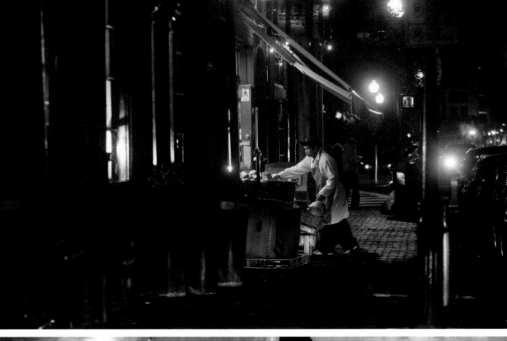

NOVEMBER 25 After fifty years serving up Boston's finest southern cuisine and entertaining live jazz, Bob's Southern Bistro closed its doors in the South End. The renowned eatery, formerly known as Bob the Chef's, was sold by its owner, Darryl Settles, and was to reopen as an upscale lounge. But the neighborhood stalwart did not end its run without first getting an old-fashioned New Orleans–style send-off that was by turns joyous and sad.

▲ **NOVEMBER 26** A heavy fog covered Joe Moakley Park on William Day Boulevard in South Boston. The park takes its name from the late long-time member of the U.S. House of Representatives.

▶ **NOVEMBER 27** For Don Rodman, growing up in a single-parent home in Dorchester's Franklin Park area meant that cultural events were a luxury his family couldn't afford. His wife, Marilyn, showed him the benefits of enjoying the city's rich arts community and now the successful auto dealership owner–turned–philanthropist makes it his mission to get the city's young residents into Boston's best theaters. On this night, the Marilyn Rodman Theatre for Kids program bought out the house at the Colonial Theatre, all 1,650 seats, for the evening show of the musical *Mamma Mia!*

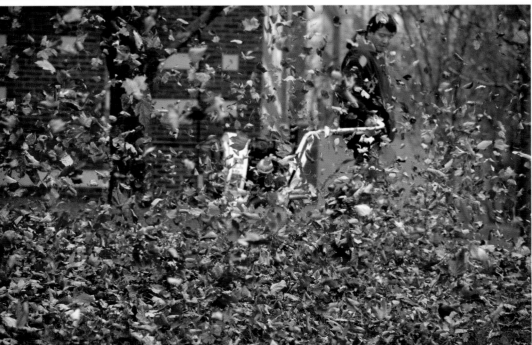

▲ **NOVEMBER 28** Dalay Parrondo, Kelsey Hellebuyck, and Caitlin Peabody of Boston Ballet were in their best form during a dress rehearsal of *The Nutcracker* at the Opera House. More than three hundred dancers, plus the trademark expanding Christmas tree, make up the production, which runs through the Christmas season. *The Nutcracker* has been the anchor of the Boston company's fall schedule for forty years. It moved to the Opera House in 2005 after many years at the Wang Theatre.

▶ **NOVEMBER 29** Crews from Cambridge Landscaping Company chased the leaves off the lush green lawns of the Harvard Business School.

▲ **NOVEMBER 30** Academy Award–winning actor Morgan Freeman had his makeup touched up to film a scene in the Public Garden. *The Lonely Maiden,* a comedy about three museum security guards who plot to steal back loaned masterpieces they have grown accustomed to, also stars Christopher Walken, William H. Macy, and Marcia Gay Harden. It was set to open in theaters in November 2008.

▲ **DECEMBER 1** Young riders could barely contain their excitement along the platform at South Station as they boarded the 2007 Citizens Bank Polar Express for its voyage to the "North Pole" at Gillette Stadium.

▶ **DECEMBER 2** Cardinal Séan Patrick O'Malley celebrated a mass at the Cathedral of the Holy Cross, not only to open the Advent season, but also to mark the bicentennial of the Boston archdiocese. The celebration was scheduled to close with a service at the Boston Convention & Exhibition Center on November 23, 2008, the Feast of Christ the King.

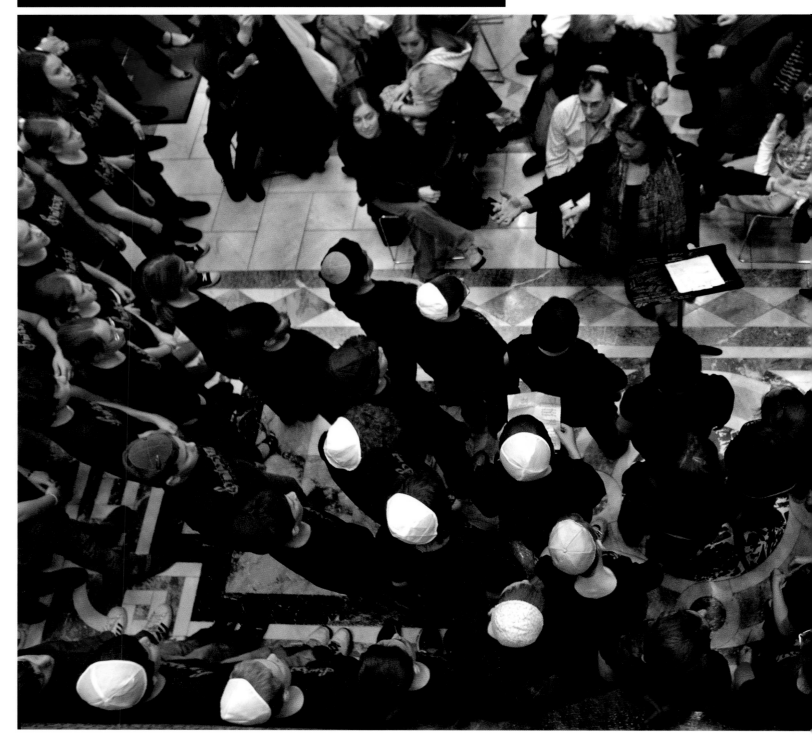

◀ **DECEMBER 3** The cheers of approval kept coming for Salvatore Ferragamo designer Massimiliano Giornetti following a runway show of his latest pieces for the famed Italian fashion house at the Institute of Contemporary Art. Some three hundred scored invites to the swanky soiree, which marked the museum's first year in its new home on the South Boston waterfront.

▼ **DECEMBER 4** Rabbi Rachmiel Liberman participated in a Menorah lighting ceremony in Nurse's Hall at the State House. Several synagogues from the area were represented as state officials, religious leaders of different faiths, and community groups were on hand to celebrate Hanukkah, the eight-day Jewish festival of lights.

▶ **DECEMBER 5** Even when the General Court of Massachusetts, the state legislature in general parlance, isn't in session or having a hearing, court officers keep a watchful eye over the historic State House. Here, House court officer Anthony Viveiros grabbed a quick word with House chief court officer Gene DiPersio in the State House chamber between sessions.

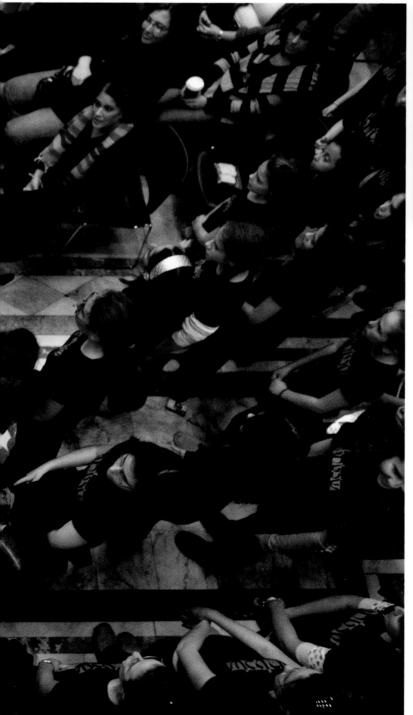

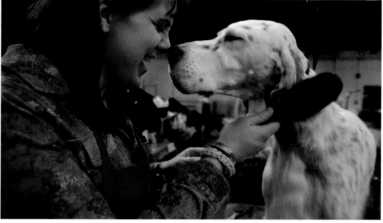

▲ **DECEMBER 6** All breeds and sizes of dogs from the Boston terrier to the English mastiff were on display and in competition at the Bay Colony Cluster Dog Show at the Bayside Expo. For many of the owners, groomers, and trainers, the canines are more than companions, and they often spend most of their free time traveling for shows.

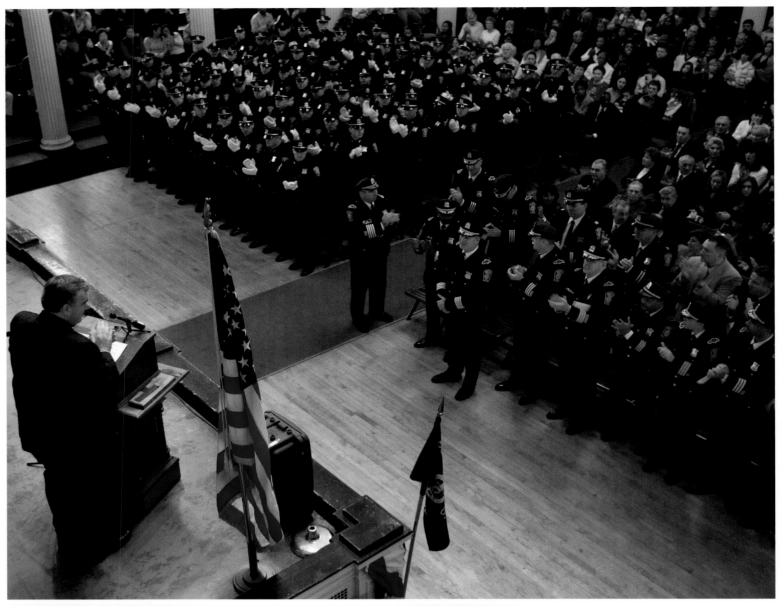

▲ **DECEMBER 7** Boston police superintendent John Gallagher received a standing ovation when it was announced at the Boston Police Department graduation ceremony in Faneuil Hall that Gallagher would be retiring after decades of service to the city.

◀ **DECEMBER 8** The trees lining the Commonwealth Avenue Mall have an additional season to show off their majesty, the holidays. City departments get the lights up and keep the park pathways clear for one of the more magical snowy walks in greater Boston.

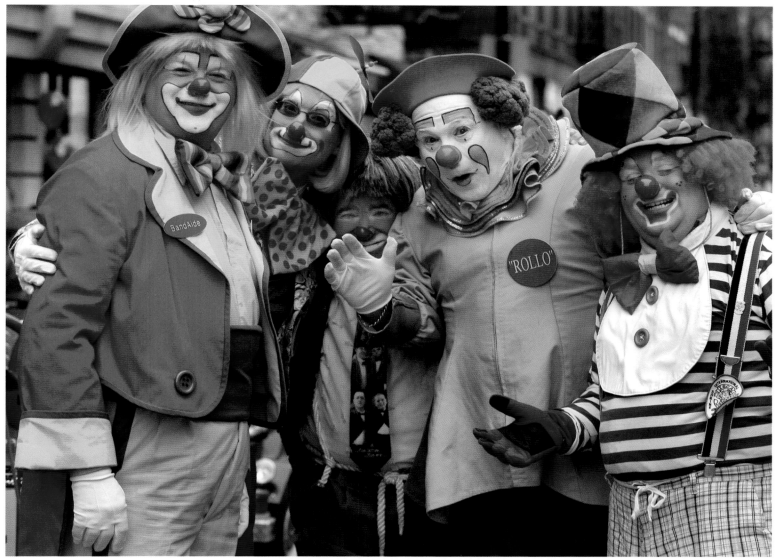

▲ **DECEMBER 9** These clowns took their job seriously at the North End Christmas Parade. Despite cold weather, thousands turned out for the thirty-seventh parade, an event that boasts it is the only one in the city where Santa Claus arrives by helicopter.

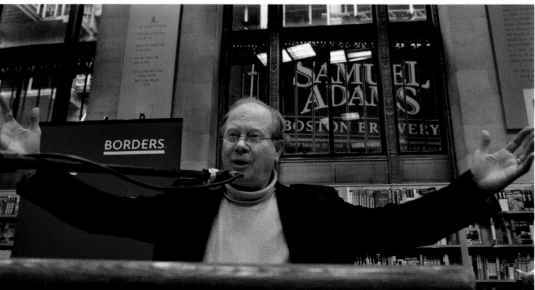

▲ **DECEMBER 10** Pulitzer Prize–winning author Joseph J. Ellis couldn't appreciate the passing endorsement he received as much as his audience at the Borders in Downtown Crossing did. The Mount Holyoke College history professor would be on tour for more than a year in support of his latest tome, *American Creation: Triumphs and Tragedies at the Founding of the Republic.*

◀ **DECEMBER 11** A woman sheltered herself from rain in the archway of the front doors of Boston University's Marsh Chapel.

▲ **DECEMBER 12** The LeeVees, a side project of Guster's Adam Gardner and the Zambonis' Dave Schneider, were the special guests of the Boston Pops Orchestra and maestro Keith Lockhart at the twenty-fourth "A Company Christmas At Pops" concert.

▶ **DECEMBER 13** The snowfall didn't break any records and the city's meteorologists got the forecast exactly right. Still, enough things went wrong during the afternoon that tens of thousands of people were stuck in hours of traffic that paralyzed the city. Some students didn't make it home from school until after 11 P.M.

▼ **DECEMBER 14** It was a night to make Isabella Stewart Gardner proud, a swish affair that is unlikely ever to be repeated. Fully decked out in their finest formal attire, famed mezzosoprano Frederica von Stade held the 150 gala guests in rapt attention at a dinner in the Gardner Museum. It was the last event to be held in the Tapestry Room until the museum completes a new addition.

■ **DECEMBER 15** Just because you live in the city, doesn't mean you don't have some of the region's best hills for sledding. Justine Frechette, Kate Donovan, Jean Bulger, and Kate Bulger enjoyed their downhill trip at Farragut Park in South Boston.

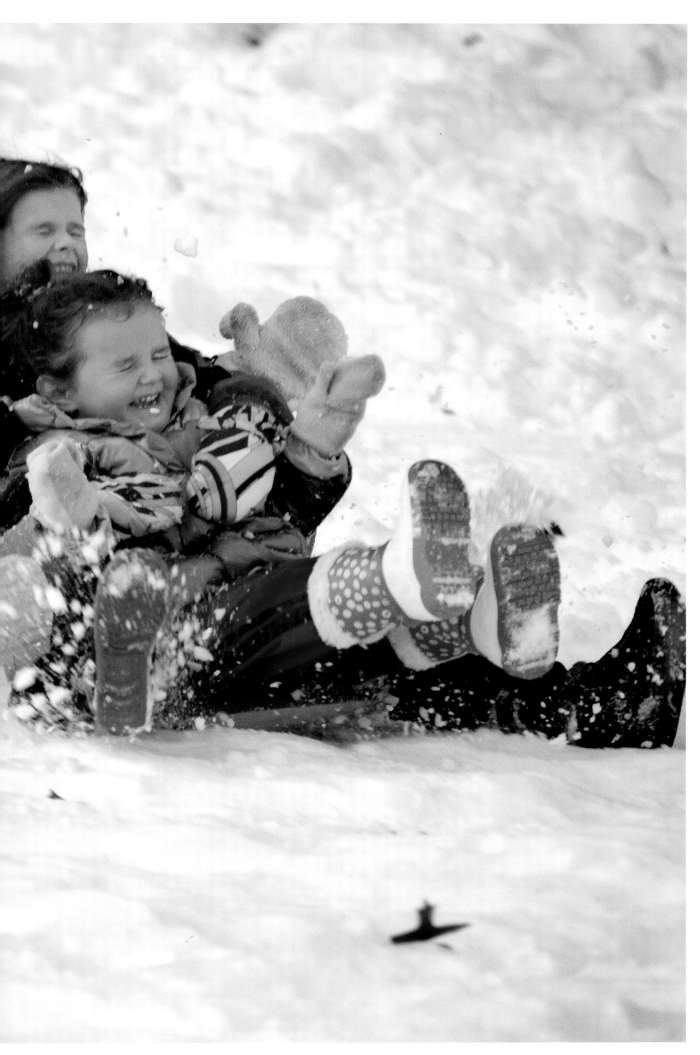

◀ **DECEMBER 16** More than a thousand volunteers lined up to hand out gifts to families arriving at the Bayside Expo Center for "Christmas in the City." Now in its nineteenth year, the annual party was started by Jake Kennedy and his wife, Sparky, to give homeless children a toy of their choice for the holiday. As it has each year, everything, including the buses to transport the families, is donated.

DECEMBER 17 It doesn't look like it, but there actually was enough space on the sidewalk carved out of the piles of ice and snow to allow a woman to walk on Boylston Street near Copley Square.

DECEMBER 18 Things were looking good for governor Deval Patrick's plan to build three resort casinos in Massachusetts when the hearing attendees in a packed Gardner Auditorium gave Patrick a standing ovation after he spoke. The day included seven hours of testimony, including Patrick who invoked the country's forefathers in making the case for casinos: "In 1762, John Hancock raised lottery money to rebuild Faneuil Hall after a fire. Lottery funds were used to finance the Revolution."

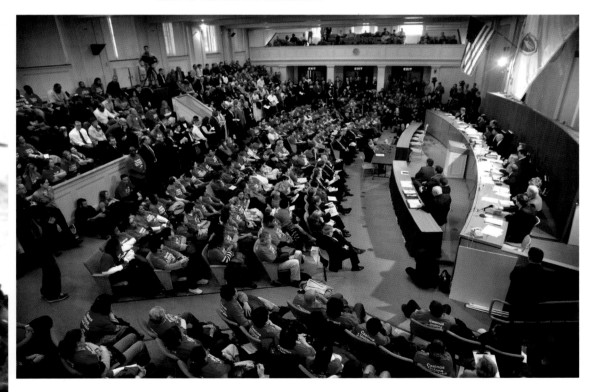

DECEMBER 19 The Boston Police Department's mounted unit earned a salute from a passerby on Boston Common.

■ **DECEMBER 20** It's hard to tell who's enjoying this snowy outing at the Arnold Arboretum more, Adam Schatten or the dogs in his charge. Schatten has jerry-rigged the leashes so that he can get a little help down the hill from Baumont, Taz, Lucy, and Ripply.

◄ **DECEMBER 21** An arriving traveler at Terminal D at Logan International Airport searched patiently for his luggage. Since the construction on this terminal was completed in early 2008, it has been referred to as part of Terminal C.

◄ **DECEMBER 22** Shortly after his death at age eighty-seven, former city councilor Albert "Dapper" O'Neil was remembered with flowers at a mural showing Dapper (left) with his hero and mentor, former Boston mayor James Michael Curley. The mural was painted on the wall of the West Roxbury Pub & Restaurant, near the Gormley Funeral Home, where the bombastic and beloved O'Neil was waked.

▶ **DECEMBER 23** Five-year-old Jack Gavin and his sister Alla, three, joined a holiday window display at the Greenhills Irish Bakery on Adams Street in Adams Corner.

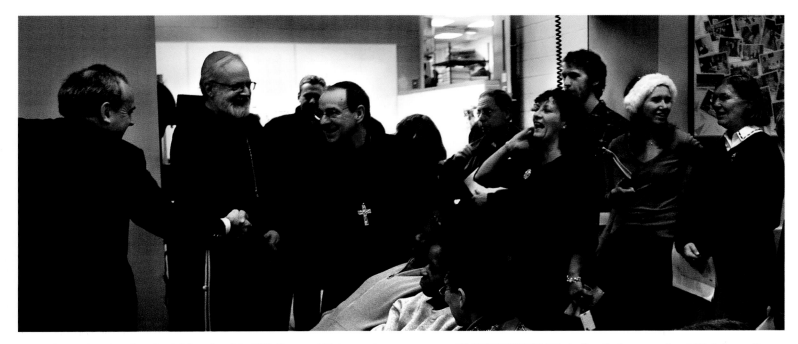

▲ **DECEMBER 24** Cardinal Séan Patrick O'Malley and Episcopal bishop the Right Reverend M. Thomas Shaw visited with the staff and volunteers at the Pine Street Inn before they rolled up their sleeves and helped set the tables for the homeless shelter's holiday meal.

▼ **DECEMBER 25** In the first moments of Christmas Day, at midnight mass, the choir in the former St. Margaret's Church, now the Blessed Mother Teresa of Calcutta Church in Dorchester, launched into a holiday hymn.

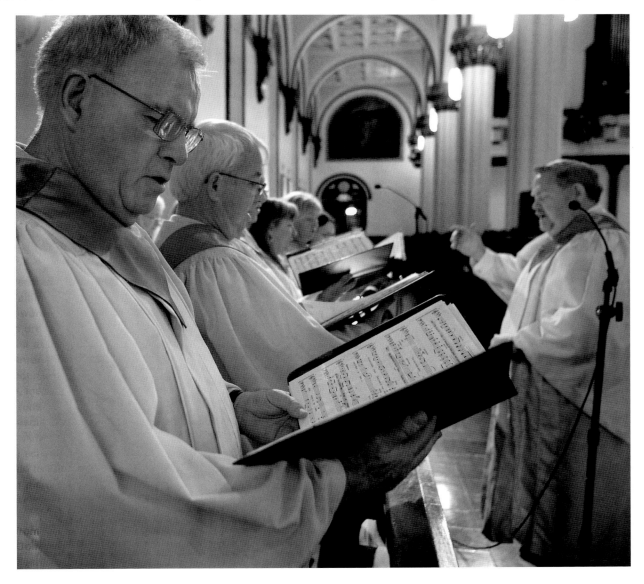

▲ **DECEMBER 26** The Zamboni hadn't yet completed refinishing the ice at the Frog Pond rink on Boston Common when young skaters made a break for the fresh, glassy surface.

▲ **DECEMBER 27** Lucilla Chan of Brighton enjoyed herself at the city New Year's party at the Seaport World Trade Center on the South Boston waterfront.

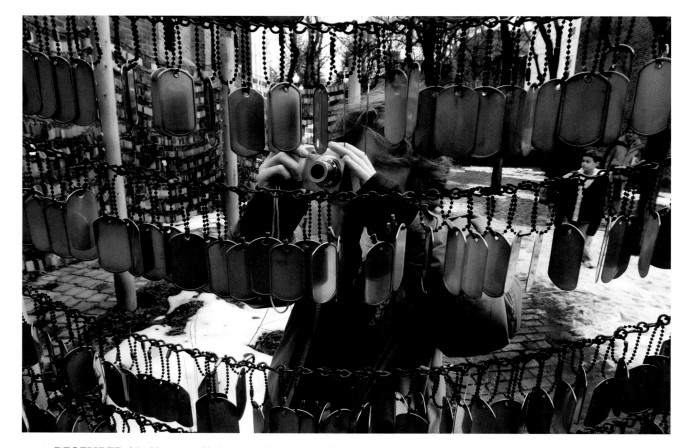

▲ **DECEMBER 28** Margaret Mohaney, who came to Boston for the day from Rhode Island, took a photograph of the Memorial Garden, a display of dogtags in Paul Revere Park in the North End. The traveling exhibition was created to honor civilians and those in the armed forces who have died in the Afghanistan and Iraq wars.

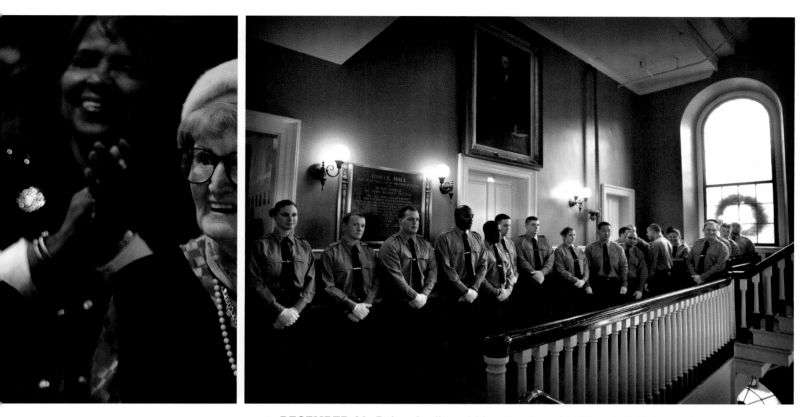

▲ **DECEMBER 29** Before family and friends gathered in Faneuil Hall, twenty-five new emergency medical technicians were welcomed into the ranks of the city's emergency medical services department. Four EMTs and paramedics were promoted to the rank of lieutenant at the ceremony, which marked another milestone for the department. By this date, Boston EMS paramedics and EMTs had answered their hundred-thousandth medical emergency call.

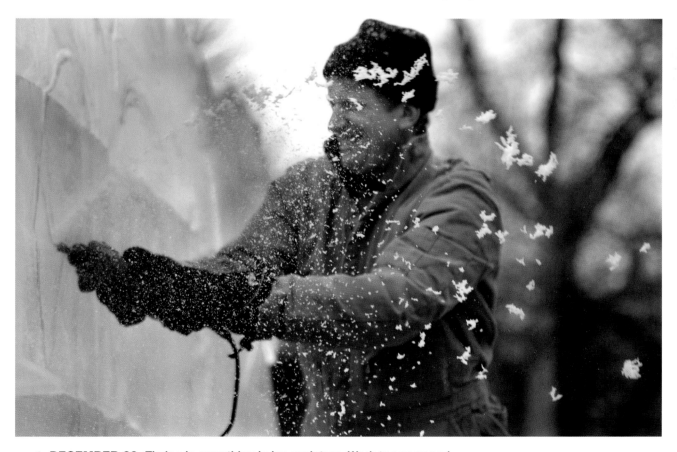

▲ **DECEMBER 30** Timing is everything in ice sculpture. Work too soon and Mother Nature may alter or destroy your handiwork. Wait too long and you risk that your masterpiece won't be ready in time. One thing is true regardless of the conditions outside: The ice artwork on Boston Common is as much a part of First Night as the parade.

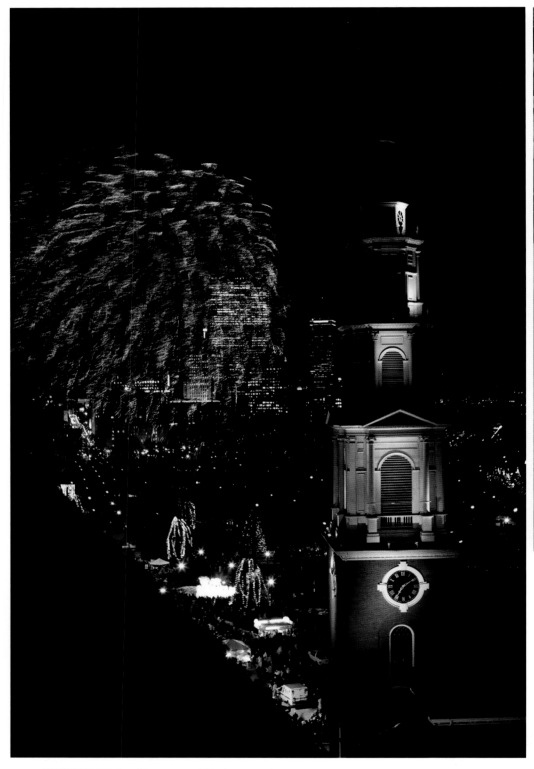

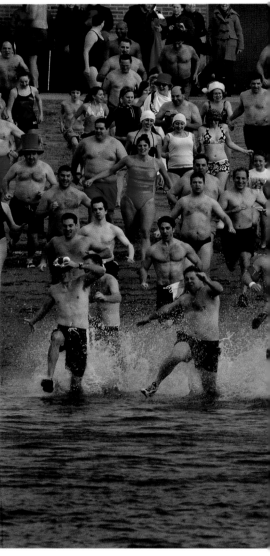

▲ **JANUARY 1** More than five hundred brave souls took part in the L Street Brownies' annual plunge in Boston Harbor. One of Boston's best-known rituals, the New Year's Day dip was the 104th such outing for the South Boston organization, which also uses the day's events to raise money for local scholarships. Swimmers, who were photographed from a Boston police boat in the harbor, caught a bit of a break: the temperature hit a high of 38 before snow and rain arrived midday.

▲ **DECEMBER 31** They were billed as the Children's Fireworks, but the early pyrotechnic display over the Boston Common as part of Boston's First Night celebration attracted as many adults as it did those too young to stay up for the late-night show over Boston Harbor.

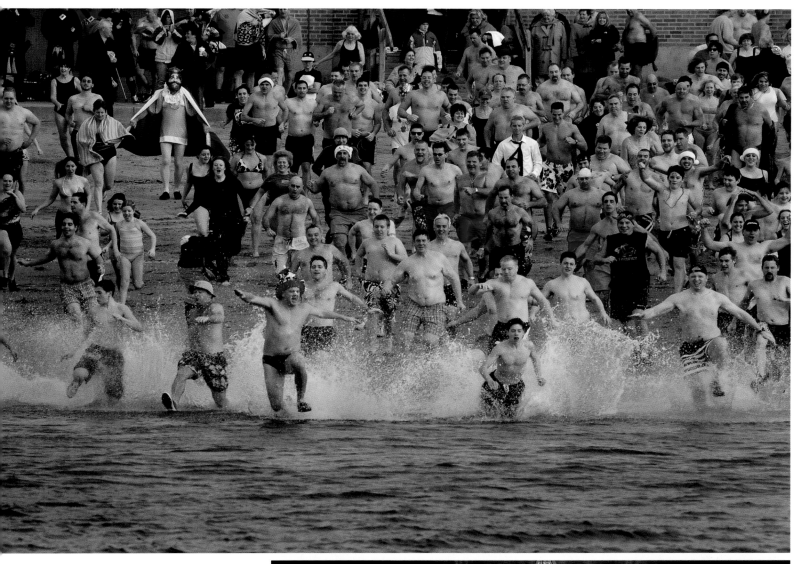

▶ **JANUARY 2** The 30,000-square-foot, High Victorian–style Charlestown Five Cent Savings Bank building in Thompson Square is a favorite of photographers, fans of architecture, neighborhood residents, and tourists. The office building, constructed in the mid-1870s, retains much of its stateliness inside, where few get a chance to poke around. The Charlestown bank is now part of Citizens Bank.

JANUARY 3 Steep steps, uneven floors, low ceilings, and narrow doorways are all regular parts of a Boston moving company's daily repertoire. This mover didn't need any help carrying a piece into a home on Massachusetts Avenue near Tremont Street, at the Roxbury–South End line.

JANUARY 4 Boston firefighter Pat Foley of the department's Aerial Tower No. 3 walked along the roof of the former Hotel Eaton, a condominium complex ravaged in a fatal New Year's Eve fire. When the impressive red-brick building on South Boston's Emerson Street was operating as a hotel, it was serviced by a trolley line and served as the temporary home of notable Bostonians, including Babe Ruth when he pitched for the Red Sox.

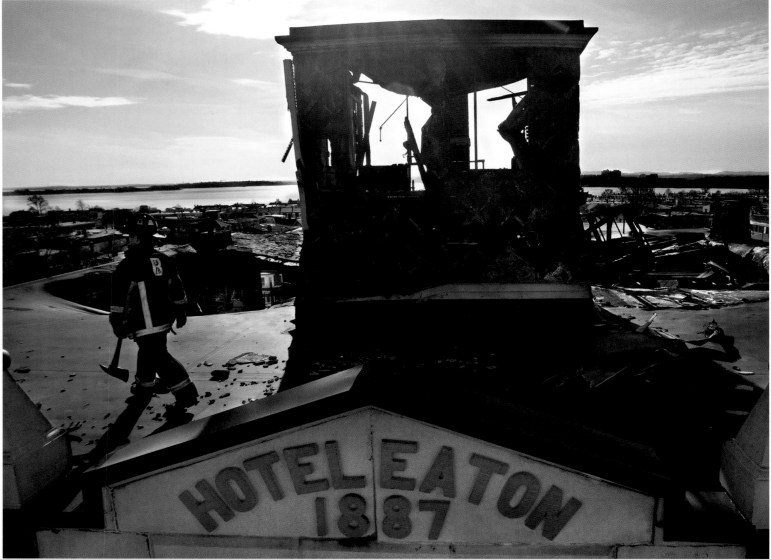

JANUARY 5 New York Yankees general manager Brian Cashman was on the hot seat at the Hot Stove, Cool Music roundtable at Fenway Park. The question was, which major league team would sign free-agent pitcher Johan Santana? But it was all in good fun with the event's host, Red Sox general manager Theo Epstein (left), and his Toronto Blue Jays counterpart, J.P. Ricciardi, at the baseball chat held to raise money for Epstein's Foundation to Be Named Later.

JANUARY 6 For South End residents traveling on Washington Street, protests in front of the Cathedral of the Holy Cross are a familiar sight. From prolife to prochoice, from those fighting parish closures to advocates for victims of abuse, the front doors of the cathedral have become a town square for debates about the modern Roman Catholic Church.

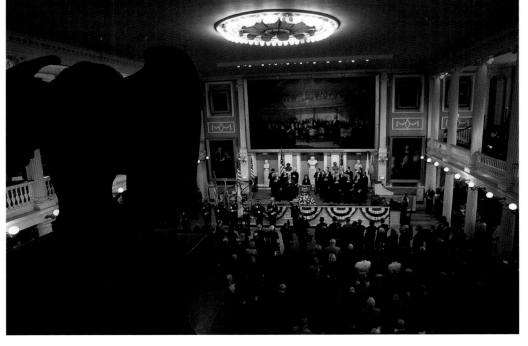

JANUARY 7 Mayor Thomas M. Menino swears in the Boston City Council at a ceremony in Faneuil Hall. The council welcomed two new members, Mark Ciommo, representing the Allston-Brighton district, and At-Large Councilor John Connolly.

◀ **JANUARY 8** Actor Josh Brolin joined Boston University professor Howard Zinn on stage at Emerson College's Cutler Majestic Theatre after the first of four tapings for a film version of Zinn's book *A People's History of the United States.* Also participating in the readings produced by Chris Moore and to be turned into a movie by Dan Fireman's Artfire Films were Danny Glover, Viggo Mortensen, David Strathairn, Marisa Tomei, Mike O'Malley, and Jasmine Guy.

▼ **JANUARY 9** A pair of red-tailed hawks washed off in the lagoon at the Boston Public Garden. These birds of prey, and others, have made downtown parks their home and can often be seen feeding on pigeons and squirrels they hunt in the area.

JANUARY 10 The quietness of the Copley Square MBTA Green Line station for westbound trains stood in stark contrast to its sister station across the street, where construction crews were working, often overnight, to upgrade the trolley lines.

JANUARY 11 Meritage chef Daniel Bruce was right in his element at the opening night fête for the nineteenth Food and Wine Festival at the Boston Harbor Hotel. Bruce is credited with being the wine-festival pioneer in Boston.

JANUARY 12 Flynn Patrick Foley was baptized by Monsignor Thomas J. McDonnell at the St. Augustine's Cemetery Chapel in South Boston. Ava Foley's baby brother may not have known it, but he has impressive Boston bloodlines with a few stories to brag about when he's older. His mother is Maureen, daughter of former Boston mayor Ray Flynn and his wife, Kathy. The baby's proud dad is Michael, the son of J.J. Foley's owner Jerry Foley and his wife, Marianne. Flynn Patrick's godparents are Edward Flynn and Caitlin Foley.

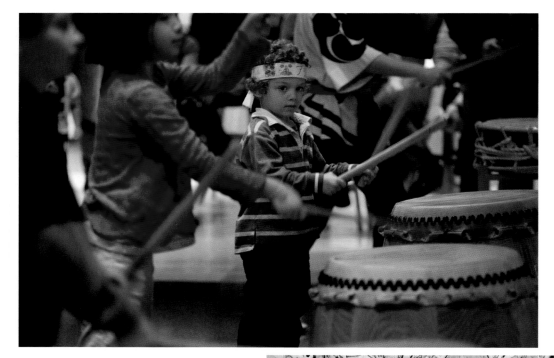

JANUARY 13 Ashur Carrasha tried his hand at some taiko drumming during a performance by Odaiko New England held at the Boston Children's Museum as part of the Japanese New Year celebration.

JANUARY 14 Most in the Hub might have wanted a break from the relentless winter, but the snow provided a great outing for this woman to go cross-country skiing along Jewish War Veterans Drive in Jamaica Plain.

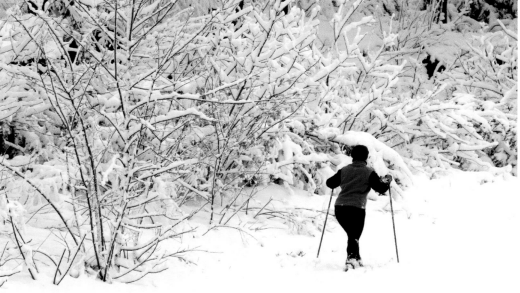

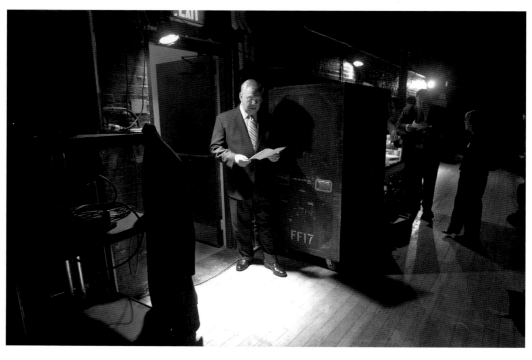

JANUARY 15 Mayor Thomas M. Menino took a few moments backstage at the Strand Theater in Dorchester to look over his State of the City address. When Menino took the stage, he promised a reduction in crime and new initiatives to link neighborhoods and communities.

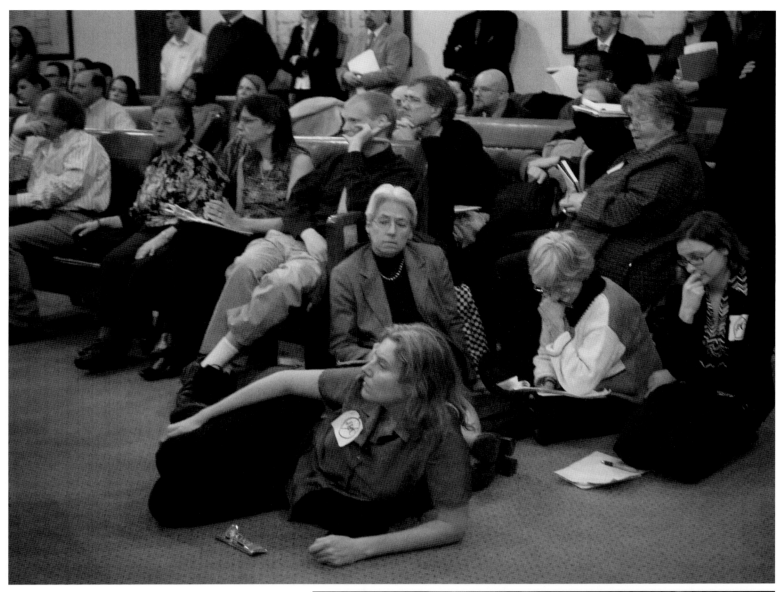

▲ **JANUARY 16** The hearing room at the State House was overflowing with people who wanted to be heard for and against the controversial Canton-based Judge Rotenberg Educational Center, the only school in the nation that uses skin-shock treatments as discipline.

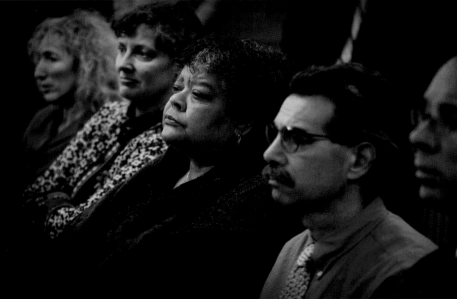

▲ **JANUARY 17** It was as if stories of Boston families having a hard time heating their homes and making ends meet foreshadowed bigger problems in the economy that would make headlines months later. When Senator Edward M. Kennedy convened a field hearing on fuel assistance at the Action for Boston Community Development's office on Tremont Street, the news was not good for those struggling to pay for heating oil while facing higher rents, increased food costs, and job losses in a tight economy.

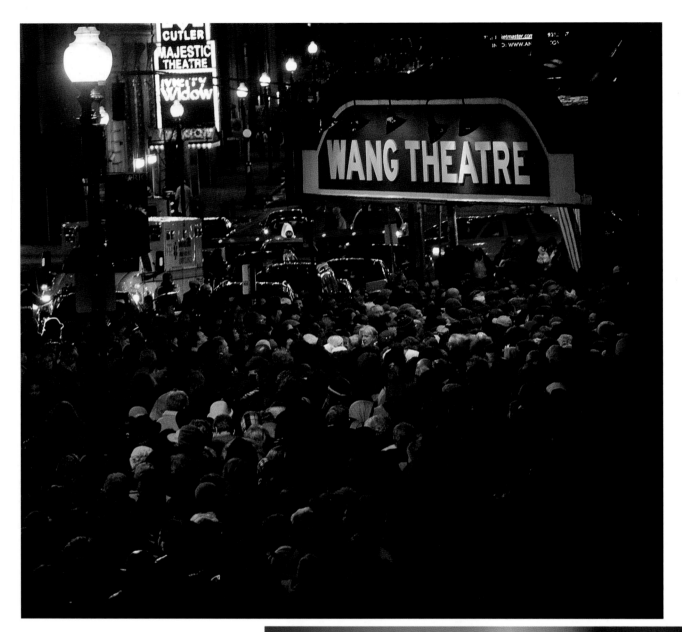

▲ **JANUARY 18** In an image harkening back to Boston's golden days as a theater town, a crowd gathered outside the Wang Theatre for a chance to hear Patti LaBelle sing at a concert that kicked off a weekend of events hosted by the City of Boston to commemorate the life and work of Martin Luther King Jr.

▶ **JANUARY 19** Members of the Hellenic Soccer Club on Poplar Street in Roslindale enjoyed a game of cards.

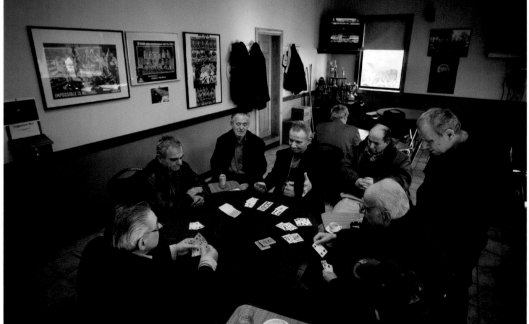

JANUARY 20 A jogger jaunted past the statue on Commonwealth Avenue Mall for Phillis Wheatley, an eighteenth-century African-American poet who came to the United States as a slave. Through her writing, Wheatley won her freedom, was accepted into her white family, and challenged the nation to reject slavery.

JANUARY 21 Rev. Dr. Zan Wesley Holmes Jr. delivered the keynote address at Boston's annual breakfast held to commemorate the life and legacy of the Reverend Dr. Martin Luther King Jr., who studied at Boston University. The gathering, held at the Boston Convention and Exhibition Center, was sponsored by Union United Methodist Church of the South End and St. Cyprian's Episcopal Church in Roxbury.

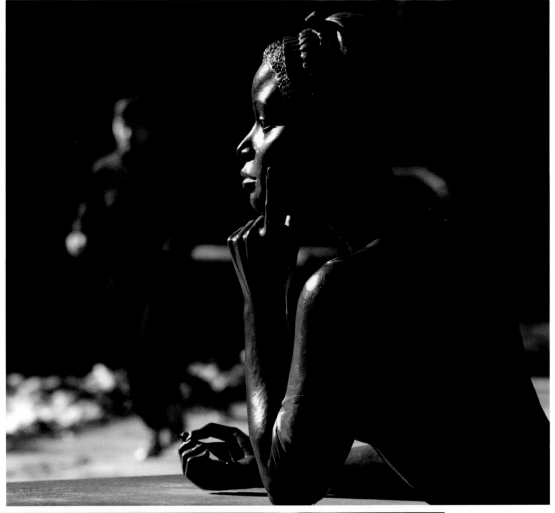

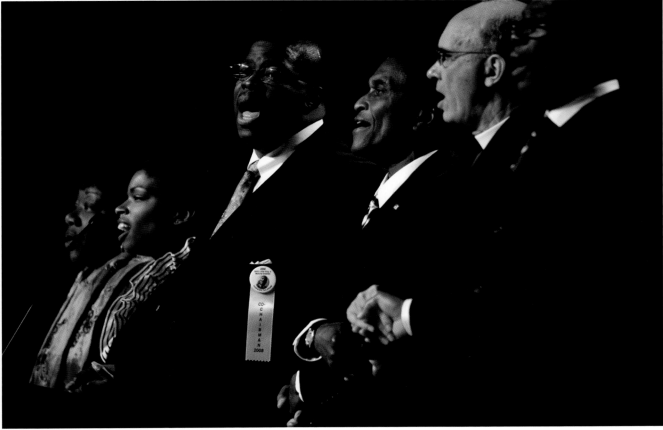

◄ **JANUARY 22** Copley Square is almost as famous for its windy gusts as for the architecture that's often blamed for causing them—as this woman may have been reminded while walking on Clarendon Street.

JANUARY 23 Massachusetts attorney general Martha Coakley and U.S. attorney Michael J. Sullivan announced the $450 million settlement involving Bechtel/Parsons Brinckerhoff, the consortium that oversaw the design and construction of the Big Dig, and several smaller firms that worked on the project. The announcement was seen as a major milestone for the state and ended several legal battles over tunnel leaks and a fatal ceiling collapse.

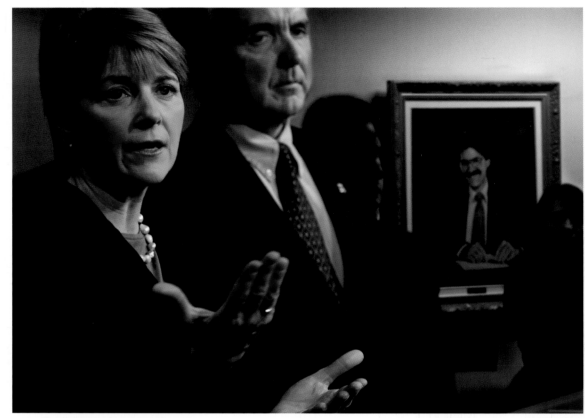

▲ **JANUARY 25** A two-man crew from Cubknoll Crane Service of Woburn prepared to work on the tallest building on a stretch of Beacon Street, at Berkeley Street, in the Back Bay.

▲ **JANUARY 24** Regimented shelves of books fill one of the rooms of the Johnson Building of the Copley Square Main Branch of the Boston Public Library, the country's first free urban library.

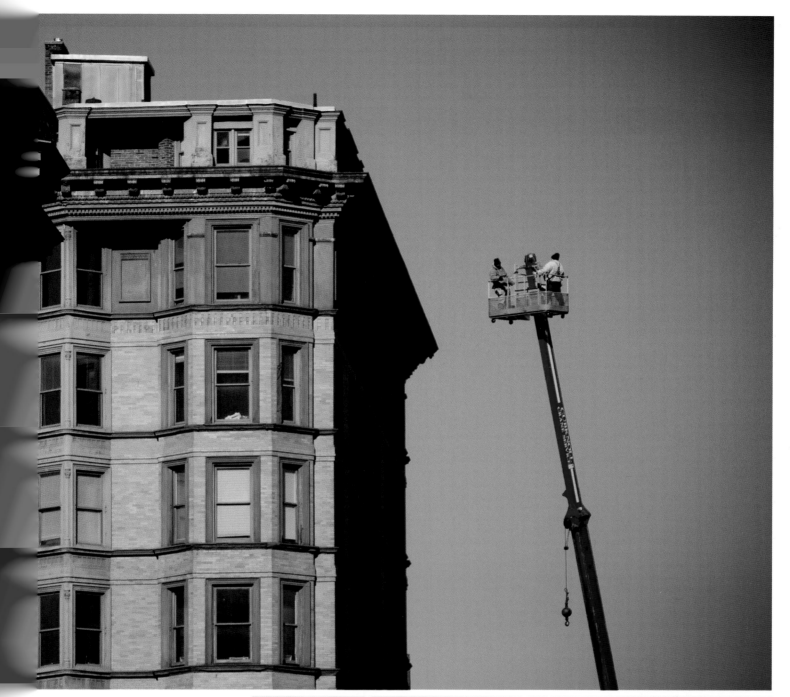

JANUARY 26 The prospect of having their heads shaved or being asked to play mental patients didn't deter several thousand people from turning out for an open casting call at Boston University's George Sherman Union for Martin Scorsese's feature film adaptation of Dennis Lehane's novel *Shutter Island.* The movie, now called *Ashecliffe* and starring Leonardo DiCaprio, Michelle Williams, Ben Kingsley, and Mark Ruffalo, was expected to open in theaters in late 2009. Crews shot for three months in greater Boston; among other locations, they used an industrial area in Taunton as a Nazi concentration camp and the former Medfield State Hospital as an asylum for the criminally insane.

JANUARY 27 Alaska? No, just a snowy day at Pope John Paul II Park off Gallivan Boulevard, featuring dog sleds from Gregg Vitello's Brookfield company Northern Exposure. Vitello's son Bailey ran with a team as people enjoyed the day organized by the Boston Natural Areas Network.

JANUARY 28 If this plaque could talk, one wonders what tales it could tell of Downtown Crossing across from the Old South Meeting House, not far from what was once Newspaper Row and the former Filene's Department Store.

JANUARY 29 A noontime concert at King's Chapel, located at School and Tremont streets, is a welcome break for many in downtown. The fifty-year-old concert series is just one of many programs at King's Chapel, the first Unitarian church in North America. The church dates its musical roots to 1713, when King's Chapel became the first church in New England to acquire an organ.

JANUARY 30 Cards from customers lined the walks of Camile Beauge's tiny tailoring and alterations shop, which has operated in the basement of 15 Court Square more than thirty years.

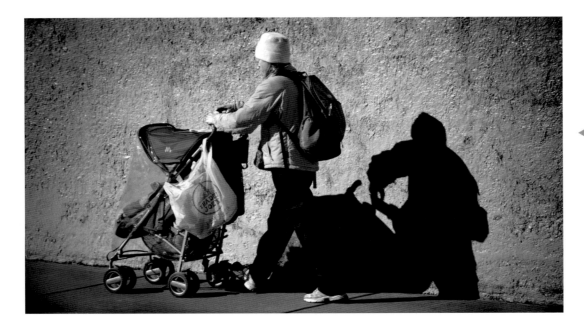

◀ **JANUARY 31** A woman pushed a baby carriage on Huntington Avenue near Francis Street at Brigham Circle.

▼ **FEBRUARY 1** When Oscar-winning actor Forest Whitaker and his wife, Keisha, a North Shore–born actress who has created her own cosmetics line, hit the posh party at Mantra in Downtown Crossing to celebrate the new edition of *Boston Common* magazine, they worked the crowd and greeted well-wishers well into the night. The two met while filming *Blown Away,* in which they played, conveniently enough, a couple.

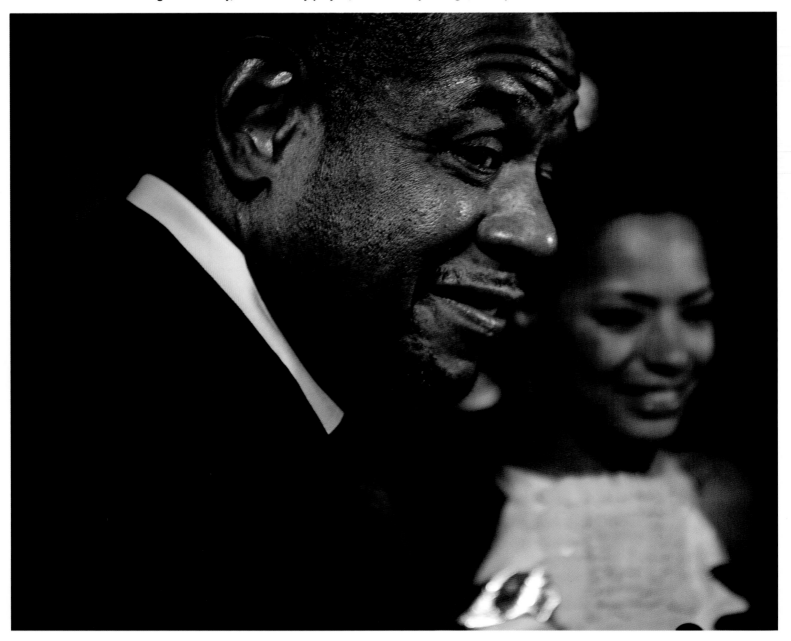

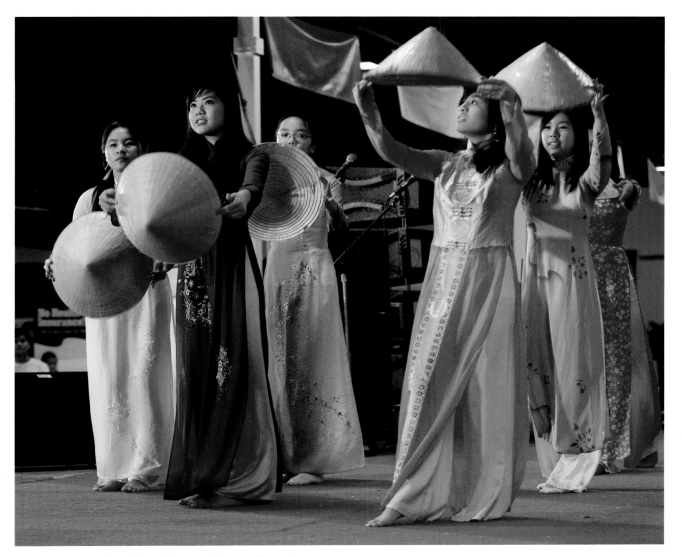

▲ **FEBRUARY 2** More than ten thousand people attended the thirty-seconnd Tet in Boston Festival at the Bay Side Expo Center to celebrate the Vietnamese lunar new year. Organized by the Vietnamese American community of Massachusetts, the event brought together thirty-six independent organizations and nineteen colleges and universities.

FEBRUARY

▶ **FEBRUARY 3** The New England Patriots in Super Bowl XLII was enough to pack every watering hole in Boston, but for the crew at the Quiet Man Pub & Restaurant the day was bittersweet. That wasn't just because of the unfortunate outcome of the game. The Sunday gathering was the last hurrah for the bar, located at the Broadway MBTA station in South Boston, which closed to make way for a residential development.

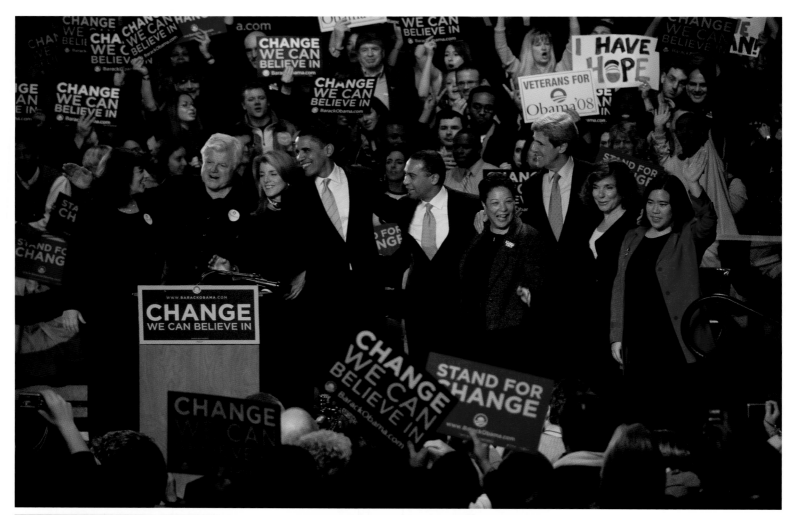

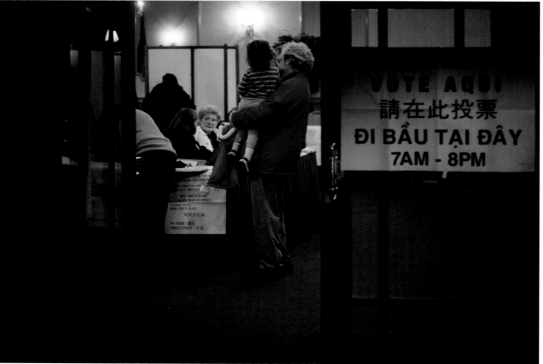

▲ **FEBRUARY 4** Supporters thronged the Seaport World Trade Center as some of the biggest names in the Bay State's Democratic Party delegation turned out to support presidential hopeful Barack Obama. Among those giving the Illinois senator their backing were senator Edward M. Kennedy and his wife, Victoria; Caroline Kennedy; governor Deval Patrick and his wife, Diane; senator John Kerry and his wife, Teresa Heinz Kerry; and Lisa Wong, mayor of Fitchburg.

▲ **FEBRUARY 5** Super Tuesday, the biggest day in the national presidential nominating process, meant a steady voter turnout at the polls, including Florian Hall on Hallet Street in Dorchester. The hall, run by Local 718 of the International Association of Firefighters, is a favorite place for many area families hosting a "time."

FEBRUARY 6
Stylist Pini Swissa put the finishing touches on Alicia Foley's hair as she prepared to leave for Bermuda for her marriage to Boston developer Arthur Winn, who seemed to beam with pride as he watched Swissa work his magic. A legal analyst, Foley brought along her dress to Swissa's eponymous salon for the test-run in preparation for the big day.

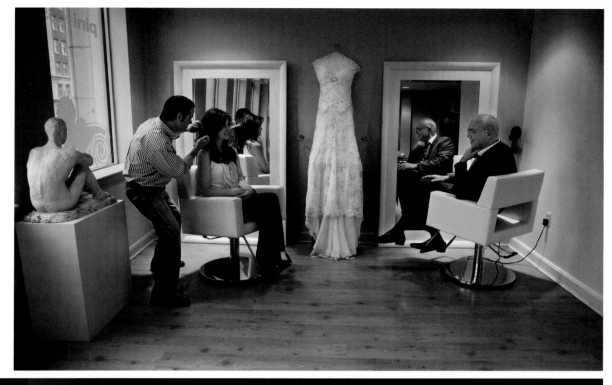

FEBRUARY 7 More than six hundred guests, many wearing shades of the theme color, attended the Go Red for Women Luncheon and Educational Forum, but Fox25 News anchor Maria Stephanos wore a stunning gold dress during the fashion show. Many of the leading ladies of Boston's television scene volunteered as models for the soirée held at the Westin Boston Waterfront Hotel.

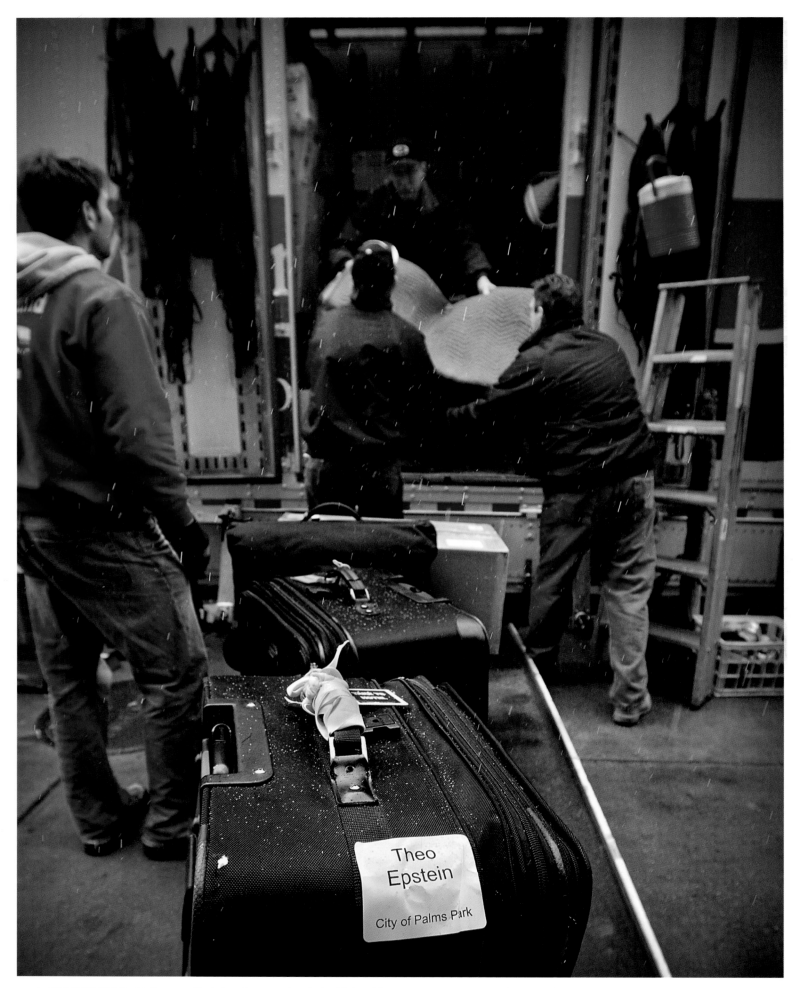

▲ **FEBRUARY 8** At Fenway Park trucks were loaded with Red Sox team gear to start the annual trek to spring training in Fort Myers, Florida. As the boxes and bags—with inscriptions such as "Manny No. 24 Florida" and "Minor Leagues"— were loaded, members of Red Sox Nation photographed the parade of handcarts before the caravan left Yawkey Way.

◀ **FEBRUARY 9** With her red dauber at the ready, Peg Senuta managed two dozen cards at one of the twice-weekly bingo games held in the parish hall of St. Vincent Roman Catholic Church on E Street in South Boston. Five parishes in the neighborhood still host weekly bingo sessions, once a staple of parish life and fundraising throughout the city.

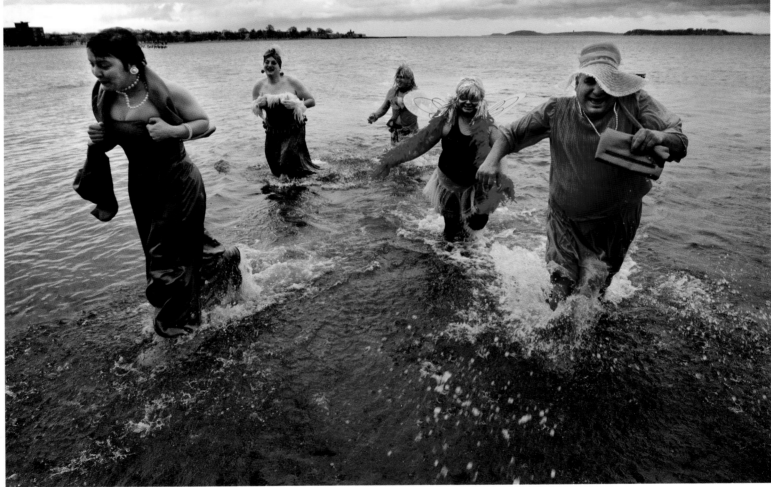

▲ **FEBRUARY 10** It's not every day that a group of drag queens run into the water at Carson Beach, but this cold-weather dip was to raise money and awareness for the Gay Men's Domestic Violence Partnership. The organization provides a twenty-four-hour hotline, emergency safe homes, legal advocacy, support groups, and training to help victims and survivors of domestic violence.

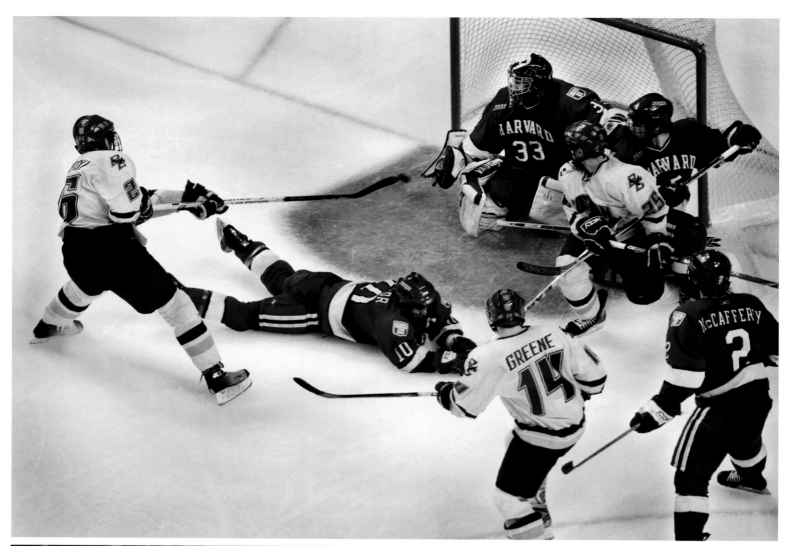

▲ **FEBRUARY 11** Boston College freshman defenseman Nick Petrecki scored the winning goal, his second of the night and of his collegiate career, for an overtime win over Harvard to take its fourteenth Beanpot title. The yearly round-robin tournament, which debuted in 1952, features Boston College, Boston University, Harvard University, and Northeastern University on two Mondays in February before standing-room crowds at the TD Banknorth Garden.

▲ **FEBRUARY 12** To celebrate the opening of its newly expanded store in Copley Place, Louis Vuitton hosted a party for 250 followed by this dinner for 75 select guests in the Mandarin Oriental Hotel & Residences, still under construction at the time. Boston event planner Bryan Rafanelli set up what would have passed for a four-star boite in the basement of the building. The several-course meal was prepared by L'Espalier chef-owner Frank McClelland, whose restaurant would move from its Gloucester Street address to the hotel when it opened in the summer of 2008.

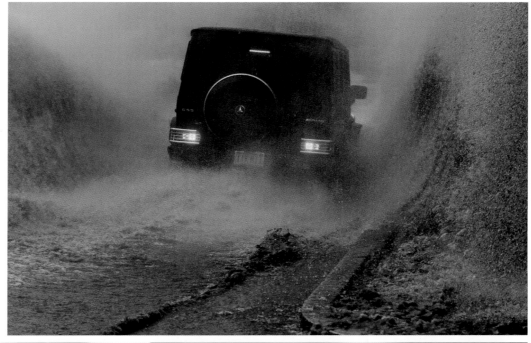

▶ **FEBRUARY 13** A driver seemed determined to test the limits of his SUV as he stormed through a flooded Storrow Drive near David Mugar Way.

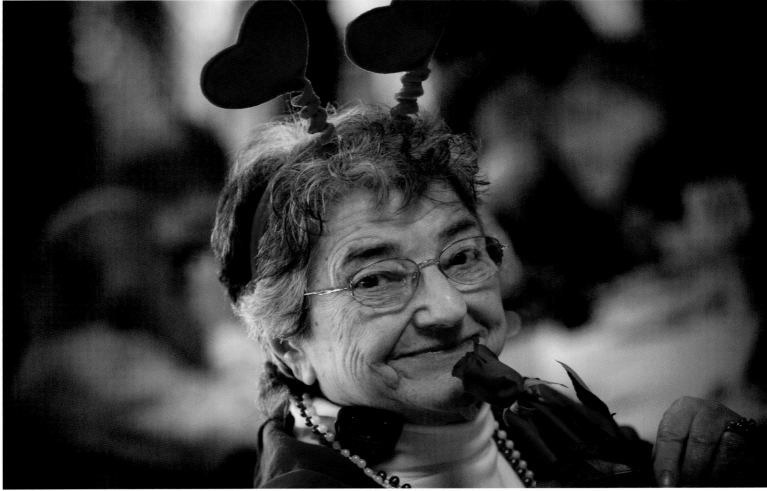

▲ **FEBRUARY 14** Suzanne Palma enjoyed her time at the Valentine's Day party at the Suffolk Downs Clubhouse hosted by the city's elderly commission. The 2008 theme, "Love's a Gamble: What Makes it Last?" gave attendees a perfect excuse to share stories with writers from Grub Street putting together a memoir of elder residents in collaboration with the city.

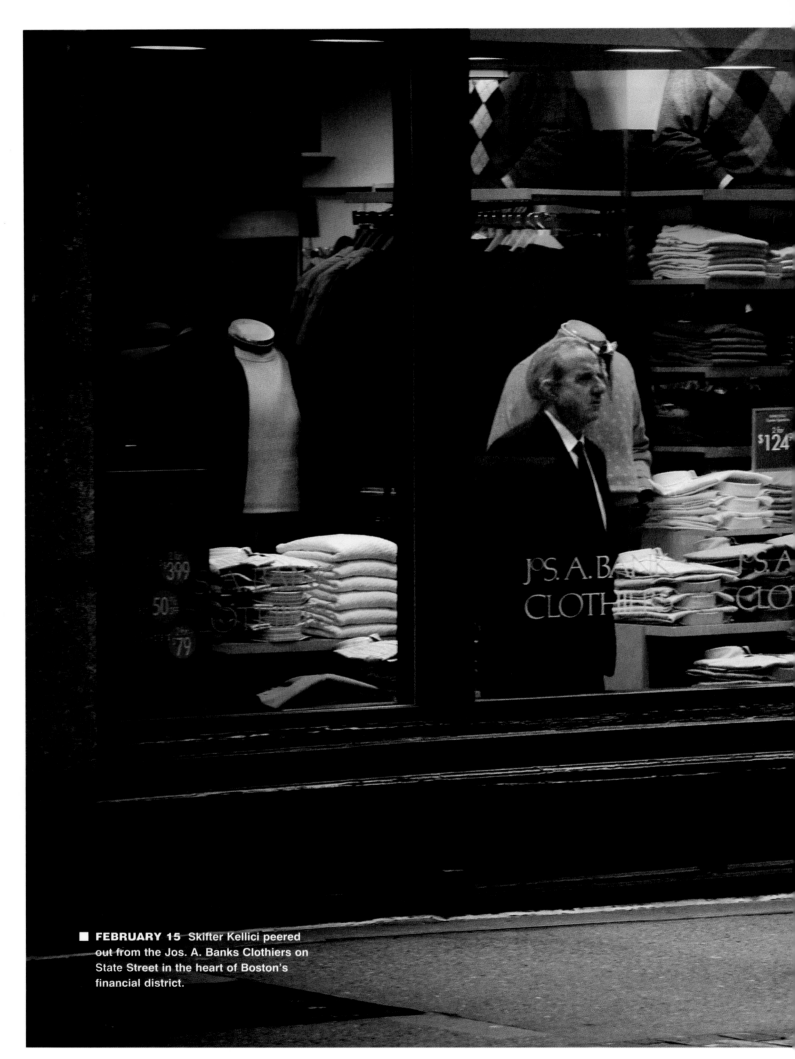

FEBRUARY 15 Skifter Kellici peered out from the Jos. A. Banks Clothiers on State Street in the heart of Boston's financial district.

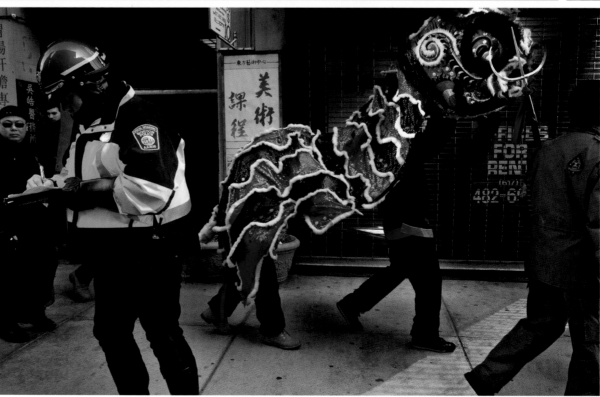

▲ **FEBRUARY 16** The sign for the historic Union Oyster House can be seen clearly from Hanover Street in the North End, but it wasn't always that way. For many years, the area around the Faneuil Hall Marketplace was blocked from view by the elevated John F. Fitzgerald Expressway.

▶ **FEBRUARY 17** John Ridlon, an officer with the motorcycle squad, wrote a traffic citation in Chinatown seemingly not noticing a dragon passing behind him and heading off to join the daylong Chinese New Year celebration.

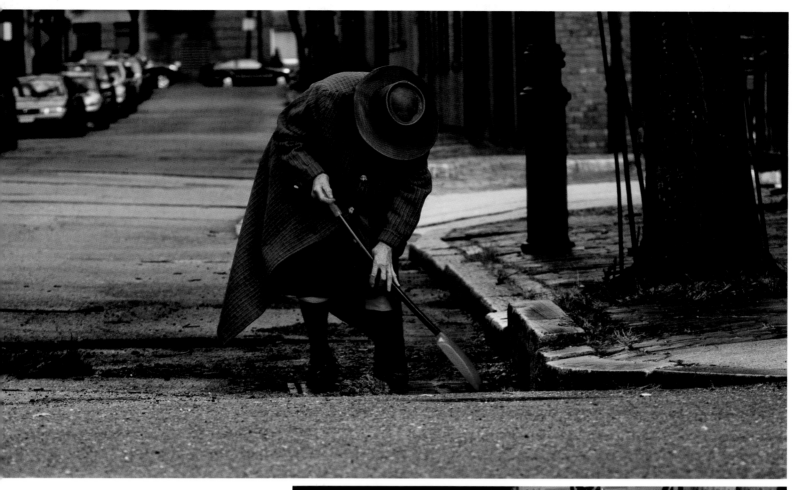

FEBRUARY 18 As she has for nearly every day of the fifty years she has lived in Bay Village, eighty-six-year-old Irene Burns cleaned up her corner of Winchester Street.

FEBRUARY 19 State Police lieutenant Ed Horton led the Massachusetts State Police pipe and drum contingent as Korean War veteran Michael Robbins paid his respects during an Iwo Jima Day celebration. Among those marching in front of the State House were Marines from the 25th regiment out of Fort Devens.

▲ **FEBRUARY 20** A couple of young people peered into one of the fifty-two windows lining the 200,000-gallon tank as a school of fish passed by. The three-story tank is the focal point of the New England Aquarium's main building on Central Wharf.

◀ **FEBRUARY 21** Matthew McConaughey playfully made a face as some of his fans called out to him during a cold and windy day on South Street near South Station. McConaughey and his costar Jennifer Garner filmed scenes throughout the region for several weeks for their romantic comedy *The Ghosts of Girlfriends Past.*

▼ **FEBRUARY 22** A man smoked a pipe as he tried to stay out of the raw weather while waiting for a bus in Haymarket Square.

▶ **FEBRUARY 23** A couple hundred contestants waited inside a ballroom at the Park Plaza Hotel & Towers to audition for a spot on "America's Next Top Model." The staff of the CW show, starring Tyra Banks, was so strict they would not allow the girls to speak to anyone, to give out their names, or even to comment on how they thought their interview went.

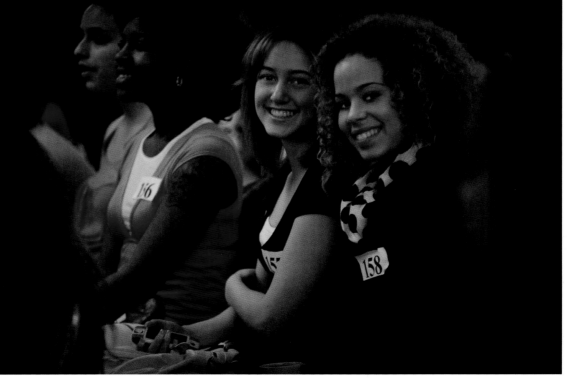

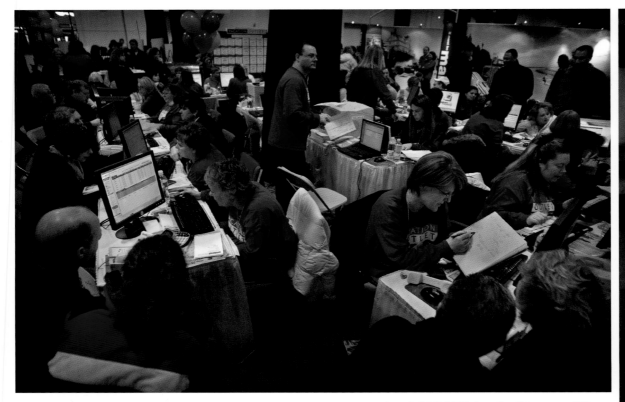

FEBRUARY 24 The crew from Vacation Outlet in Woburn was working hard so that dozens of people could get a great get-away during the third annual Boston Globe Travel Show at the Seaport World Trade Center.

FEBRUARY 25 For fifty years Bill Downey has come to Joe Monahan's barbershop on Hyde Park Avenue in Jamaica Plain.

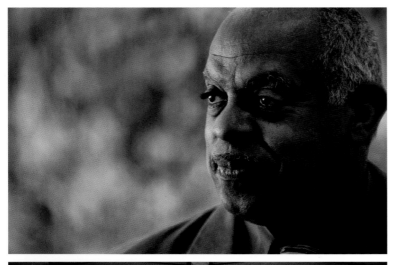

FEBRUARY 26 Director and curator of the Museum of the National Center of Afro-American Artists and special consultant to the Museum of Fine Arts, Edmund Barry Gaither was at the University of Massachusetts Boston as part of the school's Black History Month program.

FEBRUARY 27 While the image of ornately decorated double doors on red brick houses makes many think of Beacon Hill, these homes are on East Broadway across from Marine Park in South Boston. They appear ready for any occasion.

FEBRUARY 28 A Jet Blue airplane almost looked as if it was going to land on the houses along East Broadway at Farragut Road in South Boston.

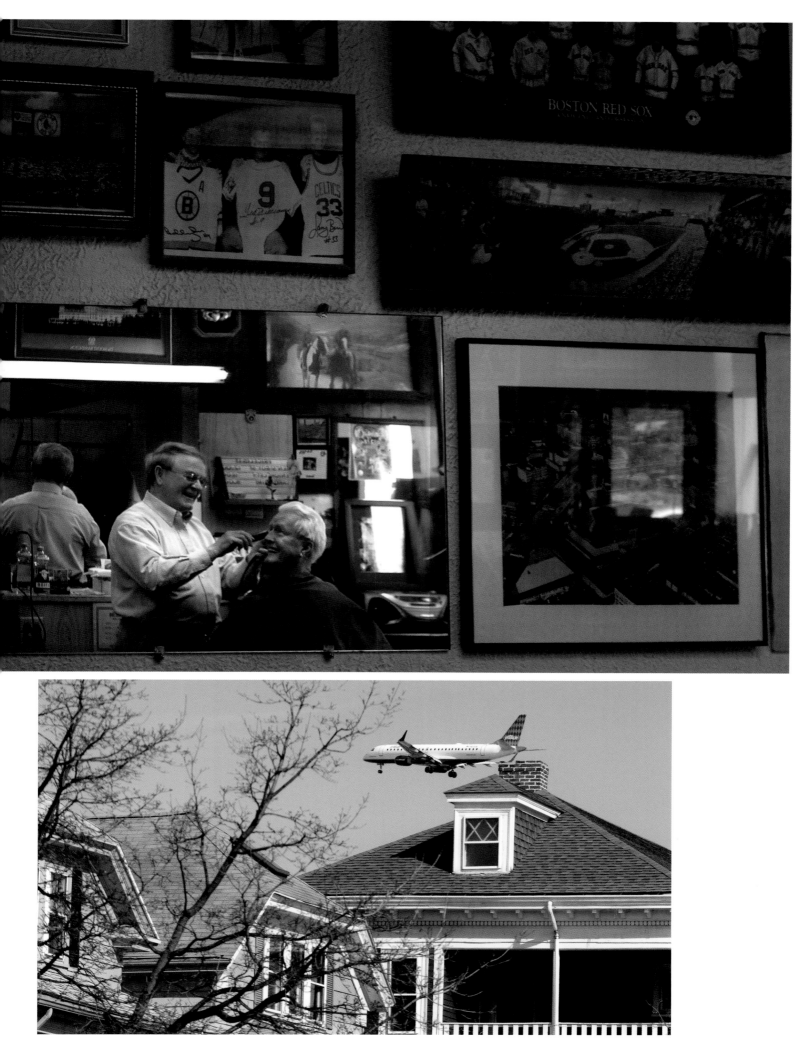

■ **FEBRUARY 29** By the afternoon, Mount Auburn Hospital had five Leap Year Day babies, all of them boys: Henry Thompson, Benicio Curcio, Drew Anderson, Maxence Grosclaude-Evans, and Orion Haile.

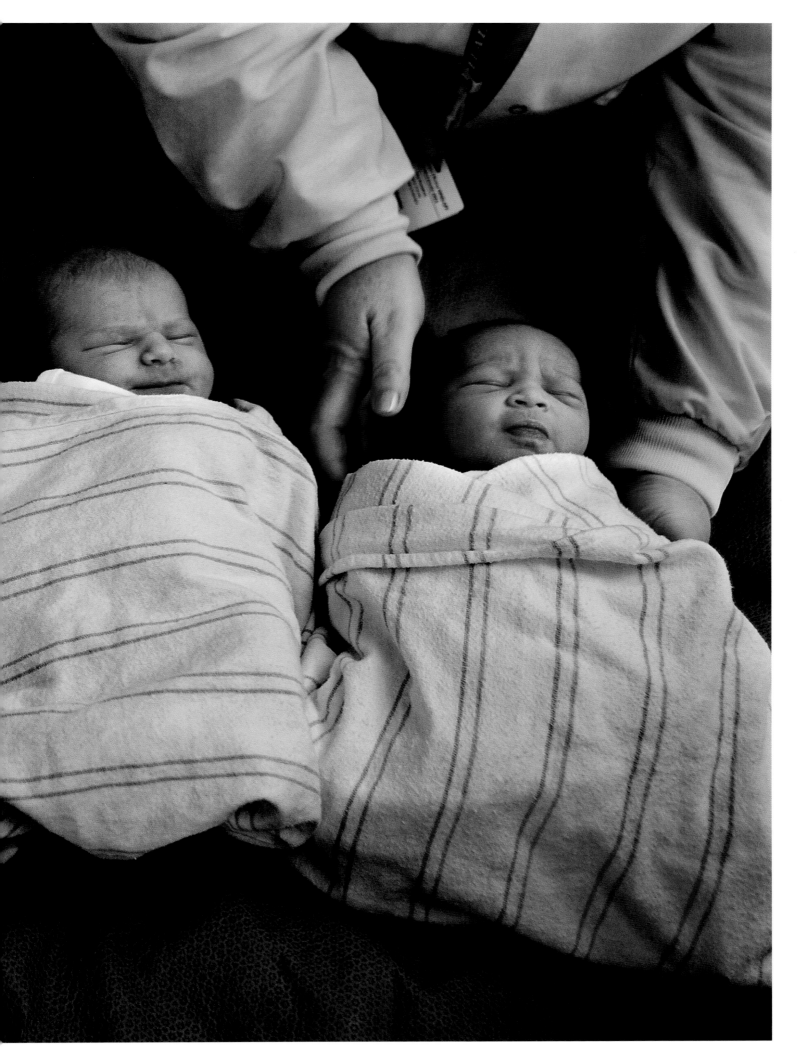

MARCH

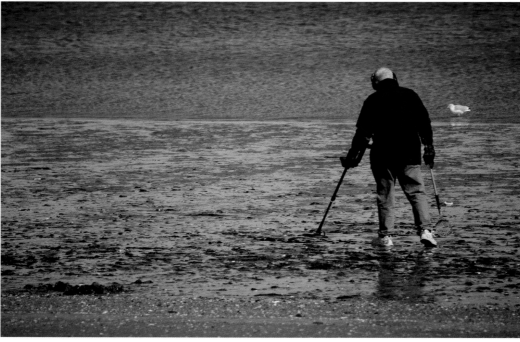

▲ **MARCH 1** Darius Rucker led his band, Hootie & the Blowfish, through a performance for a lavish private party at the Park Plaza Castle, held to celebrate a fortieth birthday.

◄ **MARCH 2** At low tide on Carson Beach, a man spent several hours scouring the sands with his metal detectors, looking for anything that might have been left behind or, more likely, washed ashore.

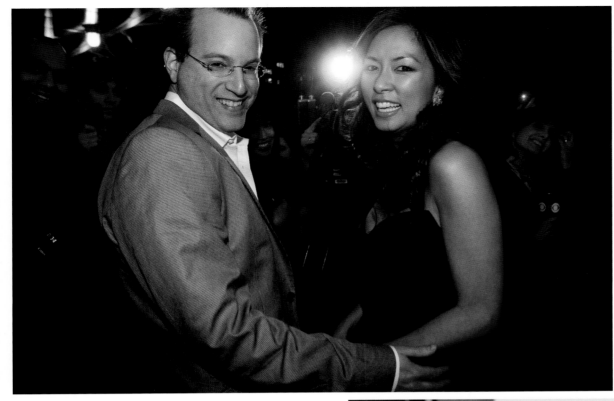

MARCH 3 Bestselling author Ben Mezrich and his wife, Tonya, arrived on the red carpet at the AMC Loews Boston Common for the Boston premiere of the movie *21.* Based on Mezrich's *Bringing Down the House: The Inside Story of Six M.I.T. Students Who Took Vegas for Millions,* the film was shot in Boston and Las Vegas in 2006 and starred Kevin Spacey, Kate Bosworth, and Jim Sturgess. Based on the box office success, Spacey and his team have optioned three other works by Mezrich.

MARCH 4 Dave Stewart of Harry R. Feldman Inc., a Boston-based land-surveying company, was part of a crew working on Beacon Street just outside Kenmore Square.

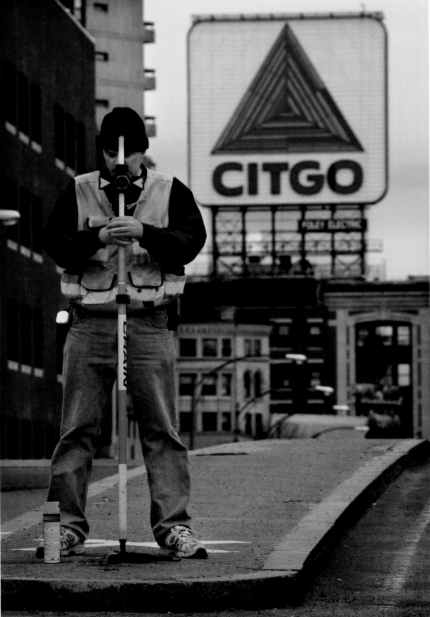

▲ **MARCH 5** Colonnade Hotel vice president and managing director Dave Colella caught a quick word with Rich Steponaitis, director of account development for American Express. The two were at Oceanaire Seafood Room for the kickoff of Restaurant Week, standing in front of what was the central vault for the former US Trust bank.

◄ **MARCH 6** About a month before opening day for the Red Sox, construction crews worked on the third base side of Fenway Park. The new Coca-Cola Corner would include a hundred-person standing-room section and more than four hundred pavilion-level seats to replace temporary luxury suites built for the 1999 all-star game.

MARCH 7 Historian David McCullough and actor-producer Tom Hanks arrived at the Boston Public Library for a sneak peek of the eight-and-a-half-hour HBO mini-series "John Adams," based on the Pulitzer Prize-winning author's biography of the second president. Hanks produced the series that starred Paul Giamatti as Adams and Laura Linney as the president's beloved wife, Abigail.

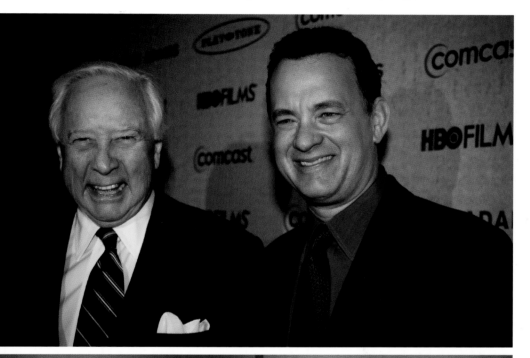

MARCH 8 No matter what the weather threatens or promises outside, the New England Flower Show at the Bayside Expo Center is a yearly oasis for many in the region. The show is one of the largest public events held in the city.

MARCH 9 His Beatitude Archbishop Anastasios, head of the Orthodox Church of Albania, was joined by Father Arthur Liolin and other church leaders at a liturgical celebration marking the hundredth anniversary of St. George Cathedral, the oldest Albanian Orthodox Church in the United States. The historic church on East Broadway in South Boston draws from forty area communities and into other parts of New England.

▼ **MARCH 10** Hector Bellevue kept the lobby of the Fairmont Copley Plaza hotel spotless early one evening.

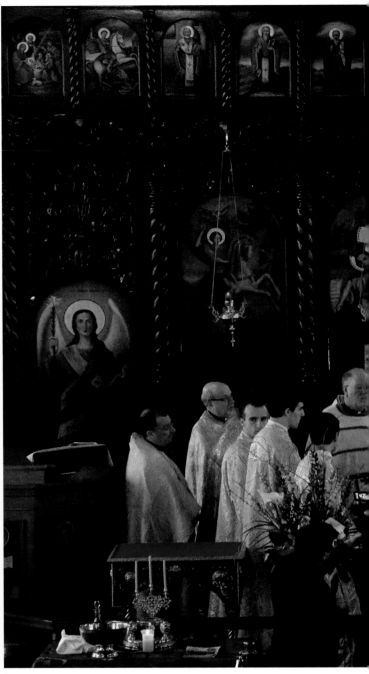

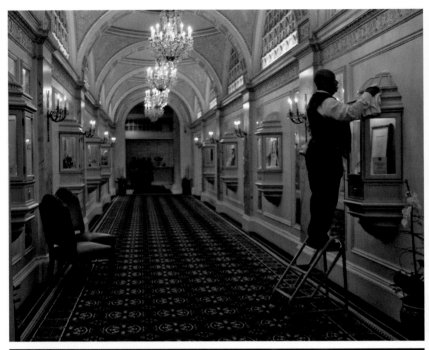

◄ **MARCH 11** Miss America Kristen Haglund received a tour of the Harris Center for Education and Advocacy in Eating at Massachusetts General Hospital from the center's director, Dr. David B. Herzog. Haglund was in town to speak about her own struggle with anorexia at a Harvard panel entitled, "Redefining Perfection: Beauty, Fashion and Body Image."

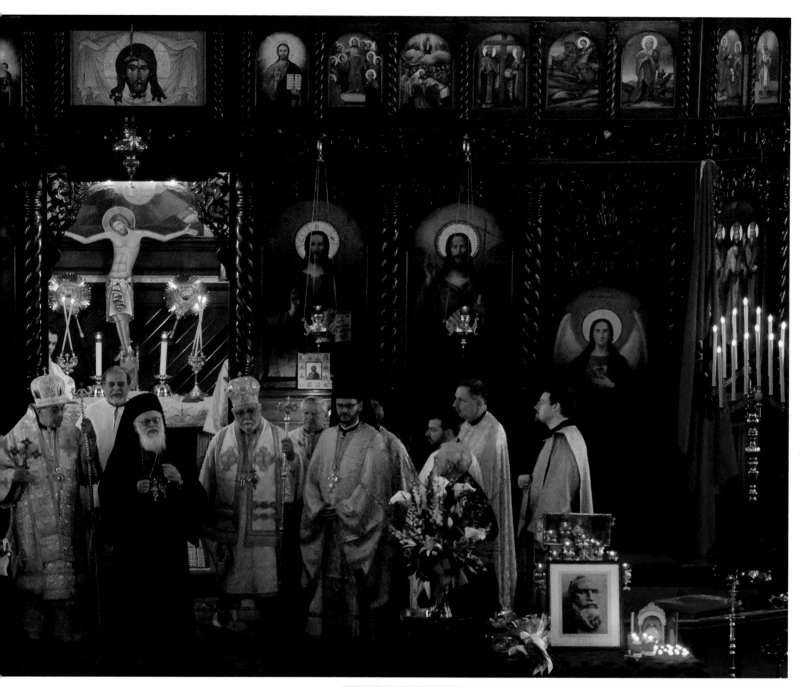

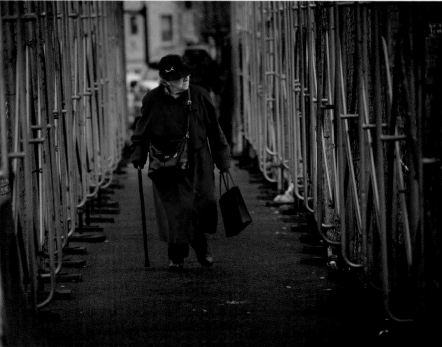

► **MARCH 12** Marilyn Barron, eighty-five, walked along Huntington Avenue in front of the Massachusetts College of Pharmacy and Health Sciences while construction was going on above her. Barron, a longtime resident of the area, said she checked the progress of the project every day and loved the school's new addition.

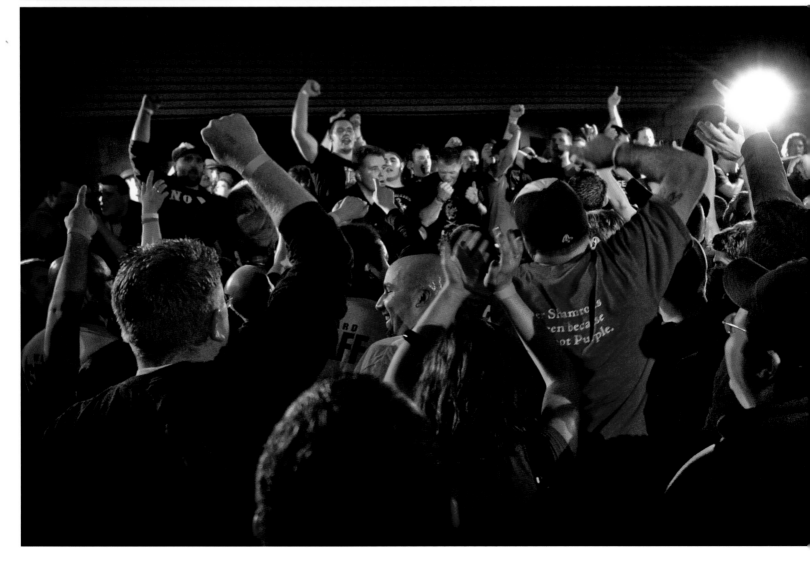

◀ **MARCH 13** David Palleiko, staff field geologist with Haley Aldrich of Boston, seemed oblivious to the cacophony of graffiti on the Providence Street wall behind him.

▼ **MARCH 14** It has become a tradition at this time of the year for Ken Casey and his Celtic punk band The Dropkick Murphys to hold a series of concerts in Boston, including a stop at the International Brotherhood of Electrical Workers union hall on Freeport Street in Dorchester.

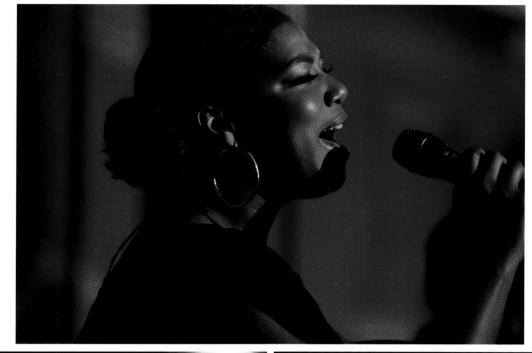

◀ **MARCH 15** Queen Latifah sang a set that included jazz standards, blues, funk, and even her 1990s hit "U.N.I.T.Y.," at a gala at the Four Seasons Hotel honoring Diane Patrick and Angela Menino. The event raised more than $350,000 for the Roxbury Comprehensive Community Health Center.

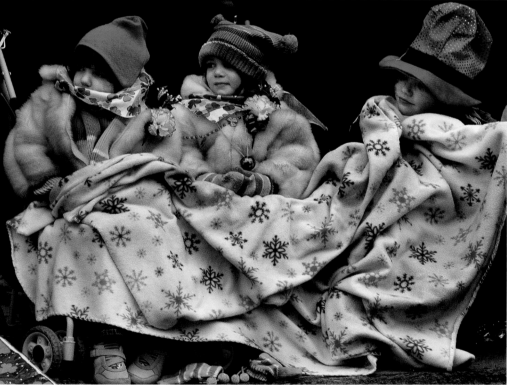

▲ **MARCH 16** Fully decked out in their best St. Paddy's Day garb, five-year-old twins Alexandra and Caroline Bohm huddled with Matthew Bianco, nine, to stay warm while watching the 108th St. Patrick's Day Parade along East Broadway in South Boston.

◀ **MARCH 17** The Boston Police Pipes & Drums Gaelic Column used their busiest holiday to raise some money for local charities. Here they stopped by the Eire Pub in Adams Corner where owner John Stenson happily wrote a check for their mini-concert. The St. Patrick's Day travels also took the column to the Franciscan Children's Hospital of Boston and the Boston Children's Museum where they spread a little cheer.

◀ **MARCH 18** Governor Deval Patrick made a last pitch to the legislature's Joint Committee on Economic Development and Emerging Technologies to support his plan for three resort casinos in the state. Despite his efforts to stress the economic benefits, Patrick's plan would be defeated, at least for this session, a short time later.

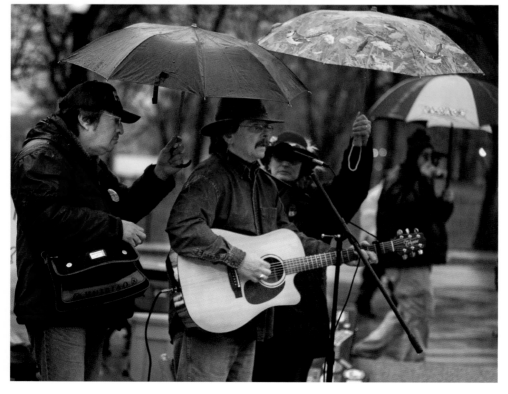

◀ **MARCH 19** Chuck Williams, a Vietnam War veteran from Mattapoisett, managed to sing a few songs as scores of protesters braved the driving rain on the fifth anniversary of the war in Iraq.

MARCH 20 Jessica Hsu's face was streaked with tears of joy as the budding doctor found out she was accepted to her first choice, Cedars-Sinai Medical Center in Los Angeles. On medical match day at medical schools like Tufts University School of Medicine, students find out where they will continue their training. Tufts saw 170 medical students learn their professional fate via the National Resident Matching Program. More than 97 percent of seniors who applied for residencies this year were paired with a program of their choice.

MARCH 21 Carlos Lopes took up the cross as part of a Good Friday procession at St. Peter Church in Dorchester. The somber Roman Catholic remembrance was led by the church's pastor, the Reverend Daniel Finn.

MARCH 22 A gaggle of tiny searchers were on the prowl for prizes at an Easter egg hunt in Dorchester Park.

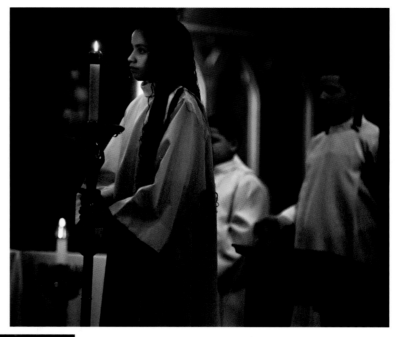

MARCH 23 Altar servers waited by the altar during a Spanish-language Easter Sunday mass at the Cathedral of the Holy Cross on Washington Street in the South End.

MARCH 24 The Bebe Nail & Skin Salon near Dartmouth Street was the backdrop for a typical Newbury Street scene.

MARCH 25 Patriots linebacker Tedy Bruschi added a little levity to a State House briefing on behalf of the American Stroke Association about the need for more funding for research. Bruschi, who suffered a stroke in February 2005, was joined at the press conference by Dr. Lee H. Schwamm, whose many titles include director of Acute Stroke Services at Massachusetts General Hospital, and state senator Mark C. Montigny.

MARCH 26 Hassen Chbani worked in a trench along William T. Morrissey Boulevard in Dorchester. The Massachusetts Water Resources Authority undertook a massive public works project to improve drainage and the water quality of North Dorchester Bay. The project was expected to be completed by June 2009.

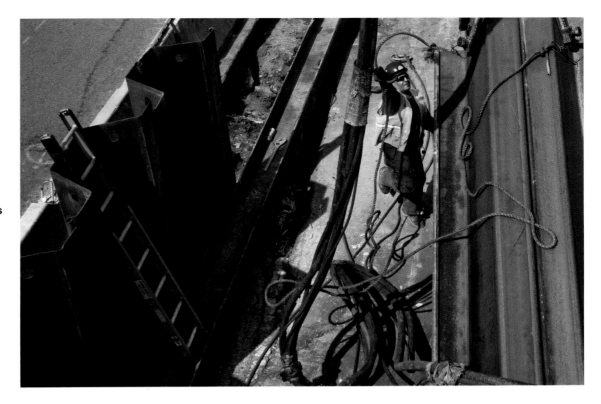

MARCH 27 Once again showing grace beyond her years, Kai Leigh Harriott was out front at a press conference to announce that she and her mother, Tonya David, would be among those honored by the Urban League of Eastern Massachusetts at their April 5 gala at the Seaport World Trade Center. About a month later, Kai, who was paralyzed from the chest down by an errant gunshot, would speak at a Peace Month event in Dorchester.

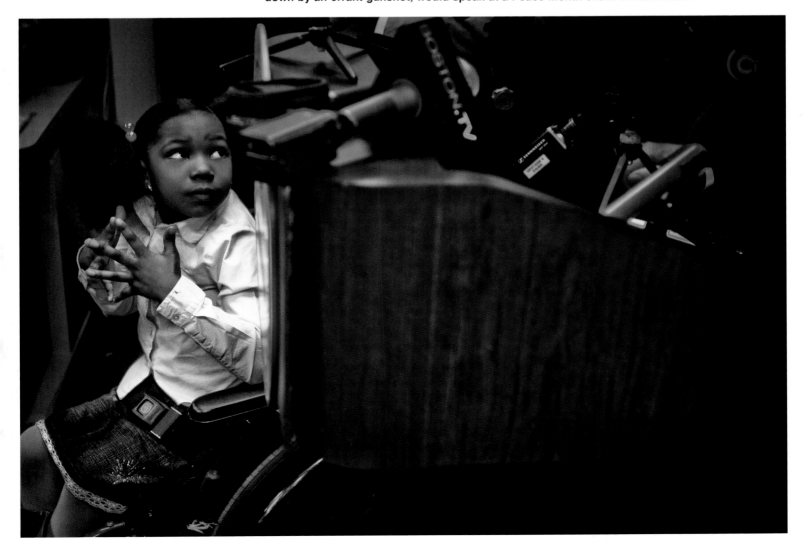

◀ **MARCH 28** They work in the public sector, hold or have held elected office, and are generally plugged into the goings-on of the city, but the topics are limited to politics or the day's headlines when these friends gather regularly at Rino's Place on Saratoga Street in East Boston.

◀ **MARCH 29** The dramatic downturn in the greater Boston real estate market and mounting foreclosures around the region yielded a glut of distressed properties. More than fifteen hundred people filled a room at the Hynes Veterans Memorial Convention Center to bid on more than 160 Massachusetts homes auctioned by Real Estate Disposition Corporation. It was the California company's second such auction in four months.

◀ **MARCH 30** While the Olympic torch was winding its way across the globe en route to the Summer Games in China, the Human Rights Torch was on a tour of its own. Some three hundred human rights activists were at the Parkman Bandstand on Boston Common as city councilor Michael Ross welcomed the alternative torch relay, which started the day in Hopkinton. The local demonstration was one of eighty such displays across the country to draw attention to Chinese human rights abuses and to "encourage China to embrace the humanitarian spirit of the Olympics."

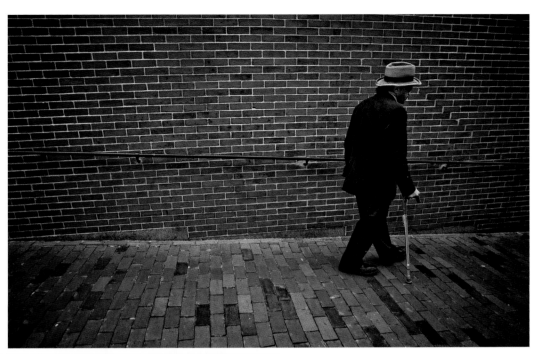

MARCH 31 Eric McIntyre, who introduces himself as a Sammy Davis Jr. look-a-like, walked along Joy Street on Beacon Hill.

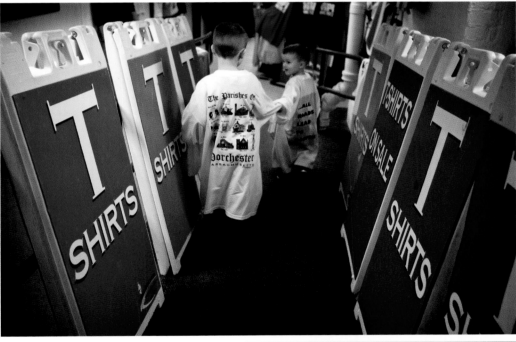

APRIL 1 Jack Doherty, who owns College Hype, a custom screen printing and embroidery company in Dorchester's Adams Corner, often lets his boys, Nolan, five, and Evan, three, try out the shop's hottest designs—even the famed "Parishes of Dorchester" shirts. Shortly after this picture was taken, Jack's wife, Annmarie, who was home with daughter Caroline, went into labor with their fourth child. A daughter, Brenna, was born later that evening.

APRIL 2 Philip Thurston of the Big Apple Circus waited backstage for the show to begin as young people from the Josiah Quincy Elementary School walked from Chinatown to the big top at City Hall Plaza.

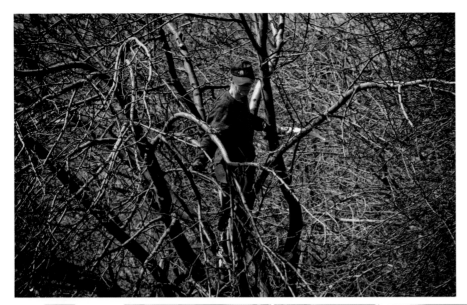

◀ **APRIL 3** Arborist Dennis Pultinas worked on the unruly limbs of an apple tree growing along Marginal Street in East Boston. Pultinas is affiliated with EarthWorks, a not-for-profit organization whose mission is to help Boston residents connect with their environment.

▲ **APRIL 4** Dr. Gary L. Gottlieb, president of Brigham and Women's Hospital, looked over construction of a dramatic transparent-glass bridge spanning Francis Street to connect the hospital's main entrance with the new Carl J. and Ruth Shapiro Cardiovascular Center which was planned for a May opening.

▶ **APRIL 5** A street musician let four-year-old Frank Gallo and five-year-old Jovina Listewnik take a turn pounding out a tune on found objects just outside Faneuil Hall.

► **APRIL 6** Four-year-old Harry Haros marched to his own beat—and in the opposite direction—as the rest of the annual Greek Independence Day Parade carried on. Organized by the Federation of Hellenic-American Societies of New England, the parade route began on Boylston Street and made its way to a reviewing stand at Charles Street.

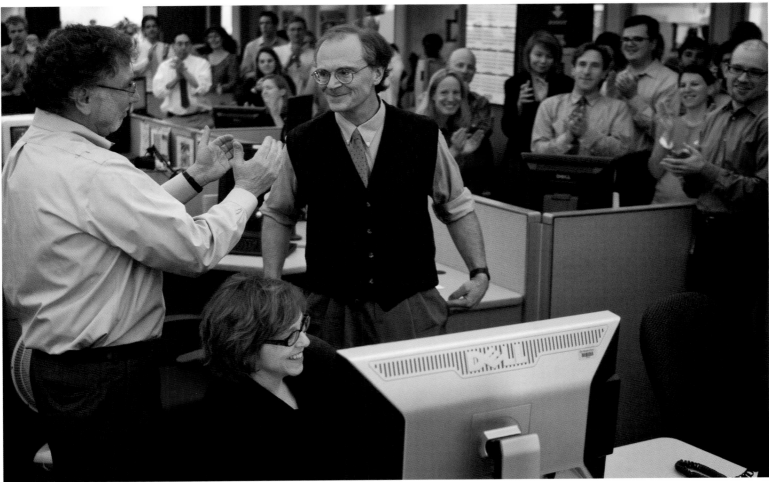

▲ **APRIL 7** *Boston Globe* editor Martin Baron congratulated arts writer Mark Feeney for being awarded the 2008 Pulitzer Prize for criticism as Ellen Clegg, the newspaper's deputy managing editor of news operations, announced the good news from an alert on the wires. Feeney won the prestigious award for ten essays on visual arts. It was the *Globe's* twentieth Pulitzer Prize.

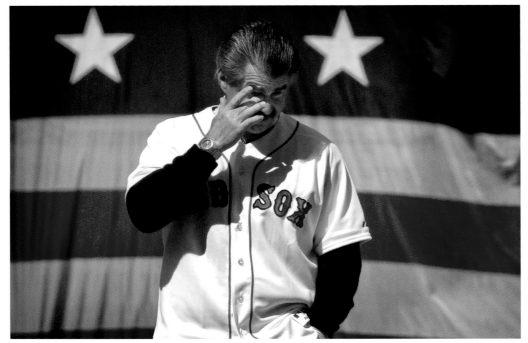

APRIL 8 As soon as he walked out on the field at Fenway Park to throw out the ceremonial first pitch, fans at the opening-day game leapt to their feet to welcome former Red Sox first baseman Bill Buckner. Unfairly blamed by outspoken fans over the years for the Red Sox loss to the New York Mets in the 1986 World Series, Buckner wiped away a few tears as the city and the team's fans showed that all was forgiven.

APRIL 9 Once a destination, much of the former Filene's store in Downtown Crossing was torn down to make way for a new thirty-nine-story, multiple-use development to open in 2011. At a price of $700 million, One Franklin Street will substantially preserve two of the four structures on the block, including much of the facade of the famed store. The project will include a 280-room hotel, 125-seat restaurant, 166 residential condominiums, retail and office space, and an adjacent park. Filene's Basement, long a separate company from its namesake upstairs, closed in 2007 after ninety-nine years as an anchor to the city's shopping district, but promised to reopen in the bottom four floors of the new tower.

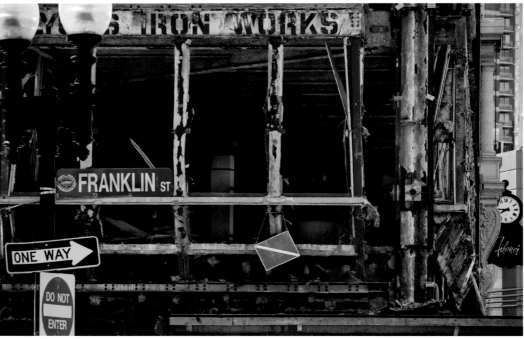

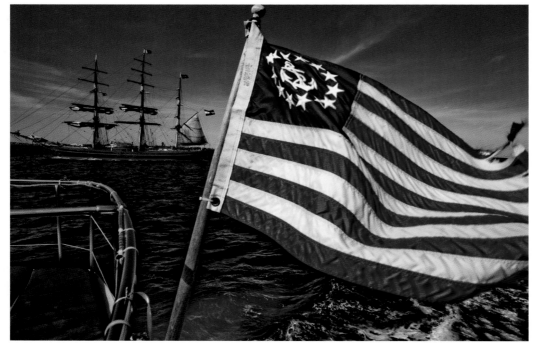

APRIL 10 The 250-foot Stad Amsterdam, a three-masted Tall Ship from the Netherlands, was given a warm welcome as she arrived in Boston Harbor. The fully rigged ship and her crew attracted even more attention as they docked at Rowes Wharf.

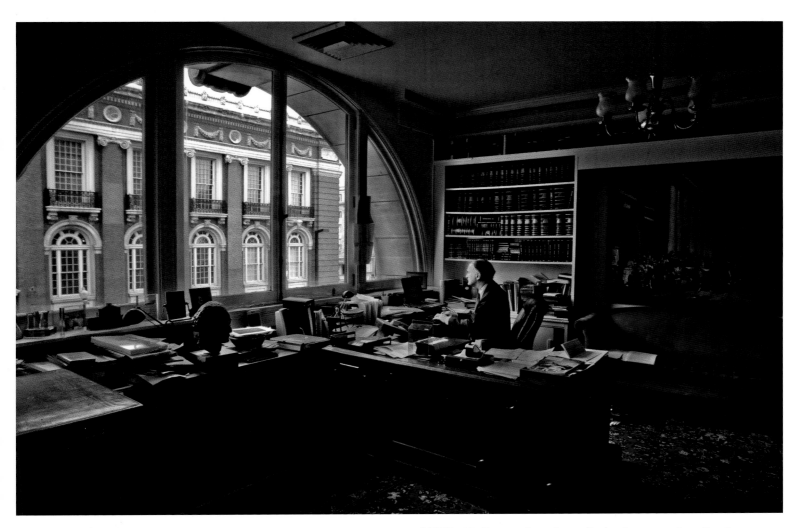

▲ **APRIL 11** Boston Symphony Orchestra managing director Mark Volpe seemed unaffected when Bill Brett turned his lens inside Symphony Hall after using a second-story window to shoot a news photo.

▶ **APRIL 12** Sandra and Lorraine Rossario were among the volunteers who turned out to clean up Roxbury's Jackson Square.

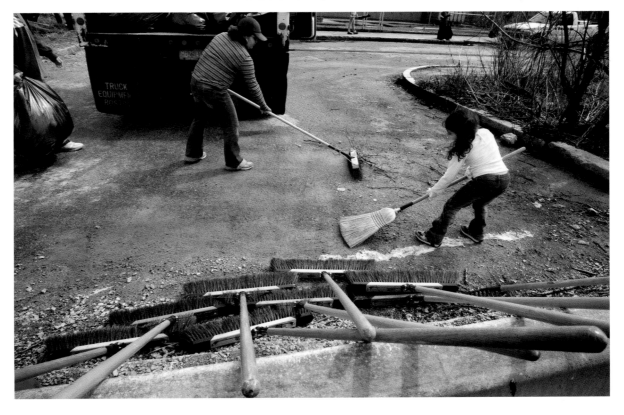

▼ **APRIL 13** Three hundred girls, all wearing bright pink "I Am Strong" T-shirts, participated in a jump-rope-a-thon at Downtown Crossing to raise awareness about the importance of self-esteem for young women. The event was organized by Strong Women, Strong Girls, which fosters high aspirations among girls ages eight to eleven, helping them to develop the skills they need for lifelong success. After their jumping was over, the young girls attended a performance of Big Apple Circus.

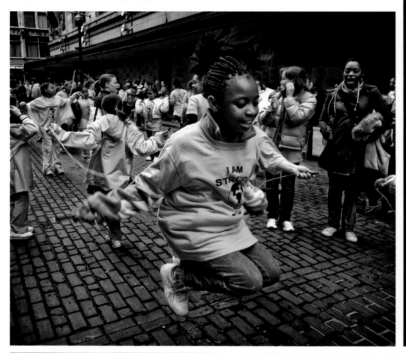

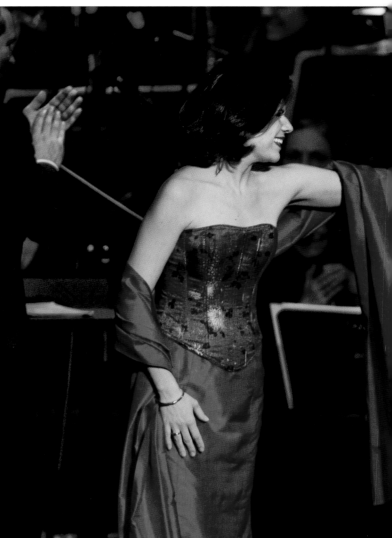

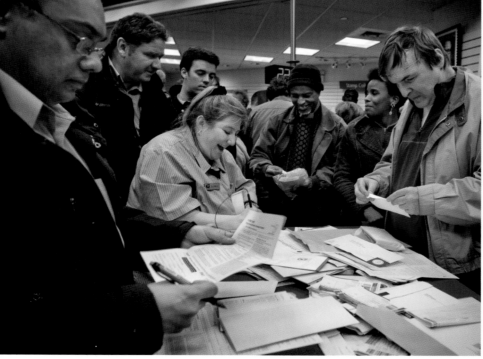

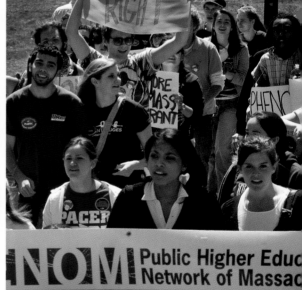

▲ **APRIL 15** With just five minutes left to get 2007 tax returns turned in, postal clerk Elena Koumboris kept order and her cool as she helped customers file at the postal annex in South Boston.

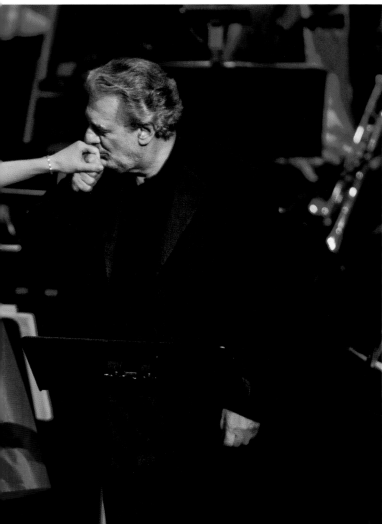

APRIL 14 Plácido Domingo welcomed soprano Ana Maria Martinez to the stage at the famed Spanish tenor's first full concert in Boston. The sold-out show at the Citi Performing Arts Center Wang Theatre was Domingo's only announced stop in the United States on this tour.

APRIL 17 Ryan Reardon, an eight-year-old cancer patient at the Dana-Farber Cancer Institute, held up the replica jersey for Red Sox slugger David Ortiz that was buried in concrete near the visiting team's locker room during construction of the new stadium for the New York Yankees. The jersey was put up for auction to benefit the Jimmy Fund and netted a whopping $175,100 for the charity when the bidding was concluded.

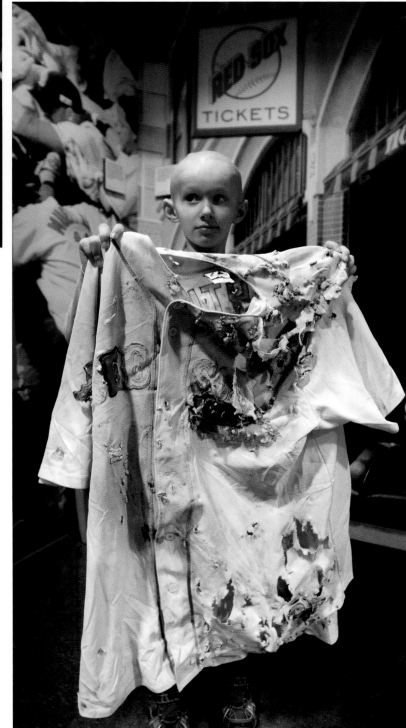

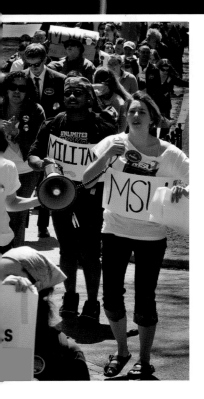

APRIL 16 Hundreds of students, faculty, and staff from around the state turned out on Boston Common for a rally organized by the Public Higher Education Network of Massachusetts to get state lawmakers to increase funding to the state's public colleges and universities.

◀ **APRIL 18** For more than fifty years Sullivan's restaurant and hot dog stand at the end of Day Boulevard at Castle Island in South Boston has opened each March through November. But you know the weather has finally warmed when the lines start to stretch out to the parking lot.

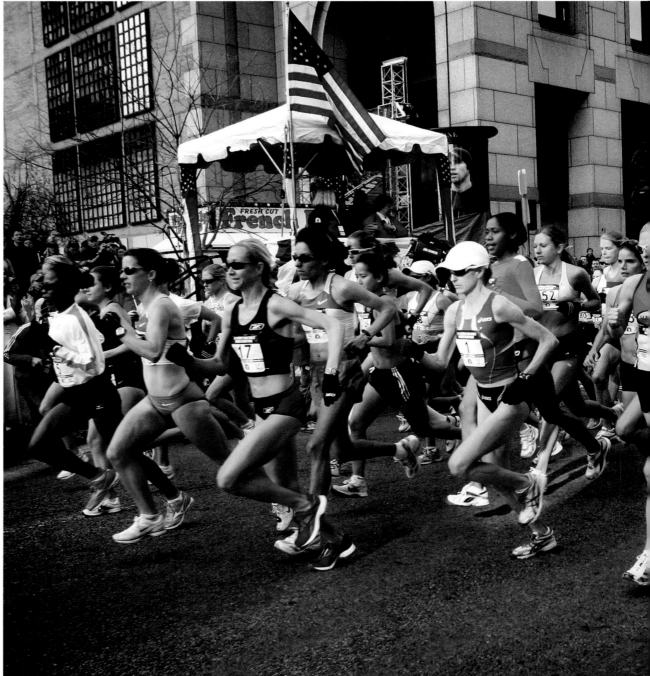

APRIL 19 Funambulism is not on the course schedule for Simmons College, but student Marjorie "Maggie" Riggs got a lesson from Roxbury resident Danny Gallagher on how to walk a tightrope on this warm afternoon at the Fenway college's campus.

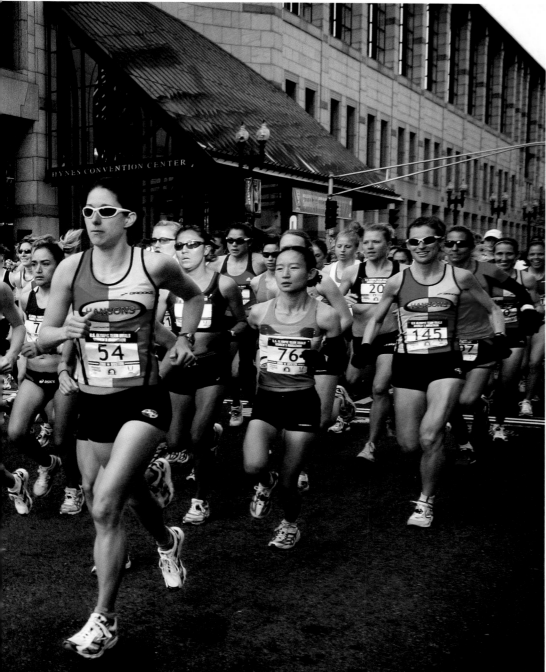

APRIL 20 The race came a day early for the women trying to secure a spot on the 2008 US Olympic marathon team. Starting and ending in the Back Bay, the Olympic trials were won by Waltham native Deena Kastor in 2 hours 29 minutes and 35 seconds. Rounding out the team were Magdalena Lewy Boulet and Blake Russell. There was one face among the 144 starters that was very familiar: Joan Benoit Samuelson, who at age fifty said this would be her last competitive race. She set an American record for her 50-54 age group. The two-time Boston Marathon winner won the first Olympic women's marathon in 1984, the only U.S. medal in the event until Kastor took the bronze in Athens.

APRIL 21 Patriots Day 2008 marked the 112th running of the Boston Marathon, and Robert Cheruiyot crossed the finish line first for the fourth time. Dire Tune would outkick Alevtina Biktimirova to win by two seconds in the closest finish in the history of the women's race. As it always does, though, the Boston race belonged to the thousands who finished the grueling 26.2-mile trek from Hopkinton to Boylston Street in the Back Bay. The entry list in 2008 totaled 21,963.

EXETER ST

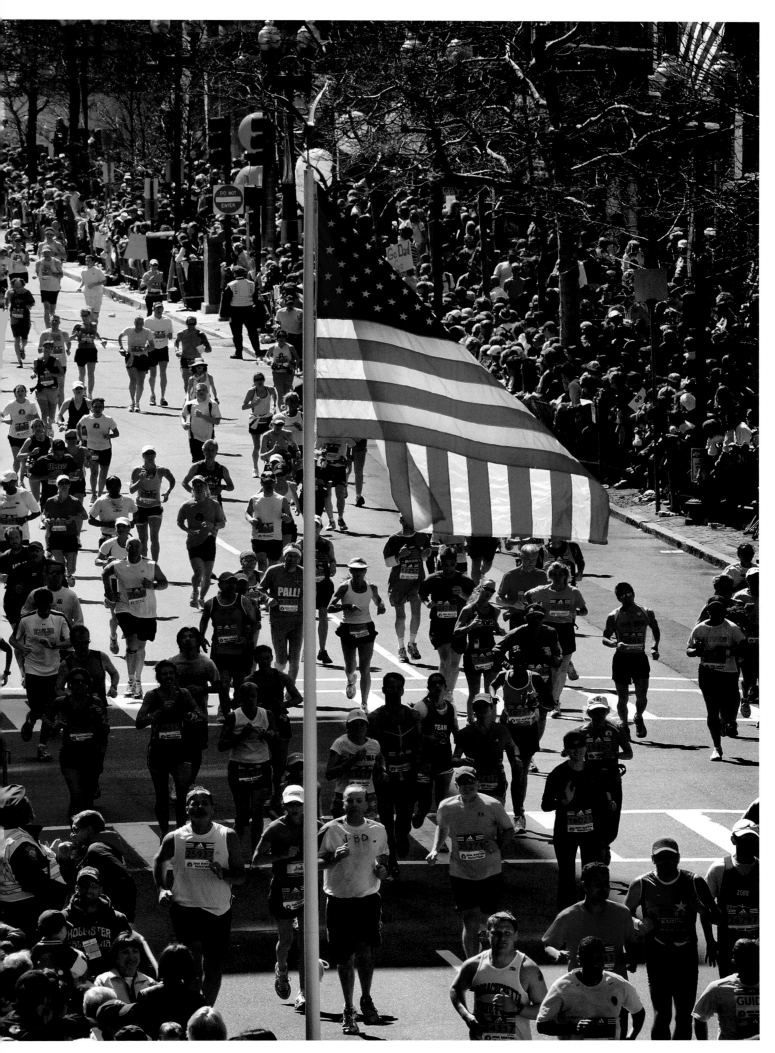

INDEX

ACKNOWLEDGMENTS

I would like to dedicate this book to the youth of Boston; I want them to take a hard look at the faces of the workers, the beautiful scenery, and the remarkable everyday accomplishments of our neighbors. You have the tools to be successful here, with the best medical facilities, colleges, universities, businesses, and government in the country. Take advantage of Boston's institutions, take notice of its great business leaders, and use these great programs to help others. In my first book, *Boston All One Family,* I tried to show how leaders in the community work as a family for Boston's common good. The encore, *Boston, An Extended Family,* captured more personalities who have achieved success and participate in the community in a positive way. Boston produces great leaders because they take advantage of this great city.

I started taking pictures of the people of Boston and covering their stories when I was fifteen years old. As I tried to take care of Boston, it was taking care of me. We have to preserve this city and continue to accomplish wonderful things. Enjoy this year in the life of Boston, and I hope you enjoy this city in the coming years as much as I do. I look forward to photographing you someday as leaders of the city.

I want to extend my love and special thanks to my wife, Ginnie, for her support; to my children, Megan, Erin, Tim, and (with special thanks) Kerry, a photographer extraordinaire, who has made her own mark in Boston. She served as my picture editor on this project and gave great support with ideas and locations; to my granddaughter Morgan; to my grandson Greyson; to my sons-in-law, Corey Gunter and John Khayali; to my brothers, Jim, Harry, and Jack, and to my sisters, Margaret and Mary—thank you all for your love and support.

Special thanks to my dear friend David G. Mugar, who has been there for me for almost fifty years! David has been there for the people of Boston too, through his work for thirty-five years on our Fourth of July celebration. It was easy to ask David to write the forward for me, because he is Mr. Boston. In addition, thanks to R.J. Valentine, who has been my friend since first grade. He is always there to motivate and encourage. What a gift to have such friends!

Many thanks to Mayor Thomas Menino; to Bobby Devine and Brian McDonough for their help in getting around the city; and to Mike Casey for listening and helping with photo ideas. Thanks to the *Boston Globe* photo staff, especially Justine Hunt, Bill Polo, Joanne Rathe, Evan Richman, David Ryan, John Tlumacki, Mark Wilson, George Rizer, David Kamerman, Tom Landers, Jim Wilson, Ted Gartland, John Blanding, Steve Haines, Stan Grossfeld, and Janet Knott. Thanks also to image technicians– photographers Jim Bulman, John Ioven, Susan Chalisoux, Tim Muschato, Kathleen Johnson, and Janine Rodenhiser.

Special thanks to Mike Barnicle, Kevin Cullen, Brian McGrory, and Mark Shanahan; and to my satellite offices throughout the city, especially Gerard Adomunes and his wife Ruth, their crew, and staff of Gerard's Restaurant in Dorchester; *Dorchester Reporter's* Bill and Ed Forrey, and Tom Mulvoy; and John's Auto Body, and Billy and Ed Balas.

I must mention Paul Joyce, Dot Joyce, Joe Milano, John Nucci; Suffolk University's public relation staff; Ted O'Reilly, Bob Madden, Dan Horgan, Rosemary Carr, Steve Ownes, Don Rodman, Tom Lacey, Rich Serino, Dr. Larry Ronan, Meg Vaillancourt, John McDermott, Paul Foster, Joe Fallon, Tim Foley, Bernie Magolis, Fran Martin, Kelley Doyle, David Ting, Jack McCarmack, Anne Marie Lewis Kerwin, Justin Holmes, and Danny Gallagher. Thanks to digital techician Chris Rioux, who stayed many late nights working for me, and Kat Kattler, who also lent her talents; and to Lynn Gonsalves, who at any time retrieves a photograph for me with a smile on her face.

My thanks to Boston Police Harbor Patrol, Billy Higgins, Boston Police Superintendent-in-chief Bob Dunford, Superintendent Dan Linskey, Captain Robert Flaherty, Captain Frank Armstrong, Captain Bill Evans, Sergeant Bill Ridge, Sergeant Detective Dan Downing, and Detective Ed Walsh. Also to Boston Fire Chief Kevin MacCurtain and public relations officer Steve MacDonald. Also to State Police Captain Charles Flynn, former Captain Joseph Saccardo, Lieutenant Jim Constine, Sergeant Jack Flynn, Sergeant Dave O'Leary, and Trooper Coley Connolly.

Special thanks to the staff of Commonwealth Editions, including Webster and Katie Bull, Anne Rolland, Jill Christiansen, and Carol Mendoza. And finally, thanks to Carol Beggy for her time, inspiration, and talents. That's three for three, Carol—my sincere thanks!

Bill Brett
May 2008